A Bigger Splash
Painting after
Performance

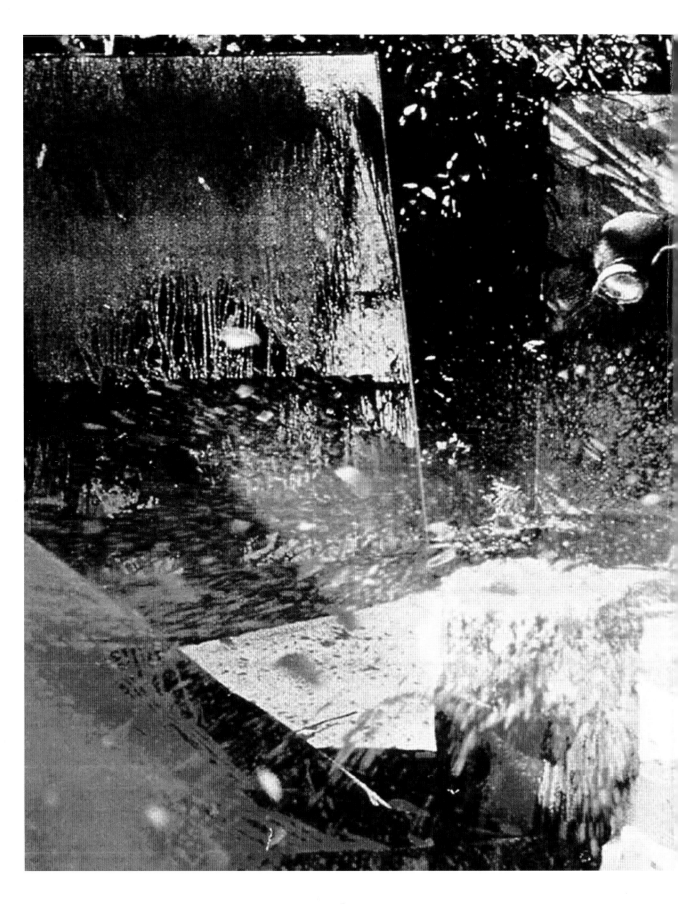

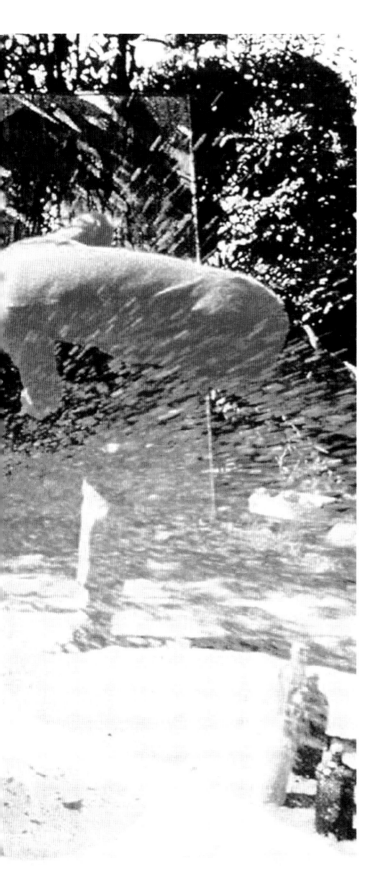

A Bigger Splash
Painting after Performance

Edited by Catherine Wood

With contributions by
Eda Čufer
Isabella Maidment
Fiontán Moran
Dieter Roelstraete
Catherine Wood

First published 2012 by order of the Tate Trustees
by Tate Publishing, a division of Tate Enterprises Ltd,
Millbank, London SW1P 4RG
www.tate.org.uk/publishing

on the occasion of the exhibition
A Bigger Splash: Painting after Performance

Tate Modern
14 November 2012 – 1 April 2013

The exhibition is supported by
ART MENTOR FOUNDATION LUCERNE

A catalogue record for this book is available
from the British Library

ISBN 978 1 84976 020 1

Distributed in the United States and Canada
by ABRAMS, New York

Library of Congress Control Number: 2012947079

Designed by Assembly
Colour reproduction by DL Imaging Ltd, London
Printed in Italy by Mondadori

Cover artwork:
David Hockney
A Bigger Splash 1967 (detail)
Acrylic paint on canvas
242.5 x 243.5
© David Hockney
Tate

Frontispiece:
Shozo Shimamoto
Hurling Colours Performance 1956
(detail, see p.44)

Measurements of artworks are given in centimetres,
height before width and depth

Contents

Foreword

One of the veins of art history that is as yet underexplored is the relationship between so-called traditional and new media, and this exhibition is an attempt to look at such a relationship, in the entanglement of painting and performance. Framing some familiar, and other less familiar, works from Tate's collection in new ways, *A Bigger Splash: Painting after Performance* looks firstly at how performance and action in the immediate post-war period radically broke down the conventions of painting by replacing pictoriality and composition with slashed, dripped upon, shot-at or cut-up canvases: new 'arenas for action'.

But the impact of performance on painting went deeper than this familiar trajectory of expressive, gestural work, however. From this starting point, the show looks towards new performative environments in which painting becomes a form of stage-setting that is continuous with the painted body of the artist or performer, destabilizing the conventional set-up of making or viewing. Into the 1970s and 80s, the idea of painting was taken into new media by a number of artists, many of whom from queer or feminist positions used ideas of face and body painting as drag and decoration. The exhibition attempts to set out this complex history, played back and forth between painting and performance, and between pictoriality and masquerade, to consider how it has impacted upon the possibilities for artists using painting as part of expanded art practices now.

An extraordinary and compelling black and white photograph that I encountered when visiting the artist R.H. Quaytman's home (her favourite photograph) shows an abstract painting propped, like a surfboard on a beach, in the sand. The painting is by Quaytman's father, the artist Harvey Quaytman, and the photograph was taken in 1960 by her stepfather, David von Schlegell, who had invited him to mount an exhibition of art on the beach. This intervention into the landscape and the way the painting is reflected and refracted in the wet surface of the shore is poetically emblematic of certain ways in which the object of painting has been recast and reused by artists since then. Painting might have lost its innocence through the prolonged attacks upon it in the twentieth century, but as the work in this exhibition that has come after this key period of action-painting and performance-painting shows, its disintegration and dispersal into the most profane spaces of everyday life – whether as décor, wallpaper, make-up, prop or theatre set – has given new life to the medium.

Tracking painting through the parallel history of performance, and performance's impact upon it, provides us with a new way to read important works in our collection: not just Jackson Pollock's *Summertime: Number 9A*, as we see it next to the Hans Namuth film of him painting on the floor, but also David Hockney's *A Bigger Splash*, seen in relation to the fantasy documentary of his life, where his paintings appear as a catalyst to action and as a backdrop. This exhibition very much reflects Tate Modern's interest in weaving major and minor histories together, to form new, richer art historical narratives. The show is a partial story rather than a comprehensive survey, but also includes experimental works from regions that

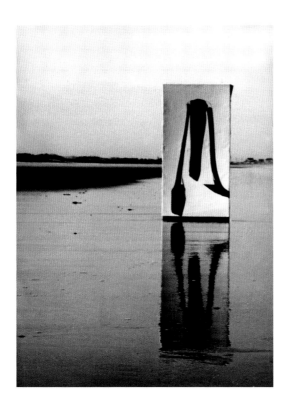

form less familiar stories of performance, including Korea, China and Japan, as well as Eastern Europe.

I would like to thank the artists in the show, Helena Almeida, Eleanor Antin, Ei Arakawa, Geta Brătescu, Stuart Brisley, Günter Brus, Ivan Cardoso, Marc Camille Chaimowicz, Lucile Desamory, VALIE EXPORT, Sam Gilliam, Wiktor Gutt, Jack Hazan, Lynn Herschman, David Hockney, IRWIN, Sanja Iveković, Joan Jonas, Karen Kilimnik, Ku-lim Kim, Jutta Koether, Yayoi Kusama, Kang-so Lee, Andrew Logan, Urs Lüthi, Lucy McKenzie, Mario Montez, Otto Muehl, Hermann Nitsch, Luigi Ontani, Ewa Partum, Wang Peng, Wu Shanzhuan, Cindy Sherman, Shozo Shimamoto, Wolfgang Tillmans, Zsuzsanna Ujj and Karla Woisnitza. We are grateful to the heirs and representatives of Guy de Cointet, Derek Jarman, Yves Klein, Eustachy Kossakowski, Edward Krasiński, Kurt Kren, Ana Mendieta, Hans Namuth, Hélio Oiticica, Pinot Gallizio, Jackson Pollock, Waldemar Raniszewski, Niki de Saint Phalle, Rudolf Schwarzkogler, Kazuo Shiraga, Jack Smith and Andy Warhol. We would like to thank the following artists featured in Ei Arakawa's films and stills: Henning Bohl, DAS INSTITUT, Nikolas Gambaroff, Grand Openings, Silke Otto-Knapp, Amy Sillman, Sergei Tcherepnin, UNITED BROTHERS.

I would like to acknowledge the generosity of the lenders and their assistants, many of whom provided essential knowledge and help in the research and organisation of this exhibition: Florence Bonnefous of Air de Paris; Anthony Yung of the Asia Art Archive (AAA); Alison Jacques, Louise O'Kelly and Rory Mitchell of Alison Jacques Gallery; Ei Arakawa; Liliana Dematteis

Fig.1
Untitled photo 1960, by David von Schlegell, showing a painting by Harvey Quaytman

and Anna Follo of the Archivio Gallizio; Belynda Sharples of the Art of Wallpaper; Charles Asprey; Domo Baal; Thomas Borgmann; Maya Brisley; Stuart Brisley; the British Film Institute (BFI); Katharina Forero de Mund of Buchholz Galerie; Andrew Wheatley, Martin McGeown and Anna Clifford of Cabinet Gallery; Cora Muennich of Campoli Presti; Ivan Cardoso; Jamie Robinson of Carter Presents; Evelyne Blanc and Olga Makhroff of Centre Pompidou; Xavier Douroux and Irène Bony of Le Consortium; Čuček Collection; Andras Edit; Nick Lesley and Juliet Myers of Electronic Arts Intermix (EAI); Andrzej Przywara and Aleksandra Ściegienna of Foksal Gallery; Daniela Oliveira of Fundação de Serralves; Galerie Lelong; Lorcan O'Neill, Laura Chiari and Serena Basso of Galleria Lorcan O'Neill; Felix Flury of gallery S O; Barbara Gladstone, Daniel Feinberg and Jodie Katzeff of Gladstone Gallery; Ingvild Goetz and Alexander Kammerhoff of Sammlung Goetz; Wiktor Gutt; Jack Hazan; Claudia Hein and Karlheinz and Renate Hein; the Hermann Nitsch Foundation; Iggy Private Collection; IRWIN; Ku-lim Kim; Jutta Koether; Yayoi Kusama and Etsuko Sakurai of Kusama Studios; Kang-so Lee; Andrew Logan; James McKay and Maja Hoffman of LUMA Foundation; Lucy McKenzie; Maureen Paley and Vera Hoffman of Maureen Paley Gallery; MissionArt Gallery; Miran Mohar; Kitty Cleary of MoMA–The Circulating Film & Video Library; Mario Montez; Ivan Moskowitz; Eva Badura-Triska, Sophie Haaser and Alexandra Pinter of Museum moderner Kunst Stiftung Ludwig Vienna (MuMoK); Jana Shenefield, archivist of Niki Charitable Art Foundation; Kata Oltai; Mizuho Kato of Museum of Osaka University; Raluca Velisar of National Museum of Contemporary Art, Bucharest (MNAC); Maria Morzuch of Museum Sztuki; Kyoung-woon Kim of the National Museum of Contemporary Art, Korea; RANDL Collection; Christina Ruf and Markus Edelmann of Ringier AG/Sammlung Ringier; Wu Shanzhuan; Uli Sigg and Marianne Heller of the Sigg Collection; Wolfgang Tillmans; Heather Kowalski and Matt Wrbican of The Andy Warhol Museum; Zsuzsanna Ujj; Roman Uranjek; Gabriele Schor and Ema Rajkovic of the Sammlung Verbund; Nadia Wallis; Karla Woisnitza; and Philippe Siauve of Yves Kein Archives.

In addition we would like to extend our sincere thanks to those who assisted in the research and loan procedure: Ashiya City Museum of Art & History; Jes Benstock; Bibliothèque municipale de Lyon; Erica Bolton; Céline Breton and Valentina Valentini of the Bibliothèque Kandinsky; Véronique Cardon of the Archives de l'Art contemporain en Belgique; Hugues de Cointet; Michael Davis; Marie-Jeanne Dypréau; Aniko Erdosi of BROADWAY 1602; Ariane Figueiredo of Projeto Hélio Oiticica; Bruno Ramos Múrias; Daniela Oliveira and Lúcia Conceição of Galeria Filomena Soares; Gurcius Gewdner; Jenny Jaskey of The Artist's Institute; Koichi Kawasaki; Claire Beltz-Wüest of the Museum Tinguely; Laurence Le Poupon of Archives de la critique d'art; Annie Gawlak and Marsha Mateyka of Marsha Mateyka Gallery; Johnny Dewe Mathews; Jane Pritchard of the Victoria and Albert Museum; Al Riches of the English National Ballet; Łukasz Ronduda of the Muzeum Sztuki Nowoczesnej Warsaw; Charlie Scheips; Marc Siegel; and Zhang Wei of Vitamin Creative Space.

At Tate Modern, I would like to thank the curator of the exhibition, Catherine Wood, Curator of Contemporary Art and Performance, for the original concept of this exhibition and for her

illuminating reconsideration of familiar works in new contexts. In all of this she has been brilliantly supported by Fiontán Moran, Assistant Curator, who has contributed enormously to all aspects of the exhibition's planning and realisation, including undertaking original research and writing for the catalogue. Thanks are also due to Liz Carney for her work on the show during her internship, and her very useful research about the historical artists, to Isabella Maidment for her research assistance, and to Amy Dickson, Rachel Taylor and Julia Crabtree for help in the exhibition's early stages. We are grateful as ever to Helen Sainsbury, Head of Exhibitions Realisation, Carol Burniers Magno, Registrar, for her exceptional and patiently meticulous work on the transport and loans, and Phil Monk, Kerstin Doble, Fergus O'Connor and the installation team for negotiating all aspects of the exhibition installation so skillfully. Thanks also to Stuart Comer, Mark Godfrey, Jessica Morgan and Kathy Noble in the Curatorial Department for discussion of the exhibition in its early stages.

We are enormously grateful to Tate Photography for the help they have provided, and as always to the team of Conservators, especially Elisabeth Andersson, Rachel Barker, Rachel Crome, Rosie Freemantle, Annette King, Louise Lawson, Elizabeth McDonald, Kevin Miles, Alyson Rolington, Julie Simek, Patricia Smithen, Piers Townshend and Tina Weidner. Thanks to our colleagues Marko Daniel, Marianne Mulvey, Simon Bolitho and Minnie Scott in Tate Learning for working on the interpretation events and texts, to the Marketing team Sarah Briggs, Jon-Ross Le Haye, Livia Ratcliffe and Celeste Menich, to Duncan Holden and Kate Moores in Press, to Nick Aldridge, Kirstie Beaven, Jane Burton, Matt Mear, Kate Vogel and all in Tate Media, and the TMS team.

For the catalogue, many thanks are due to Catherine Wood, Eda Čufer and Dieter Roelstraete for their insightful essays, and to Fiontán Moran and Isabella Maidment for their apposite contributions. We would especially like to thank the Tate publishing team for their patience and hard work: Nicola Bion, Juliette Dupire, Roz Young, and – for the elegant design– Terry Stephens of Assembly.

This exhibition was made possible by the Government Indemnity Scheme. Tate Modern would like to thank HM Government for providing Government Indemnity and the Department for Culture, Media and Sport and the Arts Council England for arranging the indemnity.

Finally, our sincere thanks go to the Art Mentor Foundation Lucerne, whose generous support has been so important in the successful realisation of this exhibition.

Chris Dercon
Director, Tate Modern

'Painting in the shape of a House'[1]

Catherine Wood

Part-painted, part-real

Some 100 years after Malevich's *Black Square* 1915, the image of the subversive artist demanding revolutionary action, destroying the past to make something new, has passed into orthodoxy. Instead of setting out to destroy painting, many contemporary artists are thinking again about its uses: vernacular or sacred. Looking to ceremonial banners, murals, ritual decor, domestic interiors or scenic art, face paint or drag, artists make new sense of the medium. Stage cloths by Natalia Goncharova might be points of reference, or a fifteenth-century Italian *trompe l'oeil* altarpiece; perhaps the make-up designs applied to David Bowie or Visage in the 1970s and 80s, or the hand-decorated chairs, tables and walls of Charleston Farmhouse painted by the Bloomsbury group.

Painting, as it is seen in relation to performance, is no longer necessarily commensurate with expressive gesture. It is very often engaged with forms of figurative representation; but, as this show seeks to demonstrate, through painting's entanglement with performativity this has become a process of interlocution and enunciation rather than passive description. Active forms of realism have produced new realities. And whereas traditional easel painting was based upon the single artist working upright before the canvas in a one-to-one relationship that was mirrored by the viewer, various vital approaches to contemporary painting are based in social or collaborative situations that tilt and shift that orientation. Many actors or players can populate this expanded arena, creating a whole new set of possibilities around it.

Fig.2
Sanja Iveković
Diary 1976
Paper, cotton balls, make-up and tissue, 35 x 47
Musée national d'Art moderne – Centre Georges Pompidou, Paris
—
Fig.3 (opposite)
Lucy McKenzie and Paulina Olowska
Heavy Duty 2001
Photograph, 29 x 23
Courtesy the artists and Cabinet, London

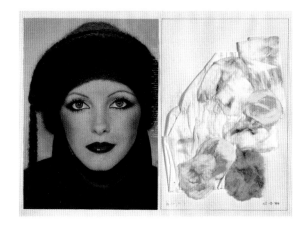

For Lucy McKenzie, an exemplar of such a practice, painting is central, but she also, and equally, designs clothes and co-runs an interior design atelier (in collaboration with Beca Lipscombe), runs a record label, and has choreographed and appeared in performances with other artists, notably the artist Paulina Olowska, also a painter, and, recently, filmmaker Lucile Desamory. McKenzie's painting is anchored in finely honed architectural décor techniques learned at a traditional school for artisanal painting, but the deliberately worn surface of her canvases are somehow continuous with the painted surfaces of the city: a graffitied wall, blocks of colour on a train door, a printed t-shirt. The one-to-one scaled realism of her works in this exhibiton shifts painting from the window-like illusionistic space associated with the Romantic canvas of the nineteenth century towards a situation whereby the painted plane of her picture protrudes into, or exists within, the space of the viewer, masking and simulating its immediate surfaces and scale. This combination of convincing representation and its disruption through the layering of mimetic elements – the clouds, the apartment walls, the painted drips – creates a poetically impossible sense of place that is, paradoxically, full of potential. McKenzie's broader practice is, arguably, grown from capacities unique to painting: she builds and inhabits new realities from its fictional foundation. Emblematic of McKenzie's attitude, the clouds layered into the domestic interior here hold a special place in painting as a portal to elsewhere – somewhere between the magical parting of the sky at the beginning of the hand-drawn world of *The Simpsons* and the cherub-filled heaven of Titian's *Assunta* 1516–18. The 'window view' of sky within this picture frame is not a depth space, nor a Magritte-style surrealist trick, but a prompt towards a dream space that encroaches into the reality of the space inhabited by the viewer.

A Bigger Splash

In a BBC documentary about the making of his work, David Hockney explains that the splash in his famous painting of a Los Angeles scene, *A Bigger Splash* 1967, took him two weeks to paint. Set against flat, blue blocks of pool and sky, the spray of water is not the spontaneous splatter that it at first appears to be, but an intricately constructed mess of hatched, scumbled and dribbled white acrylic, layered over thin washes of paint that break down into pointillist mist around the edges. This splash is not a splash, but a painstaking and poetic deceit.

It was no accident that the painting was duplicitous; indeed the young Hockney's incorporation of action into representational painting was undoubtedly a deliberate stylistic rebuff to American abstract expressionism's dominance at the time.[2] Hockney and R.B. Kitaj, who had both studied at the Royal College of Art in overlapping years between 1959–60, 'through ideological sympathy […] got themselves locked into an elaborate defense of figurative over abstract art […] in battle with the adherents of Clement Greenberg'.[3]

But what of this double bluff in Hockney's play on action painting? Its joyfulness goes beyond simple criticism of abstract expressionism – particularly if thought about in relation to the artist's colourful, dandyish persona, which was

1
Claes Oldenburg, '"Spring Calendar" program notes for Ray Gun Project 1959–60 at the Judson Gallery, New York', Achim Hochdörfer with Barbara Schröder (eds.), *Claes Oldenburg: The Sixties*, exh. cat, MuMoK, Vienna 2012 p.246. The artist announces, for 4 January, the imminent transformation of painting in rather enigmatic terms: 'construction of a house in the gallery – a painting in the shape of a house', to be followed the next day by what Oldenburg presents as 'preparation of the exterior of the gallery and the gallery windows. A painting in the shape of a gallery'. Lastly he announces the Ray Gun performances on February 23, 24 and 25 as 'a set of brief performances by artists. [From there he progressed to 'Painting in the shape of theatre' and 'painting in the shape of a city street.'].'

2
Hockney had already made a related painting titled *Accident Caused by a Flaw in the Canvas* in 1963, as observed by Christopher Knight in, 'Composite Views: Themes and Motifs in Hockney's Art', *David Hockney: A Retrospective*, LACMA, Los Angeles, 1988, p.25.

well-documented, especially in Jack Hazan's film *A Bigger Splash* 1973–4. The eponymous painting supersedes the implied reality of the Los Angeles pool scene, and, unlike the work of his abstract expressionist predecessors – Willem de Kooning, Clyfford Still or Jackson Pollock, whose exhibition at the Whitechapel Gallery Hockney had seen in 1963 – it takes care to conceal the passage of its creation too. The illusion of splashed water and of splashed paint implies performavity; but unlike the gestural brush mark or drip, it belies the activity of the hand of its maker.

This sort of surface masquerade was common in Hockney's work of this period, and would extend to frequent depictions of the partially pulled-back curtain, reminiscent of a theatre set. Such attention to artifice was inherently connected with a stylised campness, perpetuated by the depiction of an idealised, palm-treed and swimming pooled vision of Los Angeles, as well as by the behaviour of the artist and his associates in Hazan's film. Hockney's paintings – propped against walls, set up on easels, hung salon-style at home and displayed in pristine modern galleries – serve, in the film, as a provisional stage set, echoing the theatre and opera sets that the artist was already designing. But rather than simply providing décor, they actually appear to lend a certain permission to the behaviour of the protagonists. Hockney's friends and associates Celia Birtwell, Mo McDermott and Peter Schlesinger blur 'ordinary' behaviour with improvised fabulation, and the sum of this sociability and the paintings' mood and visual presence more or less removes any sense of existential authenticity in the artist's process of creation, flamboyantly and thrillingly distracting us from the mundanity of 1970s London.

The broader context of Hockney's work from this period affirms his deliberate embrace of a theatrical and queer treatment of painting: both in subject matter and painting design. This is evident in the painted stage set in *Play Within a Play* 1963, as well as in *The Hypnotist* 1963, which depicts a performer onstage, and the two men in an interior in *Notting Hill Domestic Scene* 1963. In these paintings, and others, theatre curtains, shower curtains and stage-like spaces are frequently used as frames for figures – often naked men with erotic overtones – to emphasise the trickery of depth and illusion. Hockney's first 'shower' painting, *Domestic Scene, Los Angeles* 1963, conflated erotic and exotic (west-coast) fantasy: painted a year before he went to California, its image was taken directly from *Physique Pictorial*, an LA-based men's magazine. In parallel, Hockney began designing actual sets for theatre and opera, for Ubu Roi at the Royal Court in 1966 and Glyndebourne's *The Rake's Progress* in 1975. The overlap of domestic, erotic and artistic interests were manifest in various ways: his 1980–1 sets for the Metropolitan Opera *Triple Bill* in New York, for instance, apparently 'inspired Hockney to re-think and repaint his house and studio in the Hollywood hills with the very same reds, greens and blues that he has used in the sets … [David] changes his home, the frame in which he lives, to make it consonant with his current obsession.'4 This blending of the diaristic and the domestic with invention and fiction, evident in Hazan's film, was clearly drawn from the form and content of both Hockney's paintings and his day-to-day life.

From the juxtaposition of these two worlds of representation, and the conceptual space that is stretched between, an important 'double frame'

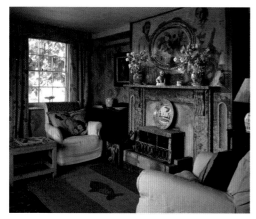

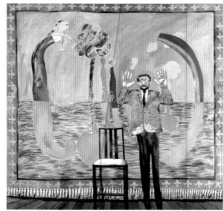

becomes apparent, through which we might consider painting as having emerged since the 1970s. That double frame is a combination of the rectangular space of the canvas and the space of its lens-based documentation, within which an image of the canvas would be embedded. While this setup was not devised by Hockney as such, his extension of its possiblities, partly in his cooperation with Hazan, defines an important transition in thinking through relations between painting, performance and the activity of daily life, themselves often performed to camera. And this is a triangulation to which a number of artists of the subsequent generation are directly or indirectly indebted.

The 'double frame' of painting might best describe our understanding of the work of Jackson Pollock from a contemporary viewpoint too. That is, how Pollock's work is seen after Hans Namuth's photographs of him making his paintings in the 1950s. According to Allan Kaprow, [5] Pollock marked the end of painting being associated with the deep space of the fifteenth and sixteenth centuries, and left artists with two alternatives:

'… One is to continue in this vein. Probably many good "near-paintings" can be done varying this esthetic of Pollock's without departing from it or going further. The other is to give up the making of paintings entirely.'[6]

Pollock's paintings have, arguably, come to be seen, just as Kaprow interpreted them, as a prompt for some of the earliest performance happenings: literal tracks of a man's movement across a canvas within a traceable period of time. The painting has become a form of reverse choreographic notation, its lines and arcs not unlike Warhol's floor-bound *Dance Diagram* 1962, Pollock's large-scale work *Summertime: Number 9A* 1948 suggests a winding, looping, dripped and dribbled factualisation of Harold Rosenberg's characterisation of the canvas 'as an arena in which to act'. As Paul Schimmel notes, '[Pollock] transformed the artist's role from that of bystander outside of the canvas to that of an actor whose very actions were its subject.'[7]

The films and photographs of the artist at work – in which he appears to be internally driven to move back and forth with a certain rhythm, to make particular decisions about the colours of the paint, about when to start and when to stop – tie this form of abstraction to the romantic notion that a pure, unmediated expression of inner life is somehow possible: a possibility that the artist himself appeared, in his strong and silent image and recited statements, to collude with. Here the act of creating is itself the principle factor, over and above symbolic or realistic representation. As Thomas Lawson put it, 'its essential quality was its declarative status',[8] meaning that there was no distance between the thing represented and the markmaking.

The calculated way in which such expressive 'freedom' was promoted as a symbol of a post-war American democracy has been widely observed. Eva Cockcroft has written about how *New American Painters*, the 1958 New York MoMA touring show that created a significant impact in London, was instigated by the soft political agenda of the CIA. As Cockcroft describes, '[abstract expressionism] was the perfect contrast to the regimented traditional and narrow nature

Fig.4
Charleston Farmhouse painted interior, decorated by members of the Bloomsbury group, which included Vanessa Bell, Roger Fry and Duncan Grant
—
Fig.5
David Hockney
Play Within a Play 1963
Oil paint on canvas and Plexiglas, 72 x 78
David Hockney Studio Inc.

3
Ibid., p.24.

4
Henry Geldzahler, 'Hockney: Younger and Older', *David Hockney: A Retrospective*, exh. cat., Los Angeles County Museum (LACMA), Los Angeles 1988, p.20.

5
Allan Kaprow, 'The Legacy of Jackson Pollock' 1958, Allan Kaprow, Jeff Kelley (eds.), *Essays on The Blurring of Art and Life*, London 1993, p.7.

6
Ibid., p.7.

7
Paul Schimmel, 'Leap into the Void: Performance and the Object', *Out of Actions* (exh cat), The Museum of Contemporary Art, Los Angeles 1998, p.18.

8
Thomas Lawson 'Last Exit Painting' 1981, reproduced in Terry R. Myers (ed.), *Painting*, London 2010, p.53.

of socialist realism.'[9] In a 1952 article in the *New York Times*, Alfred Barr condemned socialist realism and Nazi art, arguing that totalitarianism and realism were of a piece, and claimed in the touring show's catalogue that abstract expressionism was the acceptable alternative: '[Abstract expressionists] defiantly reject the conventional values of the society which surrounds them [… they represent] freedom in a world in which freedom connotes a political attitude.'[10]

Summertime: Number 9A and *A Bigger Splash* are presented here face to face as an asymmetric pairing. Shown with their respective films, they flag opposite sides of a peculiar territory. One painting is abstract, the other figurative; one an index, shown with a film about process; the other a picture, shown with a sequence of narrative scenes. Pollock's apparently 'free' way of behaving, apparently unselfconsciously creating within the filmic frame, is contrasted with the stylised, highly self-aware behaviour of Hockney and his circle. The exhibition dramatises some questions about painting that arise from the space between these positions. Firstly, is there an expanded, newly self-conscious 'arena to act' between the double frame linking painting and documentation? Secondly, if so, how – within Hockney's paintings, and beyond – do the pre-modernist painterly characteristics of representation, illusion and narrative symbolism come back into play? And thirdly, how have painters devised alternatives in the past few decades to Kaprow's two options: to make neo-Pollocks or to give up painting and make happenings?

Action and Actionism
The central section of this exhibition presents a partial history of the entanglement of painting and performance via an array of work made more or less during the period between *Summertime: Number 9A* and *A Bigger Splash*. This part of the show includes experimental practices in the late 1950s, the 1960s and the 1970s (and in mid-1980s China, due to the specific political history there) which take painting's material basis and conceptual capacity as a core framework to work with and radically challenge, but always performatively and in relation to photography and video. Action painting, by the likes of Still, Pollock and Lucio Fontana, originated in a post-war context where a desire to begin afresh with new kinds of art-making was entangled with an inability to depict the unimaginable horror of recent history or to employ representational means. As Paul Schimmel observed of much of this work in his seminal *Out of Actions* exhibition in 1997–8 at Los Angeles Museum of Contemporary Art (MoCA), 'there is an under-lying darkness [in this work] influenced by the recognition of humanity's seemingly relentless drive towards self-annihilation'.[11] Such art was not making propositions for a new reality, but erasing the recent past, undoing cultural forms and methods associated with those memories.

But by the mid-1950s artists like Yves Klein, Niki de Saint Phalle and Pinot Gallizio had already taken onboard the mediating potential of the photograph of the artist at work. Saint Phalle's 'shooting paintings', begun in 1961, were regularly photographed and filmed for TV, the artist herself frequently performing in a signature white jumpsuit;[12] Klein's 'Anthropometry' events, likewise – with their attendant live audiences, musicians and champagne. Gallizio, originally a member of the Situationists, invented the term 'industrial

9
Eva Cockcroft, 'Abstract Expressionism: Weapon of the Cold War' *Artforum*, vol.12, no.10, June 1974, reprinted in Francis Frascina (ed.), *Pollock and After: the Critical Debate*, 2nd edn, London and New York 2000, p.151.

10
Ibid., p.153.

11
Schimmel, *Out of Actions*, p.17.

12
Niki de Saint Phalle presented more than twelve 'tirs' – paintings which she shot at to explode balls of paint embedded in their surfaces – in 1961–2. More than fifty international magazines and journals published reports about her during this period. She invited Ed Kienholz and Robert Rauschenberg to participate in her tir events in the early 1960s.

painting' in 1958, a style which combined the Pollock-like drip with group painting exercises on a base of (what would become Warholian) mono-printing. His canvases were theatrically displayed like dress fabric for sale and paraded on live models, while the artist himself performed as shopkeeper, snipping up and selling paintings in one-metre sections.

Despite being frequently shown or understood in a context of *art informel*, abstract expressionism and action painting, the Japanese Gutai movement actually emerged from a quite distinct attitude, related in part to avant garde precedents rooted in performance such as Mavo in the 1920s, and Jikken Kobo ('Experimental Workshop') in the 1950s. While Pollock famously complained that he appeared as a 'phoney' through Namuth's exposure of his making process, the Gutai artists had no such psychological anxiety.[13] Much of their work was deliberately created for performance, and often for public spaces or the theatre stage. An important example by Shozo Shimamoto, whose work *Holes*, 1954, is in the Tate collection, was his *Hurling Colours*, performed on the rooftop of a department store in 1956, where the artist threw pigment in glass jars at the canvas, and the dramatic act of creation was presented as being as significant as the finished painting.

A series of 'Gutai on the Stage' events in the mid-1950s presented a wide range of painting and sculpture mediated (or even constituted) by live action. In this case, the double frame was located primarily in the relationship between canvas and proscenium stage. Gutai founder Saboro Murakami stated that 'The Gutai Group's urge for discovery demands the elements of time as well as the element of space in order to give a full aesthetic impact.'[14] In 'Gutai on the Stage' in 1957, Koichi Nakahashi threw dozens of paint-covered balls at a white canvas and Yasuo Sumi splashed buckets of paint at a vinyl scrim. In the same year, Kazuo Shiraga performed *Sanbaso*, a dance in a 'No drama', which involved archers shooting a hundred arrows through a white cotton backcloth.[15] From the late 1950s into the 1960s and beyond, Shiraga developed his painting technique further, rendering with ritual attention splodges of paint, already set out on the canvas, by swinging from a rope and moving it about with his feet. As well as outwardly embracing public performance, Gutai was informed by ideas of Zen and Kendo martial arts – the artists embodied a desire to transcend subjectivity rather than to express it as such.[16]

The work of the Vienna Actionists – Günter Brus, Hermann Nitsch, Otto Muehl and Rudolph Schwarzkogler – further complicated the question of abstraction in painting by introducing the body, particularly its vulnerability and sexuality, as a symbolic and signifying 'support' in parallel to the canvas. Importantly, the Actionists understood their work in the 1960s not so much as performance but as a new, living form of painting. So their paintings were not just the works on canvas featured within their actions, but also the photographic documents of actions involving painted bodies, floors, walls and, in the work of Nitsch, animal carcasses and blood. In the 1960s much of this work was staged solely for the camera rather than for a live audience.[17] As Hubert Klocker observed, Actionism was 'concerned with giving back to the art work, be it painting or object, the narrative potential of the

13
The 6th Gutai art exhibition was at Martha Jackson Gallery, New York in 1958, the same gallery as Jackson Pollock's. Source: Tijs Visser, 'Mal Communication', *Gutai*, exh. cat., Lugano 2011, p.17.

14
Saburo Murakami, 'Gutai bijutsu nit suite' (On Gutai Art), *Gutai* no.7, 1957, quoted in Ming Tiampo, 'Gutai Experiments on the World Stage', Marco Franciolli et al. (eds.), *Gutai: Painting with Time and Space*, exh. cat., Museo Cantonale, Lugano 2012, p.31.

15
Helen Westgeest, 'No Meaning, No Composition, No Colour: From Zero to Gutai', *Gutai: Painting with Time and Space*, exh. cat., Museo Cantonale, Lugano 2012, p.125.

16
A significant early influence was Toj Nantembo, a Zen priest in the late nineteenth century who devised the 'body as a brush' and lived in Osaka near to Yoshihara. Marco Franciolli, 'Gutai: Painting with Time and Space', *Gutai: Painting with Time and Space*, p.13.

text which had been lost to abstraction. They attempted this by means of the actionist – what Flusser called the "sense endowing" – gesture in art.'[18] Distinct from American happenings, the Actionists might be associated more with a surrealist sensibility, particularly as the 'Material-actions' of Muehl in the mid-to-late 1960s incorporated Freudian aspects of gender-play: he can be seen wearing a bikini in what otherwise appears to be a conventional set-up gender-wise, with naked women as models and instrumentalised participants.

Total Painting

A distinct new strand of experimentation with what painting might be – specifically via the use of other media – emerged a little later, through the 1960s and into the 1970s. These new forms of what I will term 'total painting' were, in general, less to do with either 'action painting' or with modernist-derived notions of expanded painting (by artists who paid broad attention to the conceptual support/surface aspects of painting, such as the French group by the same name and Daniel Buren) and more to do with ideas of paint as a specifically material surface that covers, masks and changes things. Such approaches re-cast painting as a transformative medium that claims both the abject and the illusionistic, and a mobile entity. Key artists began to think about forms of self-transformation, make-up, applied pattern, theatre sets, décor and drag as ways of extending art into reality, without giving up the idea, or the activity, of painting altogether.

Jack Smith was not a painter, but the grease paint-caked faces and figures set against decorated and draped walls in crumbling fantasy sets in his downtown apartment might be seen as one of the first instances of a form of total painting. His friend and fellow artist Claes Oldenberg's description of 'painting in the shape of a house', in which the artist inhabits a transformed reality, is a good analogy. In his fictional *Memoirs of Maria Montez* (written 1963–4) Smith describes the B-movie star, who inspired much of his work, in painterly terms that resonate with the space he was living in and his provisionally constructed stage sets:

'Maria Montez was propped up beside the pool which reflected her ravishing beauty. A chunk fell off her face, showing the grey under her rouge. How can we get to it. We must retrieve it or else scrape off all her flesh and start all over. Best to fish the chunk out of the pool and pat it back into shape.'[19]

Smith's vividly material description of the construction of identity and glamour relates directly to the paint-pasted faces of the performers in the films *Flaming Creatures* and *Normal Love* (both 1963) and photographs from the very early 1960s, as well as the set: his own crumbling-plaster rented apartment, its ramshackleness and exotic elements of eastern architecture and painted scenes presenting, in his mind, an alternative to the establishment 'eggshell walls of MoMA'.[20]

One might trace a shift in this period from the early self-transformations of Smith and his (proto-Warholian) co-stars, with their exaggerated painterly glamour-cum-abjection, via forms of post-Actionist painting. Stuart Brisley's studio and installation environments in London and Warsaw pushed such totality to extremes, extending the painted surface across the four

Fig.6
Claes Oldenberg
Circus (Ironworks/ Fotodeath),
performance at the Reuben Gallery,
New York, February 21–26, 1961 1961
Claes Oldenburg Studio

walls of the room that he was in, and all over his face and body. Paint was mixed with bodily fluids and other found materials and textures to create highly complex environments in which any hierarchy between support and markmaking, or between the horizontal and the vertical, was destablised, as was the relationship between artist and artwork as the two appeared to merge.

The work of Geta Brătescu, in 1970s Bucharest, was also in some ways concerned with a pure artistic sense of freedom, equally different from Pollock's approach in that it used materials and spaces in the domestic environment, in contrast to the prescribed, official forms of art under the communist regime. *Towards White* 1975 charts Brătescu's own gradual self-obliteration by paper and paint within the studio space, as she becomes embedded, step by step, within a monochrome space – a process that she documents. Helena Almeida, too, in her *Inhabited Paintings* 1975 explored the threshold between the canvas and self-as-surface:

'I was my work. There was no distinction between the canvas, the dimension of the canvas, and me. There was no distinction between the inside or the outside. My inner self was my outer self and my outer self was my inner self.'[21]

In *Nude Performance* 1977, Korean artist Kang-so Lee, who went on to make theatrical assemblage paintings on canvas in the 1980s, painted his body and exhibited the documentation of the action beside a painted cloth on the floor, like a shed skin. In the early 1980s in China, after the end of Mao's period of Cultural Revolution, artists began to experiment with performance in reaction to the dominance of socialist realism painting. New Freudian ideas of self-expression, previously banned, were filtering through and might be linked to a number of expressive actions, such as that performed secretly in the studio by Wang Peng. But there was also, not dissimilar to Pollock in post-war America, a notion of washing clean the language of art via paint-splashing actions, here combined with deconstructions of Chinese calligraphy, in the performance-installations by Wu Shanzhuan.

Ana Mendieta trained as a painter but, like the Actionists, re-incorporated materials and forms that carried a folk-like symbolic currency: blood, earth and foliage were used as deliberately primitive tools for self-transformation in her performed photographic self-portraits. Hélio Oiticica experimented with forms of 'living painting' in his *Parangolés*, inspired by Brazilian carnival. A fan of Jack Smith, and acknowledging his influence, Oiticica later collaborated with Smith star Mario Montez to make a series of camp Tropicalia performances.[22] In the 1960s Yayoi Kusama extended her dot painting aesthetic from canvas and walls into actions such as *Flower Orgy* 1967, combining the virus-like spread of the 'infinity net' aesthetic with the 'flower power' face painting of the American hippy culture to create extraordinary live tableaux. Contemporaneously, Bruce Nauman's *Flesh to White to Black to Flesh* and *Art Make-Up* 1968 conflates monochrome painting and make-up in a parody of the reductive radicalism of art-historical works such as Malevich's *Black Square*, as the artist faces the video camera as if it were a mirror and applies white and then black stagepaint to his entire face and torso, only to wipe it all off his body.

17
Gustav Metzger brought awareness of Vienna Actionism to London in his Destruction in Art Symposium in 1966.

18
'In Wiener Aktionismus, the body becomes a concrete projection surface for what Wiener calls "the politics of experience". As such it anticipates the positions of performance art as formulated in the 1970s.' Hubert Klocker, 'Gesture and the Object. Liberation as Aktion: A European Component of Performative Art', *Out of Actions*, Los Angeles 1998, p.175.

19
Jack Smith, 'The Memoirs of Maria Montez or Wait For Me At the Bottom Of The Pool' 1963–4, *Wait For Me At the Bottom of the Pool*, New York and London 1997, p.37.

20
Smith, ibid., p.37.

21
'Conversation between Helena Almeida and María de Corral' 1999, *Helena Almeida*, exh. cat., Centro Galego de Arte Contemporánea (cGac), Galicia 2000, p.172.

Although he came from a background in post-painterly abstraction in parallel with artists such as Morris Louis, Sam Gilliam's treatment of the painted canvas as theatrical drape or cape – as in *Simmering* 1975 – has a latent, magical quality that lends the work a performative attitude doubling the gestural techniques of their making with the implication that they might play a role in theatre. Seen this way, Gilliam's work might be drawn into dialogue with the work of Smith, Oiticica or Wiktor Gutt who played with performance more literally. In Warsaw 1972, Gutt initiated with Waldemar Raniszewski his *Great Conversation*, in response to artist Oskar Hansen's experiments with Open Form. This work involved continuous and reciprocal states of transformation through elaborate face and body painting and studio experimentation. Traditional art materials were used not for individual expression but towards group dialogue and performative exchange, borrowing enthnographic fantasies of African ritual to divert abstract painting towards theatrical ends.[23] In Korea in the 1970s, Ku-lim Kim, a founding member of the Fourth Group – established in 1969, and whose goal was to 'destroy existing art and construct a new one'[24] through dematerialised actions – applied painting decoratively onto women's bodies as living artworks. Towards the end of the 1970s and into the 1980s, artists Zsuzsanna Ujj and Karla Woisnitza, in Hungary and East Berlin respectively, drew on similar ideas of primitive ritual to overturn alluring images of women. Their frightening, skeletal, mask-like bodypaintings hinted at a violent and powerful interior, revoking the demure and flawless surface as the aspiration of femininity.

'Why We Paint Ourselves'[25]

A good deal of this 'total painting' concerned itself as much with paint as a transformer of environment as with individual identity. A place became a container for painting, so that the outer limit of the double frame – the documentation of the action – began to take precedence. Notions of interior and exterior were made complicated as artists explored the self-as-surface and renewed an interest in representational painting, especially in the work of Andy Warhol and Eleanor Antin. The masquerading artist or subject could be explored within the deliberately pictorial setup of the double frame-as-mirror, and this often manifested in drag.

Two important exhibitions – *Transformer: Aspekte der Travestie*, curated by Jean-Christophe Ammann in Lucerne in 1974, and *Pictures*, curated by Douglas Crimp at Artist Space New York in 1977 (reconfigured as an important article in *October* in 1979) – also raised questions on drag and identity play in relation to painting during this period. These shows investigated how image making had come to be entangled with the increased circulation of images, which insistently reiterated ideals of beauty and gender norms. Work by women artists of the period, such as VALIE EXPORT, Eleanor Antin and Sanja Iveković, mark a series of important transitions from the Actionists' use of the female body as a prop (as classical nude painting does) towards the reclamation and transformation of the female body by the artist herself. Prior to *Identity Transfer* 1968, EXPORT tattooed a drawing of a suspender belt on to her leg; Antin plays with and mediates the idea

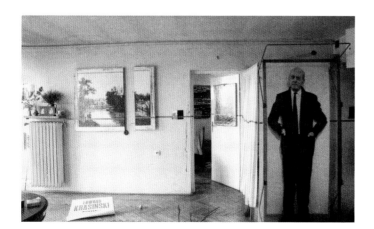

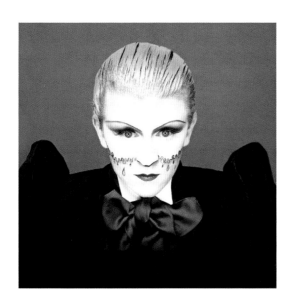

of the painter painting by applying mascara, lipstick, blusher and eyeshadow to camera, as though to a mirror, and Iveković, also through the application of make-up, dramatises the construction of identity and femininity as it is peddled in women's magazines.

Cindy Sherman, an important artist of Crimp's 'Pictures' generation, also rejected her training in painting in the early 1970s, turning to make-up and costume to create a cast of characters from her own face and body. Her personae range from feminine ideals to exaggerated archetypes, and shift between naturalism, abstracted grotesquerie, clowning and glamour. Both Urs Lüthi and Luigi Ontani – both key artists in the *Transformer* exhibition – similarly made live performance and photography to create experimental forms of drag, and, in Ontani's case specifically, inserted his image into the frame of historical painting, as Sherman did later in the 1980s.

Painting and gender norms were being deconstructed in parallel during this period, and this was being translated into, and intertwined with, other media. 'The cosmetics industry,' writes Sabine Melchoire-Bonnet, is a 'disciplinary practice [that] produces a body which in gesture and appearance is recognizably feminine'.[26] This work, much of which is from a feminist or queer perspective, straightforwardly reclaims paintedness, artifice, modelling with pigment as established, feminine practices. Attacks on the dominance of men in the history of painting are replaced by a confident attitude of assertion that painting is a practice that women have owned for a long time.

22
'Highlighting the importance of Smith and Mario Montez, an actor and icon of the queer film and theatre scene, for New York's underground in the 1960s and beginning of the 70s, Oiticica developed the term 'tropicamp' in 1971 to characterise a resistant element in the gradual commercialisation of queer aesthetics at the time.' Max Jorge Hinderer Cruz, 'TROPICAMP: PRE- and POST-TROPICÁLIA at Once: Some Contextual Notes on Hélio Oiticica's 1971 Text', *Afterall* 28, Autumn/Winter 2011, p.5.

23
In 1981 Gutt and Raniszewski staged a face-painting event at Rockowisko music festival in Lodz, which lasted three days. Some participants requested to be painted with symbols criticising the People's Republic of Poland and had the painting forcibly washed off by the police, only to return immediately to have it repainted. It is interesting to note, in relation to Yayoi Kusama's body-painting events in the US in the 1960s that Gutt makes the following observation about the event in the moment prior to the introduction of martial law in Poland: 'Those at Woodstock moved from order and stability towards anarchy and the unknown. Those at Lodz fled from chaos and uncertainty towards harmony, or at least a temporary sense of freedom.' Gutt, *Expressions on a Face*, 1993, p.126.

Taking the painted self out of the studio and onto the street, Lynn Hershmann's ongoing project throughout the 1970s extended her experiments with the construction of an ur-feminine character, built from a composite of magazine images, into everyday life. She lived a double life as herself and as Roberta, recording her encounters in photographs (taken by a private detective) and in her own writings. Derek Jarman, meanwhile, documented the flamboyant characters of London's alternative scene in the 1970s and 1980s, in part centred around Andrew Logan's *Alternative Miss World* 1972–present, in which drag and dressing up were critical and celebratory acts. Ambiguous and often outrageous characters like Leigh Bowery emerged into the city's stage to construct new identities and flaunt pure artifice in a modern equivalent of the idea expressed by Russian Futurist Mikhail Larionev's 1913 manifesto, celebrating a new fleetingly glimpsed form of painting that was deemed equivalent to the experience of modern urbanity.

'Painting Action not Action Painting'[27]

How, then, has a performative attitude towards the practice of contemporary painting grown through the activities of performance art specifically? If experiments with painting in the 1950s and 1960s retained a clear sense of the separate frames of the canvas and the documentation of the act of painting, the 1970s saw a move towards forms of paintedness as critical and experimental interventions in reality, particularly with feminist and queer agendas. But rather than pointing towards the ultimate end of painting, these experiments have, arguably, reconfigured the apparently anachronistic canvas as an enabler of or prompt towards the generation of new worlds

that are part painted and part real. The final part of the exhibition sets out a series of post-1970s positions and strategies, which are anchored in painting but which also employ collaboration, theatricality, action or participation.

For Edward Krasiński the canvas signified art's potential to create altered realities, and during the 1970s in his apartment in Warsaw, a new kind of fictive space was initiated through the artist's use of simple blue tape applied horizontally around the mid-line of his studio and living space in conjunction with, and also across, painted canvases on the walls, depicting variations on cubic void spaces. The photographs taken by Eustachy Kossakowski reveal how Krasiński, his family and associates constituted and articulated this new space, not just by occupying it, but by creating a continuum through the blue tape that bound them, and between their social activity and the utopian 'non space' of the canvas. The addition of mirrors in the Tate's installation incorporates the gallery goer too, lending the piece a sense of potentially infinite reach.

Marc Camille Chaimowicz's approach to painting, not unlike Krasiński's, spreads from the discrete canvas, virus-like, to camouflage walls, furniture, fabrics and sculptures. As a painting student in the late 1960s and early 1970s, Chaimowicz turned from expressionist abstraction towards his French heritage: to the dappled interiors of Pierre Bonnard and Edouard Vuillard and notions of bourgeois decorativeness. Chaimowicz's work tests the line between fine and applied art, and the attendant masculine and feminine associations these categories carry.[28] The artist recalls his own living space in Approach Road, London – an early site for

Fig.9
David Burliuk Kazan 1914
The State Museum of V. V.
Mayakovsky

his décor-installations, wallpaper, furniture and curtains, within which he performed early works such as *Table Tableau* 1974 – as an aberration within a street full of Acme studios let by 'serious' oil painters in dirty overalls. His interiors, such as the imagined living space *"Jean Cocteau …"* 2003–12, included in this exhibition, become, in turn, sites for the artist's performances or imply latent theatrical narratives.

The round red splatter of paint in Karen Kilimnik's early installation *Smallpox* 1990 – like a single Saint Phalle paint wound – was a similarly virus-like marker on the gallery wall, initiating the performative attitude of her elaborate stage-set-like environments of the early 1990s. These in turn became pretexts for romantic, figurative paintings of clouds, landscapes and trees, which have agitated various debates on painting and feminism, create a segue into a new form of bad painting. After Antin or Iveković, Kilimnik approaches painting as make-up in both fictive and cosmetic senses, and the flagrant decorativeness of her markmaking was exaggerated and applied, in *Swan Lake* 1992 and later work, to the context of the romantic ballet, with its nymph-like dancers, mist and musical soundtrack.

In the 1970s Joan Jonas often dramatised her relationship to traditional art materials, which she and her peers were moving away from, by incorporating the actions of drawing and painting into mixed-media performances. *The Juniper Tree* 1978 / 1994 takes painting's symbolic function in ancient world cultures as a starting point for exploring subjectivity and myth – a theme she also addressed in the context of feminine masquerade. Jonas hangs her paintings like ceremonial banners or flags to designate a space with transformative capacity, as being where something extraordinary might happen, but although paint drips blood-like from her hand-drawn symbols, the work remains entirely distinct from corporeal Actionism.

Jutta Koether's hand painted, impastoed paintings, worked through with multiple thin layers of reds, yellows and watery blue-greens, often make reference to pastoral scenes from historical painting and foliage; but, like her sticky black gloss painted 'Garlands' 2011, they are wholly inorganic. They are not part of the folk nature ritual that they reference, in which spring leaves and blossoms are twisted onto canes held aloft by dancing maidens with flowers in their hair. The paintings are deliberately corpse-like. Her drag-like appropriations of Poussin demonstrate painting as a haunted medium that can only repeat itself. And as Hal Foster observed, abstraction is a simulation of a past gesture too.[29] David Joselit has appositely described Jutta Koether's paintings as transitive, inherently formed by their place within networks, yet their surfaces – often awkwardly large scale – deliberately and obstinately refuse to allow the flow that virtual networks demand of their content. The paintings have frequently been used as backdrops for music performances, however, staged to draw attention to how they occupy space, and to how we look at them. Koether posits painting as both a necessary anchor point in her practice-in-motion and a permissive catalyst, prompting other aesthetic activities in its midst.

Ei Arakawa, who has collaborated with Koether a number times, makes work partly founded in research into the mid-century Japanese avant-garde, from which he draws an attitude

24
Chan-dong Kim, 'Deconstruction, Nomadic Reason, and Trace of Existence', *Traces of Existence: Kim Ku-Lim*, exh. cat., Korean Culture and Arts Foundation, Seoul 2000, p.13.

25
Mikhail Larionev, *The Futurist Manifesto*, 1913.

26
Sabine Melchoire-Bonnet, quoted by Patricia Phillippy, *Painting Woman: Cosmetics, Canvases and Early Modern Culture*, Baltimore 2006, p.4.

27
Ei Arakawa, 'The Ab-Ex Effect', *Artforum*, Summer 2011, p.325.

28
'Chaimowicz handles patterns as if it is a kind of virus or a code. With a variety of applications his vocabulary of marks and motifs seem to spread … apply themselves to the front and sides of objects … to all manner of surfaces beyond the canvas.' Catherine Wood, 'In Use', *Marc Camille Chaimowicz*, exh. cat., Kunstverein fur die Rheinlande und Westfalen, Düsseldorf 2005, p.35.

of provisionality and experimentation that is re-presented formally. Painting in the 1950s unquestionably occupied a central position in art practice, which it no longer holds, but Arakawa keeps returning to it – both its canonical status and its social meanings - as his own axis of navigation. He has collaborated with a number of painters in the past decade, including Kerstin Bratsch, Amy Sillman, Silke Otto-Knapp and Nikolas Gambaroff, treating their painted pictures as poetic or ceremonial initiators of action: Sillman's work became part of *BYOF (Bring Your Own Flowers)* 2007 a piece that also involved traditional Japanese 'Ikebana' flower arranging, while Otto-Knapp's silver dance paintings were paraded through Regents Park and became the prompt for an outdoor poetry reading in 2011. Arakawa has said,

'What is the difference between expression that is organized by a group of people and painting that is the product of an individual practice? Can paintings reposition our bodies as spectators? ... Painting is Watching.'[30]

The Slovenian painting collective IRWIN make work that is most closely connected in spirit to the room-like rendering of Lucy McKenzie's 'Slender Means' paintings, with which I began. In 1984 IRWIN staged *Back to the USA*, an exhibition of images of a touring show of American art that had been banned in former Yugoslavia. By repainting works by Jonathan Borowsky, Matt Mullican and Cindy Sherman, amongst others, to incorporate the the artworks' distorted perspective as seen in reproduction in a magazine, the artists and their friends could then attend a private view of the simulated exhibition. This performative attitude has perpetuated since by their carefully constructed group image, their black-tie suits instituting a masquerade of professional formality very much against the grain of the 1980s Slovenian avant-garde scene. IRWIN's 'NSK Moscow Embassy' project 1992–3 continued their strategy of effecting social space through painterly iteration, when a suite of twelve *trompe l'oeil* photo-paintings with assemblage, created after an apart-art residency in Moscow, act as drag-like reiterations of the apartment's architecture, simulating rather than documenting the setting in which talks, performances and workshops took place.

Chameleon

In the hands of the artists represented here – and others who are not [31] – there is a fascination with painting's pre-modern qualities set in combination with what Baudrillard described as the post-modern condition, in which 'The virtual camera is in our head'.[32] Baudrillard lamented that in our mediatised world our own 'reality' no longer exists. But painting offers a primary way for artists to fabricate their own realities: its artificial surfaces are at once continuations of the inauthentic post-modern landscape and – in their decisively local handmade-ness – refusals of it. Perhaps artists remain enthralled with painting because of its stubborn indigestibililty, its insistently seductive obsolesence. Far from passive, the medium's return into contemporary practice seems to press us, chameleon-like, to adapt ourselves to its environment, engendering new ways of acting and appearing. It is precisely painting's camouflaging illogic that is productively and performatively applied back into the practice of everyday life. And this collision of the designed arena of painted space, and the reality of living or performing to camera, is a productive contamination that bleeds both ways.

29
Hal Foster, 'Signs Taken for Wonders', 1986, reprinted in Terry R Myers (ed.) *Painting*, London 2011, pp.54–5.

30
Arakawa, ibid, p.325.

31
Including Nikhil Chopra, HobbypopMuseum, Paulina Olowska, or Kai Althoff.

32
He continues: '... and our whole life has taken on a video dimension. We might believe that we exist in the original, but today this original has become an exception for the happy few. Our own reality doesn't exist anymore. We are exposed to the instantaneous retransmission of all our facts and gestures on a channel.' Jean Baudrillard, 'Aesthetic Illusion and Virtual Reality', Nicholas Zurbrugg, (ed.), *Jean Baudrillard: Art and Artefact*, London 1997, pp.19–27.

Don't

Eda Čufer

Don't paint pictures, don't make poetry,
don't build architecture, don't arrange dances,
don't write plays, don't compose music, don't
make movies, and above all, don't think you'll
get a Happening by putting all these together.
Allan Kaprow

1.

To not do things in a habitual way is much harder than it seems. In his 1966 lecture 'How to make a Happening' 1966, Allan Kaprow advised, 'You've got to be pretty ruthless … to succeed in wiping out of your plans every echo of this or that story or jazz piece or painting that, I can promise you, will keep coming up unconsciously'.[1] In an earlier text, 'The Legacy of Jackson Pollock' 1958, Kaprow described how Pollock used dance to release the painting 'from the deep space of the fifteenth and sixteenth centuries to the building out from the canvas of the Cubist collages' by expanding the body movement of the painter painting while diminishing the role of his sight.[2]

Modernist painters gradually eliminated the recognisable object of representation and fell in love with the 'random play of the hand upon the canvas or paper', but they never really questioned the 'order' of the painting itself.[3] That order continued to be controlled by the painter's sight and the upright position of his body; that is to say, by controlling each move upon the canvas, the painter maintained the composition or colour balance of the painting in synchrony with the size and shape of its support. Pollock, on the other hand, discovered the joy of painting as if his hands were paws; rather than dabbing paint from can to canvas with a brush, he moved like an animal, leaving traces of his own self on the ground – a new kind of painting creature, in total motion. Moving in and out of the canvas, the creature became caught up in its own dance, tending at once to 'lose itself out of bounds' and to 'fill the world with itself', while in fact remaining entrapped in its own choreography, a self-made universe with 'no beginning, no middle and no end'.[4]

Fig.10
Dancers in *Summerspace* 1958
Choreography: Merce Cunningham
Music: Morton Feldman
Stage design: Robert Rauschenberg
Photograph by Richard Rutledge
Cunningham Dance Foundation Inc.

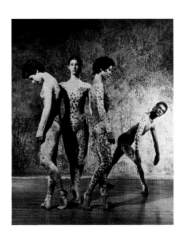

2.

I would like to rethink the so-called performative turn epitomised by Pollock's action painting in line with the historic passage of Western visual art from the autographic to the allographic mode. In his book *Languages of Art* 1968, Nelson Goodman defined the autographic arts as those valued for their genuine signature or direct human inscription, as distinct from allographic arts, which are codified (via musical score, literary script or mechanical reproduction) as a system of signification designed to reach the consciousness of another person at a distance, through symbolic and not through phenomenological means.[5]

In his search for rules that determined what makes certain arts amenable to indirect or symbolic transcription and others not, Goodman discovered that, besides painting, sculpture and printmaking, the art that built its entire modern identity and institutional practice around values of authenticity, originality, and preservation was dance, which, from the standpoint of aesthetics, had been marginalised for some time. Despite many attempts from the sixteenth century onwards, dance never succeeded in developing a working notational, or allographic, system, and should therefore be classified among the autographic arts. But this was rather unusual, considering that other transitory arts, such as singing and reciting, or arts that involved many people in their production, such as architecture, symphonic music and theatre, developed their own systems of allographic transcription centuries ago – not to mention the millennia-old systems for the graphic representation of spoken language.

3.

Kaprow was the first person to formally associate Pollock's unusual painting practice with the art of dance. 'With a huge canvas placed upon the floor, thus making it difficult for the artist to see the whole or any extended section of "parts", Pollock could truthfully say that he was "in" his work.' Being in the work is also a precondition of practice for the dancer, for in the art of dance, the dancer is her own medium, whereas in other arts, the author projects herself upon an object through which she acts upon the world. The dancer, on the other hand, doesn't act upon the world, but behaves within it. Her information about the production that she embodies is always partial, shared with partner, choreographer and audience, since the dancer doesn't create in the same medium through which others receive her work. A painter, while painting a canvas, can look at her work and see the same canvas that any viewer standing next to her would see; she stands outside the painting. But a dancer can never see the dance as spectators see it, for she exists within the space and time of the dance, while it is being danced.

Pollock turned painting into a ritual 'dance of dripping, slashing, squeezing, daubing'. To properly grasp this kind of art, Kaprow argued, spectators must be both intellectually and affectively agile. He called that kind of spectator an 'acrobat': one's perceptive aptitude must be super-fit to constantly shuttle 'between an identification with the hands and body that flung the paint and stood "in" the canvas and submission to the objective markings, allowing them to entangle and assault us'.[6] In other words, as

1
Allan Kaprow, *How to Make a Happening*, audio lecture on LP, 23 min. 43 sec., Mass Art Inc. 1966.

2
Allan Kaprow, *The Blurring of Art and Life*, Los Angeles 1993, p.6.

3
Ibid., p.2.

4
Ibid., pp.5, 6.

5
Nelson Goodman, *Languages of Art*, Indianapolis 1968.

6
Allan Kaprow, *The Blurring of Art and Life*, Los Angeles 1993, p.5.

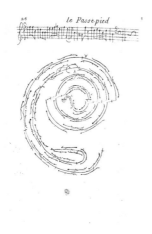

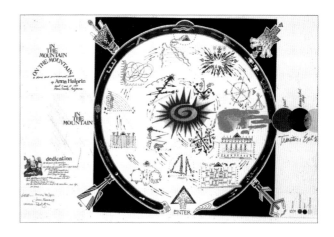

decoded by Kaprow, Pollock's experiments required not only a new, but an acrobatic consciousness, one capable of simultaneously living and behaving in the undivided 'art-life-work' and of observing the immediate results of lived acts on the notoriously unstable and unbounded surface, whose function constantly shifts between acting as a support for movement (the dance floor) and a support for looking (the canvas).

4.

By eclipsing painting and dance, Pollock intensified a twist that had already been initiated in the recent history of the arts. The quite loud return to painting by American artists in the interwar and post-World War II period felt in many ways like a gesture of romantic yearning for something that had already passed. Indeed, a generation earlier, in his prophetic essay 'The Work of Art in the Age of Mechanical Reproduction' 1936, Walter Benjamin had already announced a major historic shift in the cultural function and

production of art: for the first time in history, the (autographic) work of art was emancipated through mechanical reproduction from its dependence on ritual, and 'begins to be based on another practice – politics'.[7]

In 1913, Kasimir Malevich and Marcel Duchamp produced what would become two of the most perplexing artworks of the twentieth century: *Black Square* and *Bicycle Wheel*. Malevich first exhibited his stunningly empty and colourless painted image in 1915. That same year, Duchamp named his bicycle wheel mounted upside-down on a chair a 'Readymade'. Later, both artists would produce replicas of these works, which clearly marked the decline of visual art's autographic status and gradually shifted the entire discussion about art elsewhere. Instead of depicting an object or image to be looked at, *Black Square* and *Bicycle Wheel* functioned as transcendental reductions pointing to the emerging mechanisms that would underline the politics of visual and discursive

Fig.11
Raoul A. Feuillet, *Choreographie ou L'Art de décrire la dance* 1970
A page from a manuscript of baroque dance notation system published by R A. Feuillet but developed collaboratively by a group of ballet masters who belonged to the Académie Royale de Dance, founded in 1661 by Louis XIV

Fig.12
Anna Halprin
In the Mountain–On the Mountain
1981–2
Excerpt from the score
Courtesy the artist

regimes of then unforeseen but already emerging hi-tech societies. As Boris Groys reminds us, Malevich reduced painting to a 'pure relationship between image and frame, between contemplated object and field of contemplation, between one and zero. In fact, we cannot escape the black square – whatever image we see is simultaneously the black square. The same can be said of the readymade gesture introduced by Duchamp – whatever we want to exhibit and whatever we see as being exhibited presupposes this gesture.'[8] A few decades later, Pollock became a hero by awakening the pleasures associated with painting practice; instead of reducing the painting to pure form, he activated and expanded the practice of painting through space and movement.

5.

The legacy of Pollock that preoccupies artists even now was precipitated by his capacity to be simultaneously inside and outside his work. Harold Rosenberg's famous dictum that action painters use the canvas as an arena of action was followed by a generation of artists who used the world's environmental and social arenas as the canvas for a new type of depiction. From the very inception of this trend, artists had ambiguous takes on authenticity as a value to be found on the other side of the art/life divide. After traditional visual art practices started being appropriated, recycled and simulated through various mechanical imaging technologies, real time-based performance art began to be valorised as the only way to preserve the values of irreproducible and irreducible direct human inscription. Thus body and movement-based art became the only viable medium for many artists, while others' attention was focused on something else – something even more obvious,

but harder to see. The very blurring of art and life was for many artists (and non-artists) the only way to disclose how life had become irreversibly entwined with and undifferentiated from art.

By the 1960s the ubiquitous technologies of reproduction, simulation and communication started to seriously threaten to break down the entire phenomenological world into allographic equivalents of circulating information, generating an artificial double of humans and their world. The importance of aesthetic problems associated with the art of dance grew in relation to the awareness that, by changing the outside world, men and women were changing their inner worlds as well. According to Rudolf Arnheim, dance can never be lastingly reduced to a pure form, a medium. It can become art temporarily, by the total objectification of the body and the body's submission to pure form, which it has to become in order to be accepted as such by the spectator. 'If the spectator views the dancer as belonging to practical reality, he sees something monstrously unnatural, comparable to what we should feel if we meet a Picasso figure walking in the public street.'[9]

6.

Today artists would feel fortunate if they still had the power to produce the effect of estrangement or to invoke the uncanny, perhaps by faking an art-figure walking down the street or by presenting pedestrian movement on the stage. Art's interest in life as medium appeared at the moment when modern society became aware of the political opportunities opened up by new information technologies capable of creating fictive communities and realities through purely aesthetic means. The so-called performative

7
Walter Benjamin, *Illuminations*, New York 1969, p.224.

8
Boris Groys, 'The Weak Universalism', e-flux journal. No.15, 2010, www.e-flux.com/journal/the-weak-universalism/ accessed 2012.

9
Rudolf Arnheim, 'Concerning the Dance' *Salmagundi: DANCE* issue, no.33/34, Spring-Summer 1976, pp.89–92.

10
Allan Kaprow, *The Blurring of Art and Life*, Los Angeles 1993, p.10.

turn coincided with the birth of a new technocratic class of public relations agents, advertising agencies, environmental engineers, systems and fashion designers, and a whole army of entertaining, education, information and culture industries. The political and aesthetic interests accordingly expanded from the production of iconic objects to the production of living social subjects.

In 1958 Allan Kaprow described his first Happenings as new proposals for making 'total art' and referenced Richard Wagner, the symbolists and the Bauhaus as earlier examples of thinkers and artists engaged with the experiment. But he pointedly disagreed with their approach, particularly their attempts to organise traditional art forms into new totalities under the aegis of 'master directors'. Traditional art forms, developed over a long period of time, had highly articulated formal autonomies. They were self-sufficient, not amenable to mixture. 'But if we bypass "art", and take nature itself as a model or point of departure, we may be able to devise a different kind of art by first putting together a molecule out of the sensory stuff of ordinary life.'[10] Any number of experiences, subject matters and perceptions (known or invented) can then be used as material for a structure and body of a new work. The balance (composition) that was previously dictated by canvas or other media is now 'primarily an environmental one'.[11]

Whether this new work (which is just another temporary event among many others) is art or not depends on the perceptions of those who are involved in its making, for works that play with the blurring of art and life require that special spectator, whose acrobatic consciousness is able to constantly slip in and out of the work – from acting to seeing and vice versa. The new life-art form of Happening that Kaprow proposed can thus be experienced, viewed and interpreted in a number of different ways. As life and art, these kinds of events are potentially both affirmative/constructive – that is to say, supportive of social action and creative perception that is different from those offered by other social agencies – and deconstructive/mimetic, in that their being mimetic of mechanisms for reality production, enables them to function as deconstruction. Speaking about *An Exhibition*, a Happening in Hansa Gallery, New York, in 1958, Kaprow emphasised that 'we do not come to look *at* things … we simply enter, are surrounded, and become part of what surrounds us, passively or actively according to our talents for "engagement", in much the same way that we have moved *out* of the totality of the street or our home where we also played a part. We ourselves are shapes (though we are not often aware of this fact).'[12] By involving human agents in the centre of the work, those agents, like dancers in a dance, become the medium of the Happening; their perceptions and behaviour affect the final outcome of the life-art-work. 'There is,' wrote Kaprow, 'a never-ending play of changing conditions between the relatively fixed or "scored" parts of my work and the "unexpected" or undetermined parts.'[13]

8.
In an era when art began to be contextualised by politics, it was common to draw direct parallels between the two. 'Master directors' of 'total art', whether of Wagnerian or historic-avant-garde

Fig.13
Allan Kaprow
18 Happenings in 6 Parts 1959
Excerpt from the score
The Getty Research Institute,
Los Angeles

11
Ibid., p.11.

12
Ibid.

13
Ibid., p.12.

14
Roger Copeland, *Merce Cunningham: The Modernizing of Modern Dance*, New York 2004, p.136.

utopian persuasions, performed a role reminiscent of dictators in various totalitarianisms of the twentieth century. Art produced in America and Western Europe in the second part of the twentieth century, on the other hand, was often associated with regimes of victorious liberal democracy. After the Nazi holocaust and Communist purges, it was necessary for artists to rethink the art of previous decades. Were there perhaps some structural mistakes, or errors in thinking, made by art itself? Could art be considered co-responsible for some of these political catastrophes? In his critique of the German 'hunger for wholeness' exemplified by *gesamtkunswerk's* craving for totality, John Cage made an explicit connection between modernist art obsessed with pure form and the Germanic obsession with racial purity.[14] John Cage – and subsequent generations of artists who built on his legacy – introduced and meticulously integrated theories of indeterminacy and hybridism into their composition of artwork, by which they not only surpassed purist modernist models of art, but also mimicked the new forms of governing and control that were forming within the geo-political parameters of the Cold War.

However known it might have been that Kaprow's Happenings were heavily scripted, the now-available archival documents relating to them reveal an even more thorough scoring and scripting than one would expect. André Lepecki, who was responsible for the re-staging of *18 Happenings in 6 Parts* in 2006, expressed his surprise and fascination on discovering that what is widely described in scholarship as 'the script' or 'the score' for this work is, rather, 'a massive textual and visual work, almost autonomous in itself in its prolific poetic ramifications and

performative potentialities'. A significant part of this event happened only on paper where, Lepecki discovered

'a truly rhizomatic collection of virtual ideas, beautiful poems, impossible actions, architectural dreams, sharp, short manifestos on art, music and theatre, hilariously self-aggrandizing narratives, hilariously self-depreciating narratives, brilliantly compact theoretical texts, insightful quasi-ethnographic snapshots of quotidian expressions, acute diagnostics of urban life, heart-breaking confessions of the artist before the huge challenges posed by this project'.[15]

Sometimes historic records surprise us by revealing uncanny and unexpected connections. Janelle Porter reports that while searching for ways to script or score live, life-resembling events, Kaprow came across Labanotation – arguably the most successful movement notation system ever produced.[16] Capable of recording and analyzing every human or animal motion, Labanotation was derived from genuinely modernist utopian principles. It is beautifully, visually coherent, showing rational space disturbed by movement and fragmentation. There is a cubist touch to it. But this system (first published by Rudolf von Laban in 1928), which virtuously integrated a long knowledge of the arts with that of modern science, was put to sinister political use when adopted as an organisational tool for massive stadium dance exercises during the 1936 Nazi Olympic games. Like other modern monumental orderings of the world-in-itself according to formulaic or systemic reductions, the idea of movement notation, in the final analysis, elicits a certain absurdity that probably amused Kaprow when formulating his

Fig.14
Rudolf von Laban
Labanotation, 1928
an example of a score (left)
and main symbols (right)
The Laban Archive

life-art-work enterprise. Don't we already cover the earth with steps that we have lived? Why then do we need to recreate and repeat them?

9.

The 'performative turn' coincided historically with the 'allographic turn' and with the age in which art became contextualised by 'total politic.' Whether consciously or not, art's reinvention and use of the body and 'real time' social practices (as materials and sites of authenticity, spontaneity and freedom of the sort usually associated with worship and other pre-secular practices of the past) mirrors the historic loss and profound transformation of these agencies in the technologically altered, secularized world. Like painting, drawing, sketching and other two-dimensional means of depicting the experienced phenomenal world, dance notation systems seek to translate into two-dimensional scripture a phenomenon represented by action that is taking place within three dimensions of space and one dimension of time. By adding measured time to spatial forms of depiction, dance notation reveals the contradictory structure of new forms of representation where the perceived and depicted phenomenon becomes inseparable from its unfolding and changing in time. The 'acrobatic' user (recorder-agent) of this new system is asked to think, feel, and move according to this or the other political or artistic script, and simultaneously analyze these actions in their relentless unfolding. Like the autographic art of dance, the objects-events that are simultaneously art and life – integrated through division – resist fixation and static appreciation, and join the ruins of time as soon as the artist or other participants get up and walk back into the life-play they came from or are heading toward next. The advantage of static arts is, of course, that we can contemplate at leisure a transient state of nature or daily life, and observe (and potentially intervene into) a multitude of its relationships and gradations. Drawing, sketching, marking and painting continue to represent a way of thinking, controlling and navigating the elusiveness of ongoing multitudes of actions that are simultaneously representing and constructing the realities of this world. As two-dimensional-allographic equivalents of events in time, these practices have become technologically and politically incorporated into our daily lives—recording, choreographing, and perpetually assimilating us into an image of remote and invisible 'master-directors'.

Did Happenings and other open-ended, time-based philosophies and practices of art as proposed and practiced by John Cage, Allan Kaprow and their contemporaries truly find a working formula for 'art as art' in the age of 'total politic'? The answer certainly doesn't lie in any object of art that they left behind. It is more likely to be found by considering how their legacy affects our contemporary perception and interpretation of what is actually depicted, revealed and unfolded through the most recent forms of art that reference avant-garde precedents. Are these practices the mimesis of the existing world or the affirmation of the world yet to happen? How do we reconcile the two mutually exclusive commands implicit within the reality of one object-event now that the avant-garde prohibition 'don't!' has lost its acrobatic twist due to the success of its own underlying 'do it yourself' ideology?

15
André Lepecki, *Allan Kaprow*
18 Happenings in 6 Parts,
Gottingen 2007, p.47.

16
Jenelle Porter, *Dance with Camera*,
ex.cat., Institute of Contemporary Art,
University of Pennsylvania, Philadelphia
2009, p.17.

Painting
(the Threshold of the Visible World)

Dieter Roelstraete

Nature (Sensation) everywhere combines, intellect everywhere separates.
Friedrich Schiller

The Hamburger Kunsthalle is home to one of the best-known paintings of the first half of the nineteenth century and possibly the single most widely reproduced image associated with the Romantic movement, and with the history of German Romanticism in particular: Caspar David Friedrich's magnificent, yet surprisingly small, *Wanderer über das Nebelmeer* 1817. Depicting a solitary figure perched atop a mountain and imperiously looking down upon a gathering of fog below, this Romantic masterpiece has been the subject of countless interpretations and graced numerous book and record covers. It is an Olympian emblem of Nietzschean isolation on the one hand, and man's minuteness in the face of Nature's shock-and-awe on the other. And it is also, of course, a milestone both in the history of landscape painting and in the micro-history of the *Rückenfigur*, a quintessentially Romantic trope in Western art, which in part originated in Friedrich's *oeuvre*, where the viewer looks at the wanderer's back and the wanderer stands in front of us, partly obscuring our view of both his and our world. In fact, he stands at the very threshold of the visible world, like the mysterious doubled figure – which Friedrich's painting, in my mind at least, inevitably invokes – in René Magritte's famous *La reproduction interdite* 1937.

A couple of rooms down from the diminutive amateur mountaineer hangs another painting: a small portrait, made by Friedrich's contemporary Georg Friedrich Kersting, of Caspar David Friedrich seated in his studio at work behind the easel. Curiously for an artist who revolutionised the landscape genre and is now best remembered for his sweeping vistas and panoramic intimations of the inhospitable sublime, Friedrich is shown here

Fig.15
Caspar David Friedrich
View from the studio of the artist (left window) 1806
Pencil and sepia on paper, 31.4 x 23.5
Collection Österreichische Galerie im Belvedere

—

Fig.16
Georg Friedrich Kersting
The Painter Caspar David Friedrich in His Studio 1812
Oil paint on canvas, 51 x 40
Nationalgalerie, Staatliche Museen zu Berlin

sat in a poky little room with just two windows – one closed off entirely, the other only half open, and neither especially large – with nothing of note to be glimpsed through them. In another portrait by Kersting – this one now owned by the Alte Nationalgalerie in Berlin – Friedrich is depicted leaning on his chair, contemplating the painting on the easel in front of him, which, like the wanderer, we only see the back of, and is an echo of Velázquez's *Las Meninas*. In neither of these portraits is the great landscape painter looking out the window, to the world beyond; in fact, he has his back turned to it – the very picture of brooding inwardness. Looking in quiet, bemused satisfaction at his own painting (presumably a landscape, but a view of *what* exactly?) affords him all the world he needs. It's all in there.

In his authoritative four-volume study of nineteenth-century art, Albert Boime has remarked that the historical reasons for the German triumph in the field of landscape painting, which we have come to associate with the figure of Friedrich (and to a lesser extent that of Philipp Otto Runge), may partly be located in the complex of territorial traumas inflicted upon the German lands in the first decades of that century. When Napoleon's troops first overran the Holy Roman Empire in the early 1800s, and the emperor himself instituted its dissolution in 1806, the last remaining symbol of fractious German unity was torn asunder. In place of its dizzying patchwork of more than three hundred separate sovereign states and principalities, an only slightly less disorienting mosaic of thirty-nine states, called the Confederation of the Rhine, was imposed from without. This is the precise political context in which the rise of landscape painting in Germany must be viewed, and it is the traumatic nature of much of this territorial reshuffling that informs the emergence of a peculiar subgenre of Romantic landscape painting – namely, that defined by the open window. This iconographic motif is alluded to, in part, in the above juxtaposition of *Wanderer über das Nebelmeer* and the two portraits of Friedrich in his studio. (Interestingly, one of these portraits graces the cover of a book by Hans Belting, titled *The Germans and their Art: A Troublesome Relationship*.)

Indeed, the half-obscured windows shown in the background of both portraits by Kersting also made an appearance in Friedrich's own work: they are the subject of a well-known pair of graphite and sepia drawings made slightly earlier, in 1805–6, when Napoleon was in the process of carving up the Holy Roman Empire. These drawings show a dramatically cropped view of the Elbe flowing through Dresden. So modest, in fact, is the glimpse afforded by these crops that the pictures hardly qualify as landscapes. Their real subject is the window, not the view. And true enough, Sabine Rewald writes about these drawings that

'[Friedrich] inaugurated the motif of the open window in Romantic painting. In it, the Romantics found a potent symbol for the experience of standing on the threshold between an interior and the outside world. The juxtaposition of the close familiarity of a room and the uncertain, often idealized vision of what lies beyond was immediately recognized as a metaphor for unfulfilled longing, as evoked in the words of the Romantic poet Novalis:

Fig.17
René Magritte
*Not to be reproduced /
La reproduction interdite* 1937
Oil paint on canvas, 81 x 65
Museum Bojimans van Beuningen

"Everything at a distance turns into poetry: distant mountains, distant people, distant events: all become Romantic."[1]

What is more important for our present purposes, however, is that the motif of the open window can also be read as an early expression of painting's nascent self-reflexivity, a clear if still somewhat timorous signal of art's emerging modernity, as the rectangular or square shape of the canvas perfectly echoes the window as a view on to the world. The painting marks the threshold of the visible world; or, as a window onto a world kept at bay, it becomes the exemplary liminal space of the world we choose to inhabit, to call home, to live and work in.

Here, a sideways reference to a painting by one of Friedrich's better-known contemporaries is in order, namely Carl Gustav Carus's *Studio Window* 1823–4. In this curious masterpiece, the eponymous studio window is shown half-obscured by a painting – of which, once again, we see only the back. And many a modern viewer, finally, will be drawn to the fine latticework of Friedrich's studio drawings, where spare, slightly skewed horizontals and verticals presage Marcel Duchamp's *Fresh Widow* from 1920, as well as the entire twentieth-century history of Malevichian and/or Mondrianesque grids. If Malevich's black square was regularly interpreted to signal the end of painting, it is perhaps also because as a window, it no longer showed anything – night had fallen on the other side of art. Indeed, one of Friedrich's drawings even makes a guest appearance in Rosalind Krauss's landmark essay 'Grids'. Krauss is especially attracted to the window motif as a cipher of the deep simultaneity of opacity and transparence, which has become one of the hallmarks of modernist painting: 'as a transparent vehicle, the window is that which admits light – or spirit – into the initial darkness of the room. But if glass transmits, it also reflects.' It *mirrors*. It is this dialectical tension that Krauss goes on to explore to even greater effect in the contrasting of the so-called centrifugal and centripetal powers of the grid, of which the window, as seen in early nineteenth-century German painting, is such a compelling early example:

'because of its bivalent structure (and history) the grid is fully, even cheerfully, schizophrenic. I have witnessed and participated in arguments about whether the grid portends the centrifugal or centripetal existence of the work of art. Logically speaking, the grid extends, in all directions, to infinity. Any boundaries imposed upon it by a given painting or sculpture can only be seen – according to this logic – as arbitrary. By virtue of the grid, the given work of art is presented as a mere fragment, a tiny piece arbitrarily cropped from an infinitely larger fabric. Thus the grid operates from the work of art outward, compelling our acknowledgement of a world beyond the frame. This is the centrifugal reading. The centripetal one works, naturally enough, from the outer limits of the aesthetic object inward. The grid is, in relation to *this* reading a *re*-presentation of everything that separates the work of art from the world, from ambient space and from other objects. The grid is an introjection of the boundaries of the world into the interior of the work.'[2]

In both cases the painted grid, as incarnated in the open window motif rendered on canvas,

1
Sabine Rewald, *Rooms with a View: The Open Window in the 19th Century*, New Haven and London 2011, p.3.

2
Rosalind Krauss, 'Grids', in: *The Originality of the Avant-Garde and Other Modernist Myths*, Cambridge Mass. 1985, pp.18-19.

3
The territorial reality of fragmentation, as we noted earlier, was certainly instrumental in the development of the German Romantic tradition of landscape painting – a genre that is almost entirely anchored in an ontology of yearning. If Friedrich belongs to any utopian strand within 'modern' art history – and as the great contemporary and pictorial counterpart of the likes of Hegel, Schelling and Schlegel (the quintessential philosopher of the fragment), he could be said to have inaugurated a truly modern, i.e. self-conscious notion of art – it is precisely because of the nostalgic dream of wholeness that animates many of his landscapes.

figures as an asymptote that marks the boundary between inner and outer, world and self, visible and invisible, beyond and within, fragment ('a tiny piece arbitrarily cropped') and whole ('an infinitely larger fabric'). And so an entire history of painting could be (re-)written using the *fragment* – that sacrament of contemporary theory – as its organising principle.[3] According to centrifugal reading, the painting would then figure as a mere fragment of a greater whole that can only ever be longed for – furtively glimpsed through one of Friedrich's windows, for example. In centripetal mode the painting would be that greater whole itself – a whole world unto its own, inviting inhabitation and activation, urging us to turn our back on that which is falsely forced upon us as the 'real' world outside art.

It is this latter body of ideas that appears to subtend much of the work gathered in the exhibition *A Bigger Splash*. The painting is not just a window *onto* the world – and all the world's a stage, evidently – but is a world itself, or alternatively is a stage upon which the utopian wholeness of this world can be enacted. It is an artist's proposal for a world of one's own and a world unto itself.

Speaking of staging, one thing that is usually little considered within Friedrich (and rooms-with-views) scholarship is the staged, theatrical poses of these various figures that stand on mountaintops or in front of windows.[4] The portraits of these insouciant masters of their own fate – whose individuality becomes all the more philosophically absolute, paradoxically enough, in the motif of the anonymous, faceless *Rückenfigur* – exude the auratic comfort of a

Fig.18
Carl Gustav Carus
*The Studio Window /
Das Atelierfenster* 1823/24
Oil paint on canvas, 28.8 x 20.9
Museum for Art and Cultural History
LUEBECK
—
Fig.19
Marcel Duchamp
Fresh Widow 1920, replica 1964
Mixed media, 78.9 x 53.2 x 9.9
Tate. With assistance from the National Lottery

natural, authoritative confidence in one's steady position at the edge of the world. They are content to merely look on and see its drama unfold from the redoubtable distance of 'critique' (another of the nineteenth century's great inventions). Their seemingly nonchalant but scrupulously doctored postures signal the emergence of a new model of spectatorship (recall that this iconography follows closely on the heels of the golden age of classical German drama),[5] in which the world as a whole is reconsidered as an *aesthetic* fact, as a source of aesthetic pleasure first and foremost; or, more pointedly still, in which the world's ultimate reasons for 'being there' may be whittled down to purely aesthetic considerations. Did not Friedrich Nietzsche, whose volumes have so often been adorned by Friedrich's talismanic solitary wanderers, assert in a book devoted to locating the roots of classical drama, no less, that 'only as aesthetic phenomena are existence and the world justified'? In this reading, the windows in the paintings discussed above become something akin to portals of (or to) pleasure, and painting itself provides the vantage point from which to experience the world aesthetically. Or, moving from *standing* at the threshold of the visible world, brush in hand, to actually *painting* it, the world is simply invented as an aesthetic phenomenon, as a stage for the enthused enactment of aesthetic impulses. After all, our discussion takes place against the philosophical backdrop of German Romanticism – probably the moment in history when art's demiurgic powers were at their triumphant highest, and when God was most likely to be thought of as an artist, though not necessarily a painter.

It is perhaps inevitable that this brief art-historical excursion should conclude with a tip of the hat to the grand, somewhat tarnished tradition of the *Gesamtkunstwerk* – the historical apotheosis, in many ways, of much that has been discussed in the preceding pages, and, it should be noted, a notion that was perfected in the highly artificial, transgressive world of Wagnerian opera. Indeed, anyone interested in following Nietzsche's intimations of the world's aesthetic *raison-d'être* to its existential conclusions will at some point or other either leave behind the easel and canvas to remake the world as an artwork worth living in – a process which is, of course, an exemplarily performative one, inaugurating the long history of painting as performance, since, of all the arts, it is perhaps painting that lends itself best to play-acting. Or conjure a cosmic vision of the work of art in which the self is only one among the resultant machine's many cogs – that is, it is a part that must be *played*. As art blends into life, painting no longer provides a mere view by way of a window in and on the wall, but becomes a three-dimensional space in which this creative dissolution can be tested, played out, narrated, experienced. The artist, now no longer merely being the artist but also acting the part, is seen crossing the thresholds of old and all that is solid melts into paint-heavy air.[6]

Epilogue

An afterimage, an afterthought: returning to the open window motif in modern painting and its aftermath, let us look at *Le mois des vendanges* 1959, a lesser-known picture by my great compatriot Magritte. An empty room is shown with a wide-open window to the right; framed by the window,

4
'The pose is also generative of *mise-en-scène*. The pose always involves both the positioning of a representationally inflected body in space, and the consequent conversion of that space into a "place."[...] The pose also includes within itself the category of "costume," since it is "worn" or "assumed" by the body.' Kaja Silverman, *The Threshold of the Visible World*, London & New York 1996, p.203. Quite apart from the theatrical overtones of the pose, it is worth highlighting the great care with which Friedrich *et al.* painted their subjects' outfits – an early precursor of the established modernist trope of the painter portrayed in exquisite bourgeois getup (think of Max Beckmann, De Chirico, Otto Dix, Magritte and literally countless others).

5
Although it would lead us too far to even consider mapping out the ramifications of this historical convergence, it is nonetheless worth pointing out in the context of an exhibition that aims to expand the notion of 'painting as an arena in which to act', as Harold Rosenberg put it in his 1952 essay 'The American Action Painters', and in which painting is viewed as much as a performative act as it is a mode of production or resultant stabilised art form.

a dozen and a half bowler-hatted Magrittes stand side by side, looking at us with much the same expression (that is to say, none) as the duplicated back of the anonymous head in *La reproduction interdite*. One could imagine them standing outside Friedrich's studio, waiting for the arch-romantic to finish his painting of the very view they are obscuring – or, alternatively, that they themselves constitute. They are also a self-portrait, of course, of the artist gazing at the spectator and simultaneously peering into the empty or abandoned space of artistic creation. Art has left the studio and found its way into the world. Art may be busy rebuilding this world, or the world may be busy rebuilding itself to resemble an artwork, such as the one in front of us (all surrealism in essence remains realist). The figures in Magritte's painting act, pose and perform a well-known role, in this particular case that of the immaculately dressed bourgeois anarchist – the *artist*. They stand and idly loiter at the threshold of the (visible) world; like both the painting and the window it collapses into, they *are* the threshold of the (visible) world.

Fig.20
René Magritte
Harvest Month /
Le mois des vendanges 1959
Oil paint on canvas, 130 x 162
Private collection

6

Let us also note in passing here that the moment of theorisation of the *Gesamtkunstwerk* roughly coincided with the golden age of the highly popular form of panorama painting, which was perhaps never wholly accepted by the critical establishment because of its theatrical effect and appeals to a new type of distance-less (hence 'uncritical') spectatorship. The panorama painting also marks an important moment, evidently, in the history of immersion as an aesthetic effect – something that the same critical establishment, in much the same way, continues to grapple with in today's contemporary art. Like the panorama painting, immersion is always under threat of being sidelined as kitsch – a threat that can only be dispelled by turning it into camp.

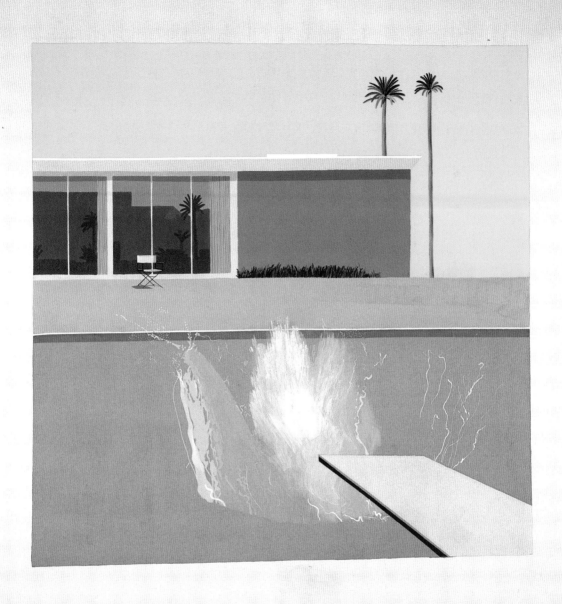

David Hockney
A Bigger Splash
1967

Jack Hazan
Film stills from
A Bigger Splash
1973–4

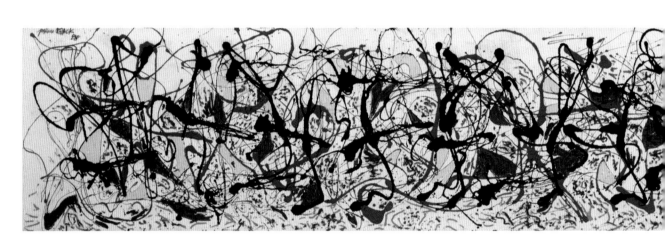

Hans Namuth
JACKSON POLLOCK '50
1950

Jackson Pollock
Summertime: Number 9A
1948

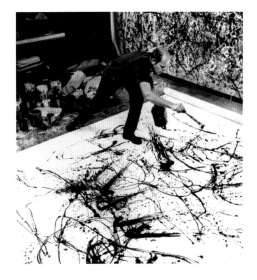

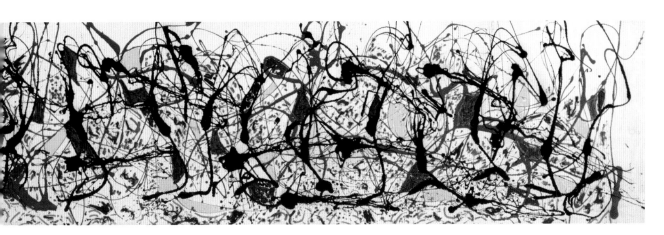

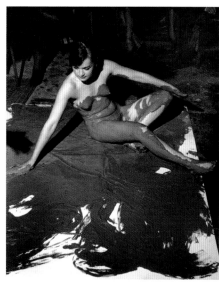

Documentation of *Anthropometry of the Blue Era / Anthropométries de l'époque bleue*, a performance by Yves Klein, 1960

Yves Klein
IKB 79
1959

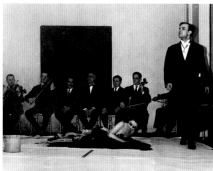

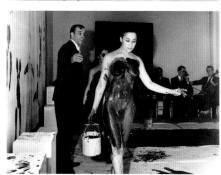

Niki de Saint Phalle
Shooting Picture
1961

Niki de Saint Phalle and visitor
during the artist's solo exhibition
Feu à Volonté at Galerie J, Paris,
30 June – 12 July 1961

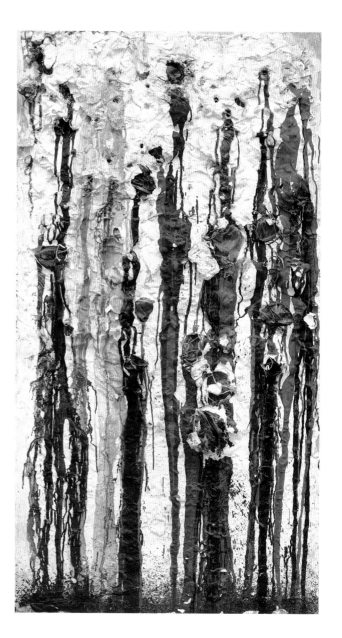

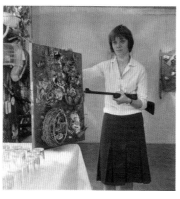

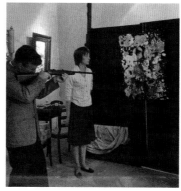

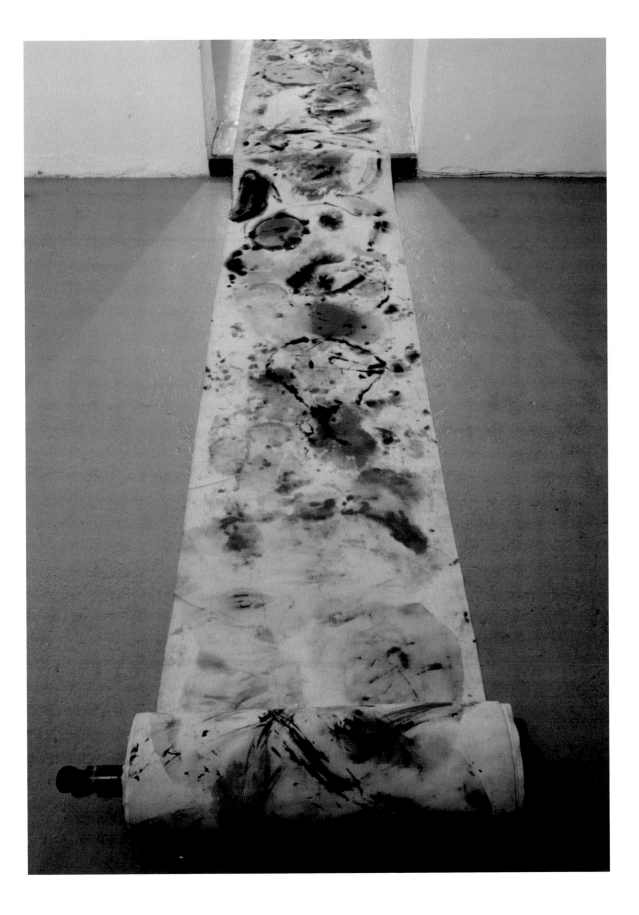

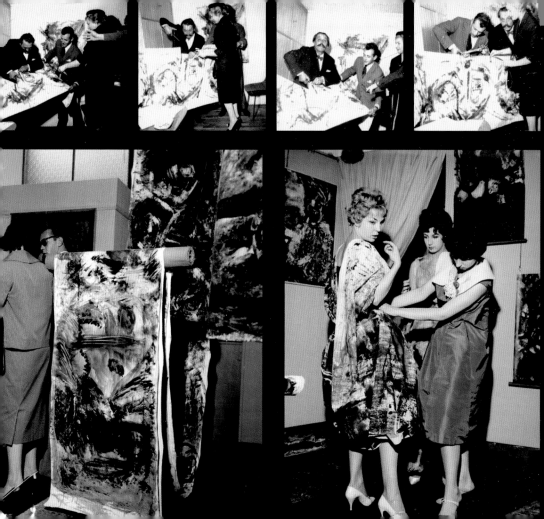

Shozo Shimamoto
Hurling Colours Performance/
Throwing bottles of paint against
the canvas, The 2nd Gutai Art
Exhibtion, Ohara Hall, Tokyo
1956

Shozo Shimamoto
Holes
1954

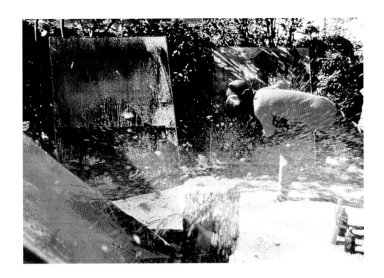

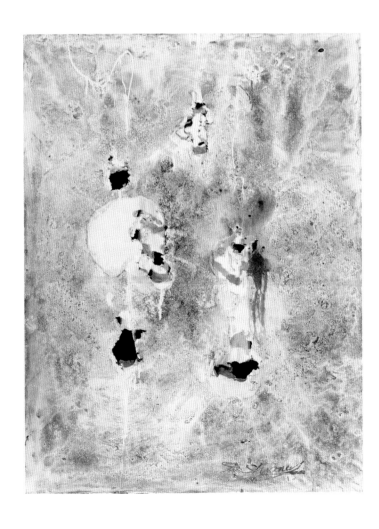

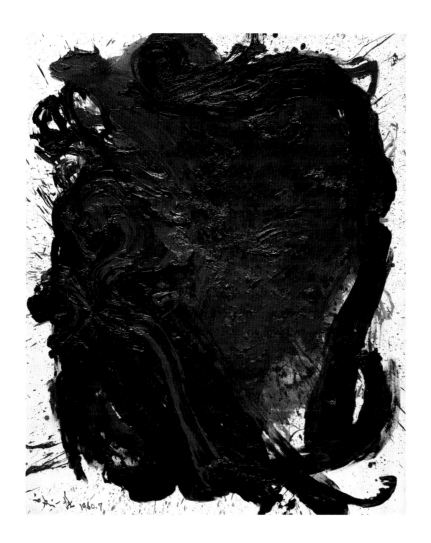

Kazuo Shiraga
Chizensei-Kouseimao
1960

Kazuo Shiraga
Shiraga painting with his feet
1956

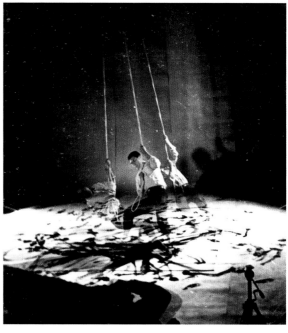

Günter Brus
Self-Painting / Selbstbemalung
1964

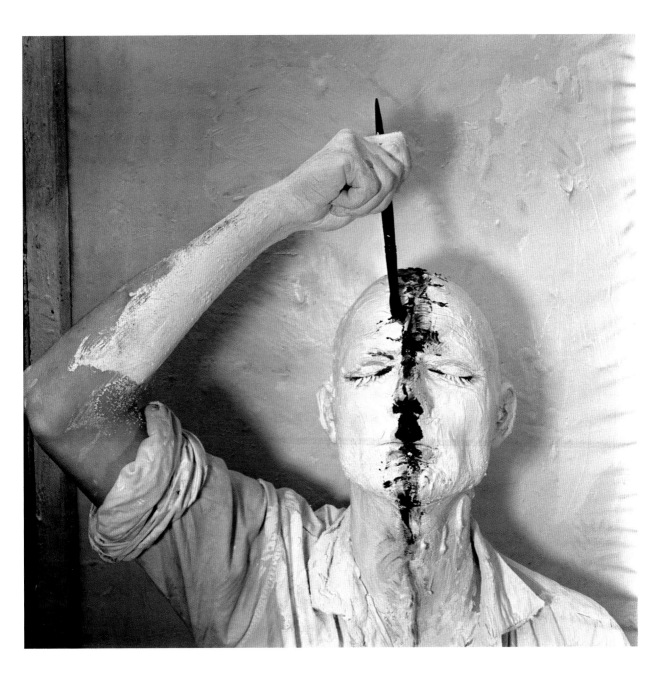

Günter Brus
Film still from *Vienna Walk*
1965

Günter Brus
Untitled
1960

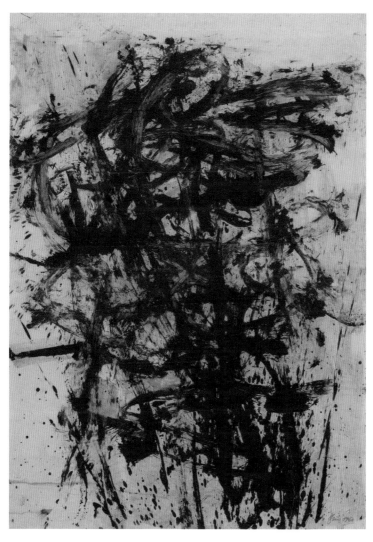

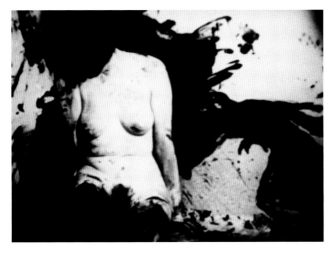

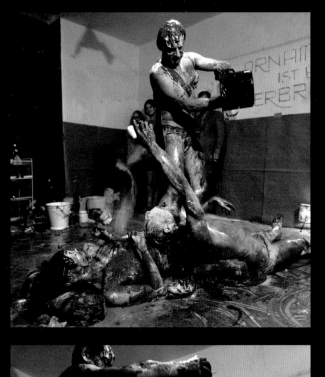
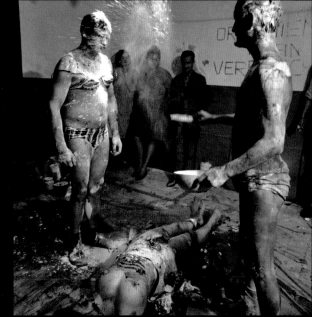
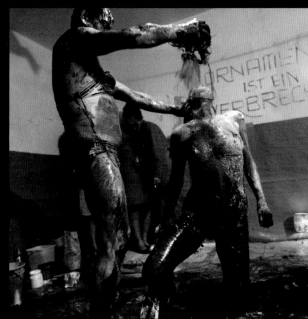
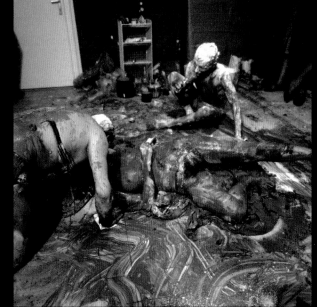

Hermann Nitsch
Poured Painting / Schüttbild
1963

Hermann Nitsch
53rd Action
1976

Hermann Nitsch
*Festival of Psycho-Physical
Naturalism (3rd Action)*
1963

(opposite)
VALIE EXPORT
*Identity Transfer 1 /
Identitätstransfer 1*
1968, printed late 1990s

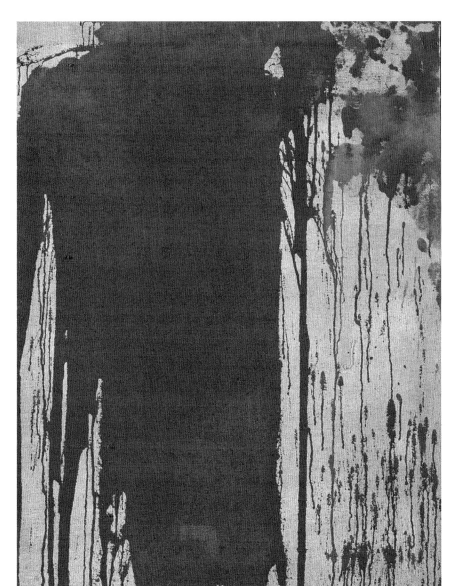

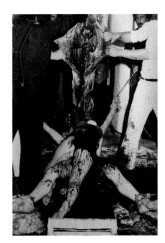

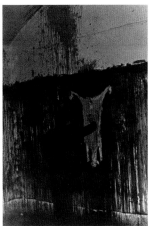

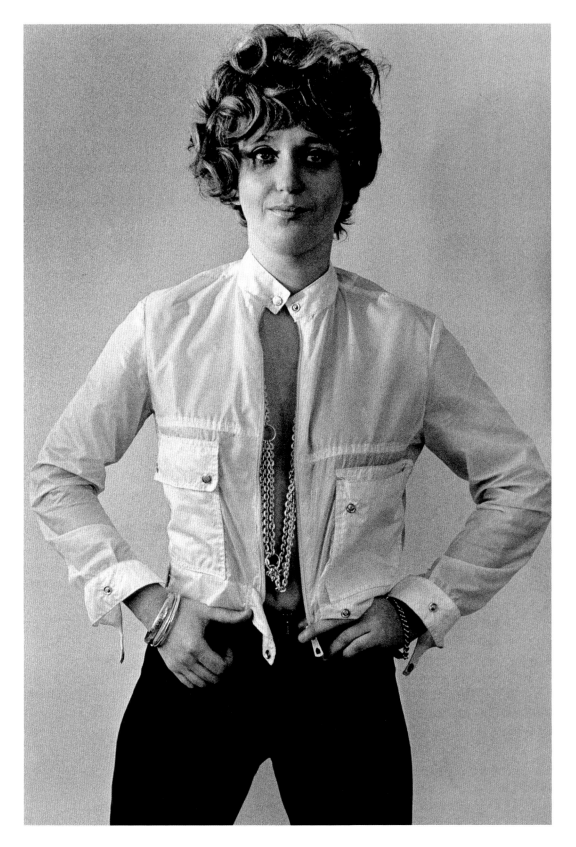

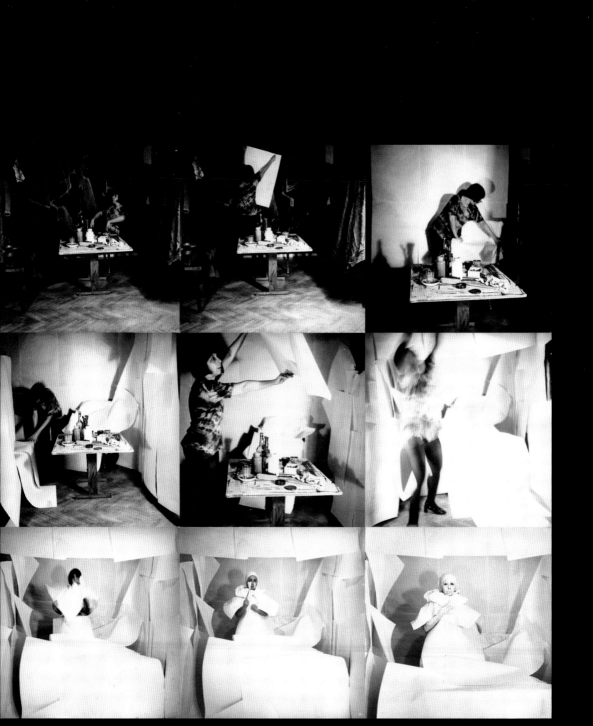

Geta Brătescu
Towards White
1975

Geta Brătescu
The Pillars
1985

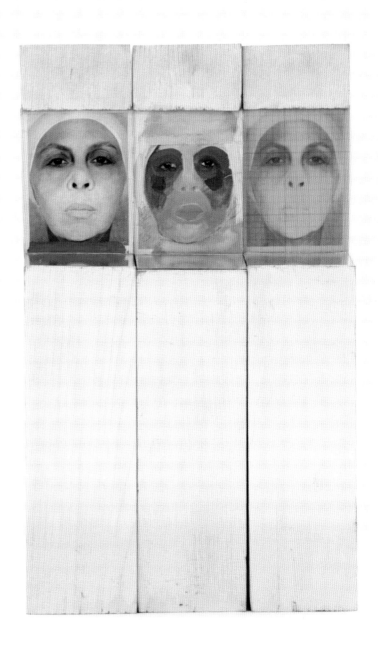

Stuart Brisley
Moments of Decision /
Indecision, Warsaw
1975

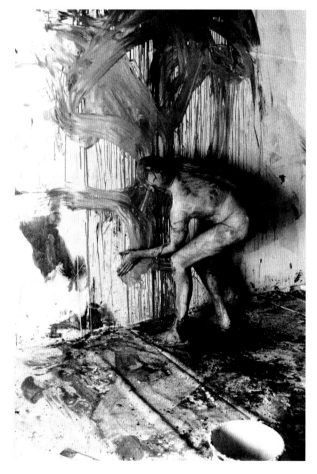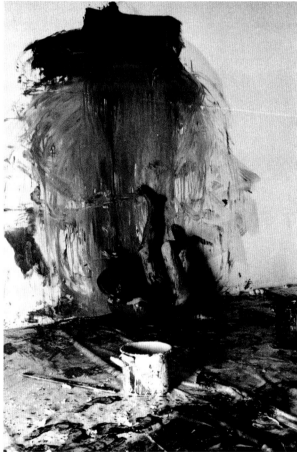

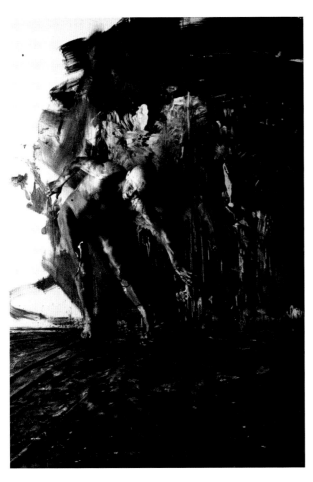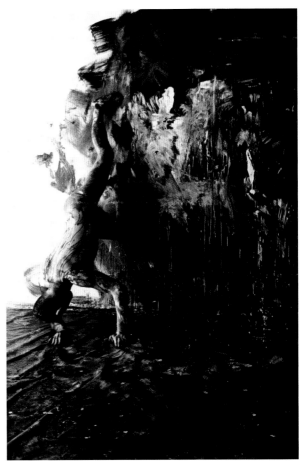

Stuart Brisley
Artist as Whore
1972

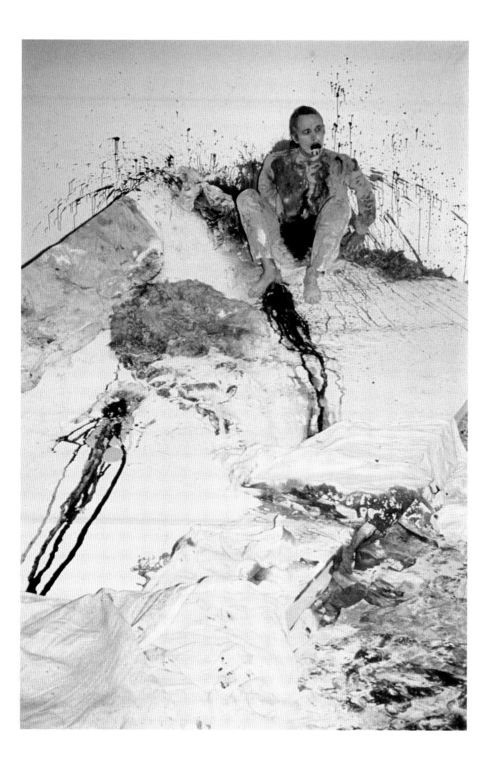

Wu Shanzhuan
Public Ink Washing
Documentation of private
performance, part of
Red Humour series
1987

Kang-so Lee
Painting
Documentation of
private performance
1977

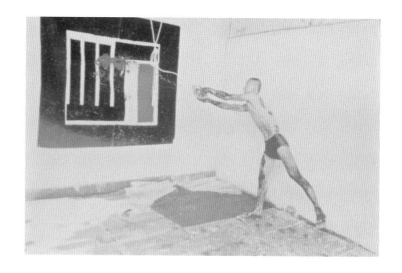

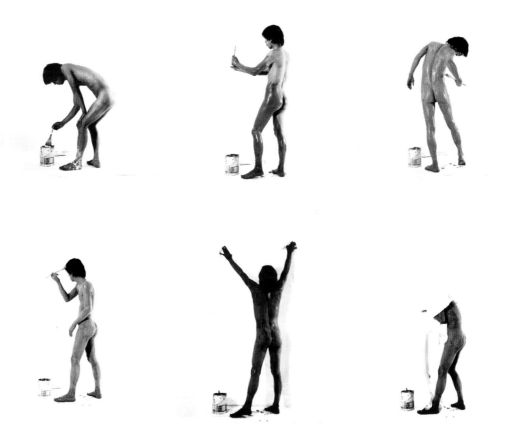

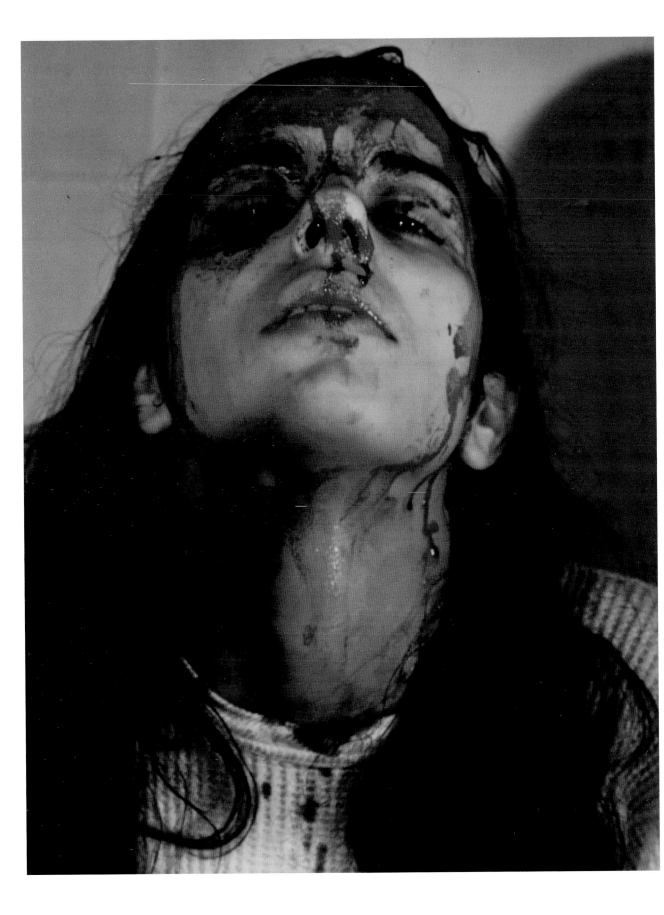

Ana Mendieta
*Untitled (Self-Portrait
with Blood)*
1973

Ana Mendieta
Untitled (Body Print)
1974, printed 1997

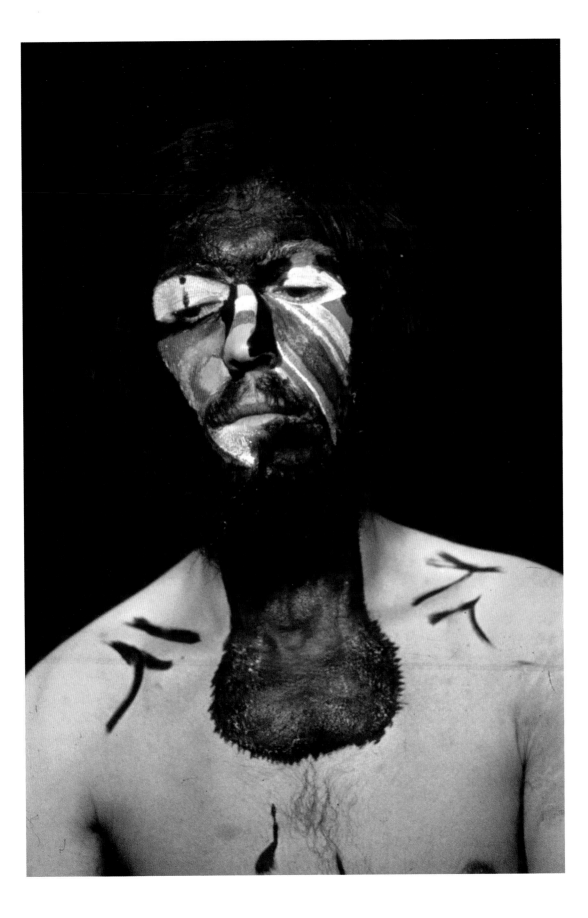

Wiktor Gutt and
Waldemar Raniszewski
The Great Conversation
1974

Wiktor Gutt and
Waldemar Raniszewski
The Hexagon Mask
1973

Ku-lim Kim
Body Painting Performance
Documentation of performance
1969

Wang Peng
84 Performance
Documentation of performance
1984

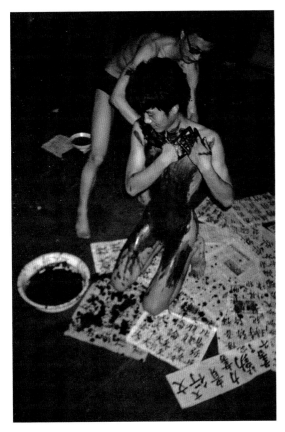

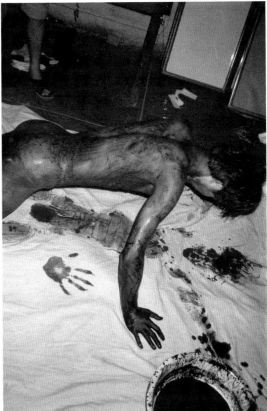

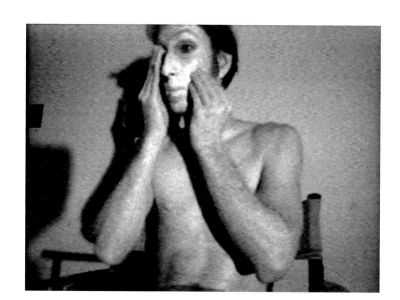

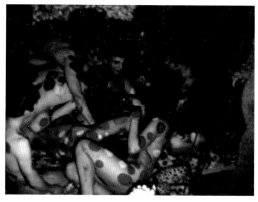

Yayoi Kusama
Film still from *Flower Orgy*
1968

Bruce Nauman
Film still from *Flesh to White
to Black to Flesh*
1968

Jack Smith
Untitled
c.1958–1962, printed 2011

Jack Smith
The Secret of the Rented Island
Performance slide
1976

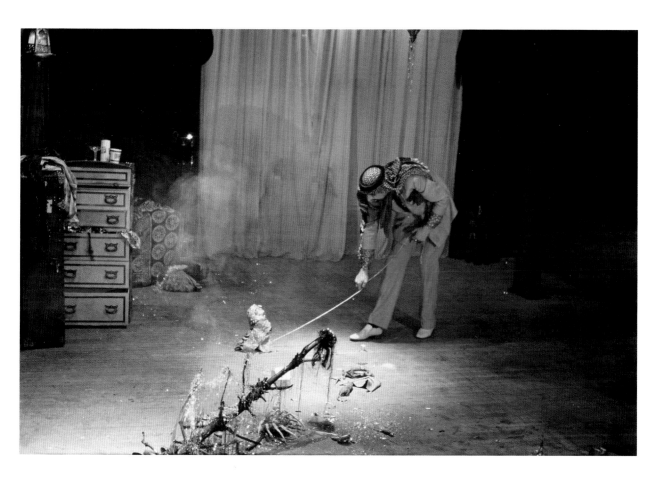

Ivan Cardoso
Film stills from *H.O*
1979

Hélio Oiticica
Production still of Mario Montez
in the unfinished film *Agrippina
é Roma Manhattan*
1972

(opposite)
Sam Gilliam
Simmering
1970

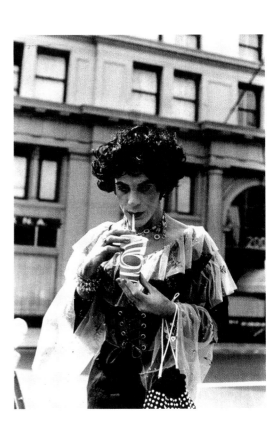

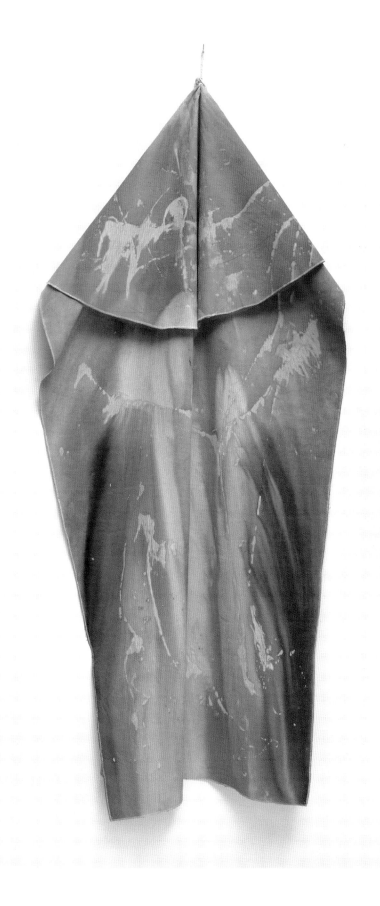

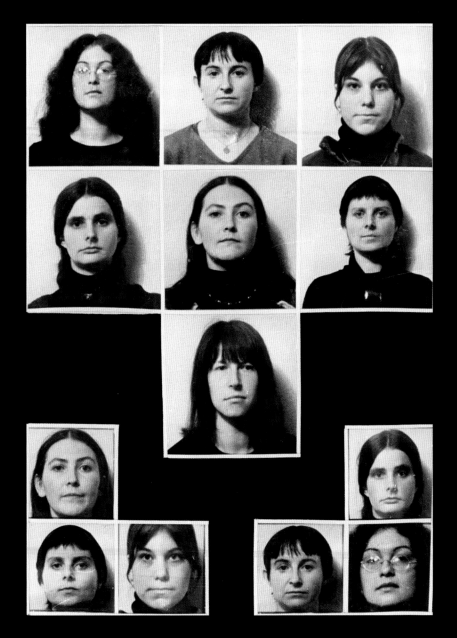

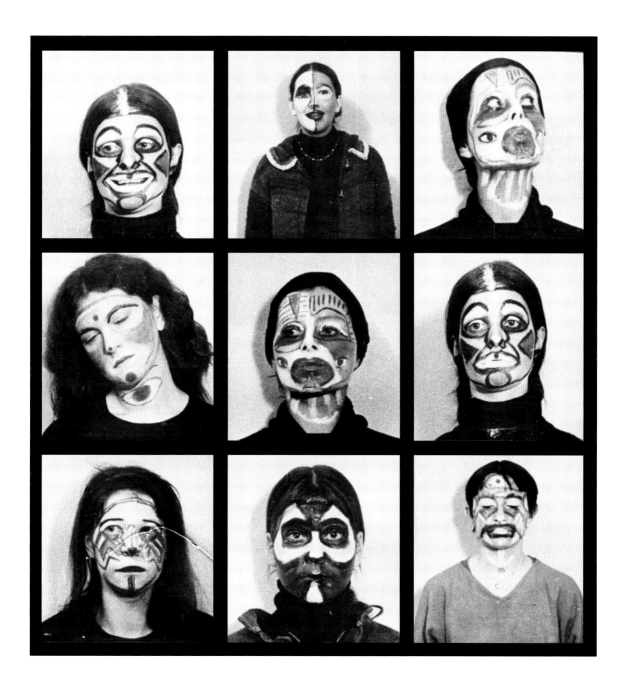

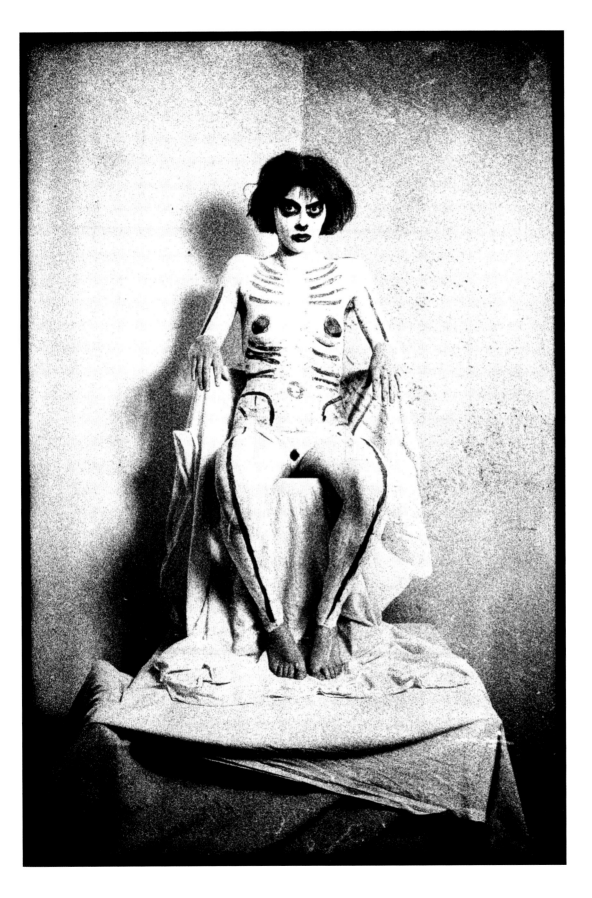

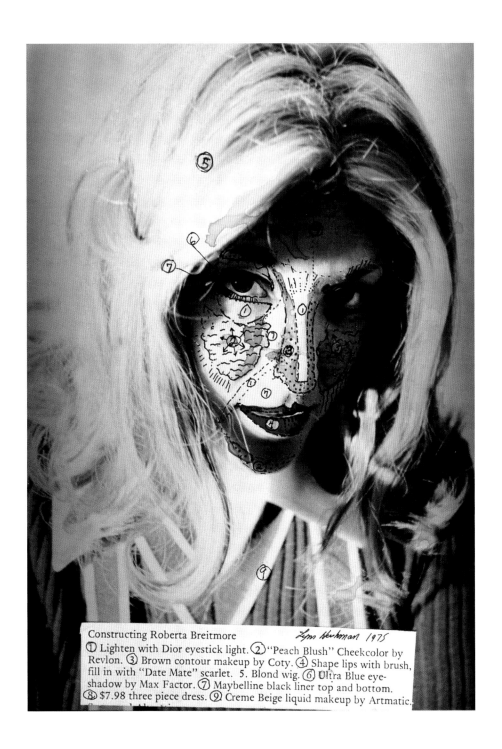

Cindy Sherman
Untitled A
1975

(opposite)
Cindy Sherman
Untitled
1976, printed 2000

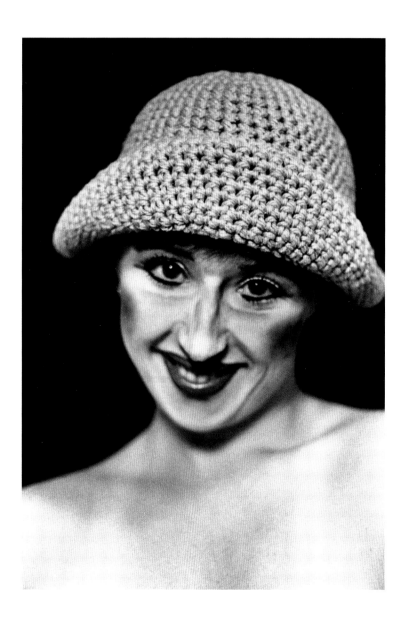

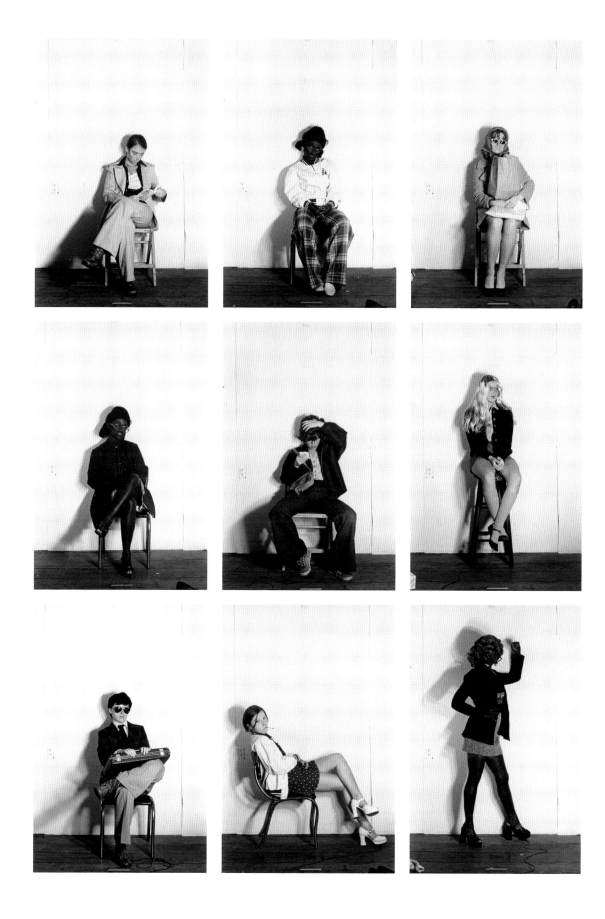

Cindy Sherman
Untitled
1983

Andy Warhol
Self-Portrait in Drag
1981

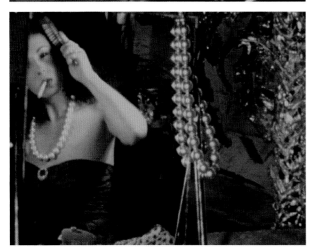

Derek Jarman
Film stills from *Miss Gaby – I'm Ready
For My Close-Up*
1972

(opposite, clockwise)
Johnny Dewe Mathews
*Andrew Logan and Derek Jarman
in the Downham Road studio, London
for* Interview Magazine
1973

Judges Kevin Whitney, Eric Roberts,
David Hockney, Robert Medley, Fenella
Fielding, Celia Birtwell and Gerlinda
von Regensburg on the front row at the
'Wild' themed Alternative Miss World at
Logan's studio, Butler's Wharf, London
1975

Ben Campbell and Andrew Logan
*Andrew Logan's Bedroom,
Outfit and Flower Sculpture,
10 Denmark Street, Oxford*
1969

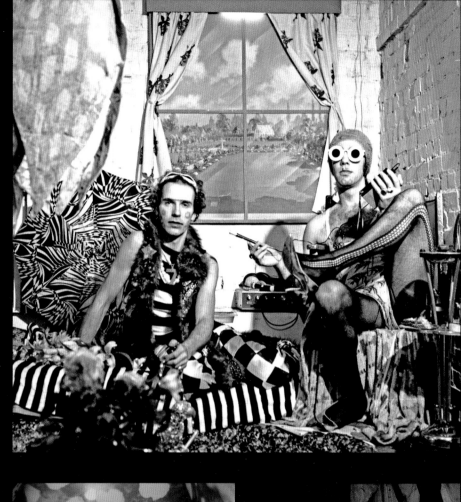

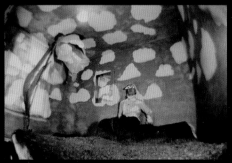

Eleanor Antin
Video still from
Representational Painting
1971

Sanja Iveković
Video stills from
Make-up – Make-down
1978

Ewa Partum
Video stills from
Change – My Problem
is the Problem of a Woman
1979

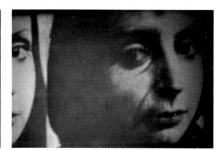

Luigi Ontani
San Sebastiano Indiano
1976

(opposite)
Urs Lüthi
Just another story about leaving
1974, printed 2006

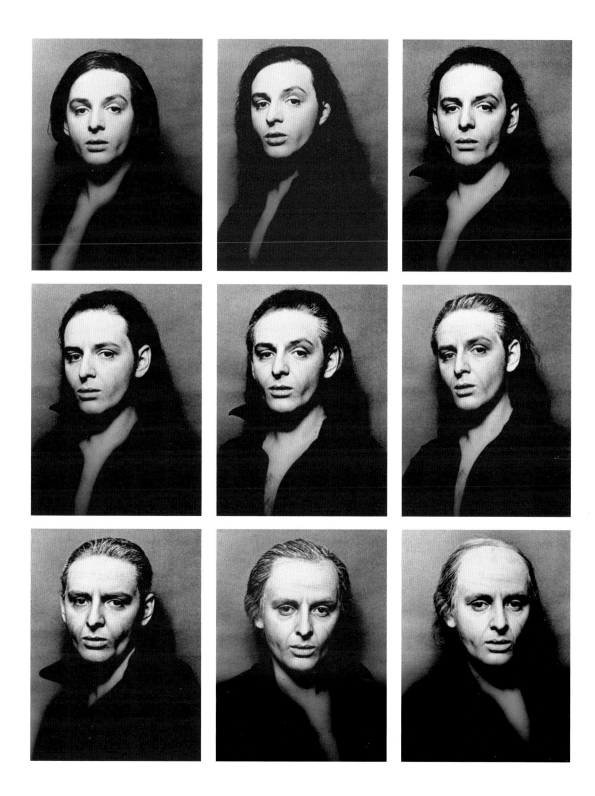

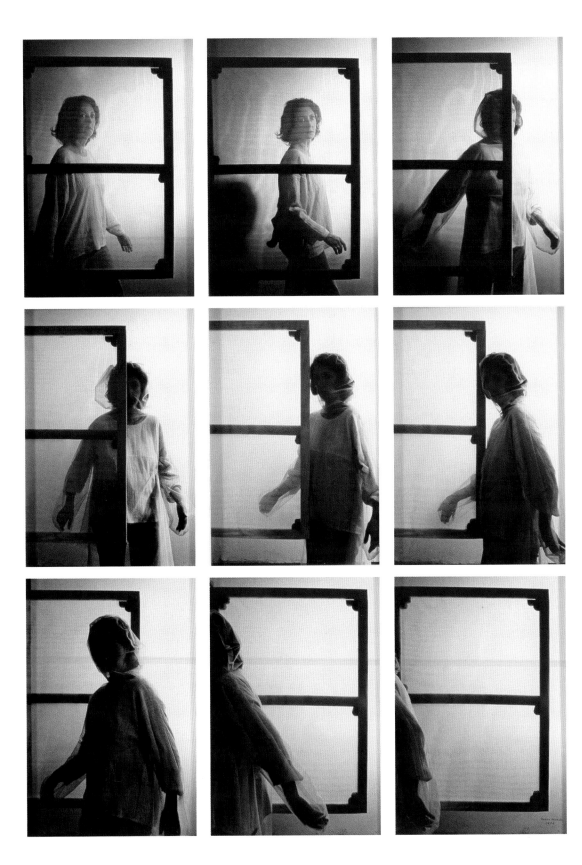

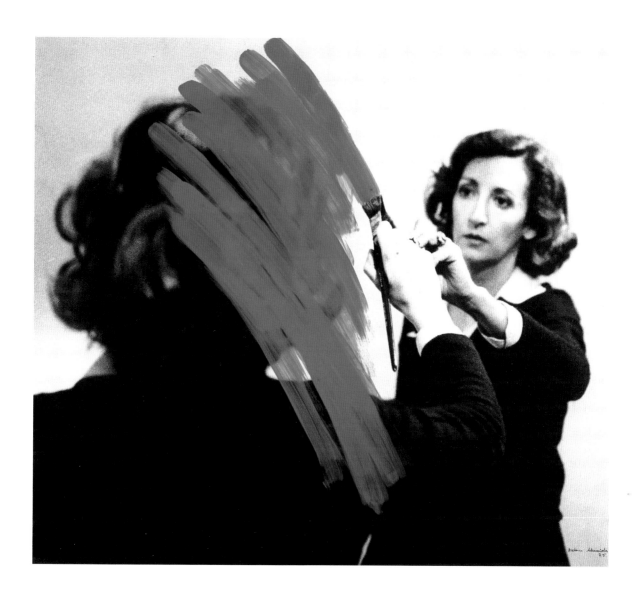

Helena Almeida
Inhabited Canvas / Tela Habitada
1976

Helena Almeida
Inhabited Painting / Pintura Habitada
1975

Edward Krasiński
Intervention 15 +
Intervention 27
1975

Edward Krasiński
Untitled
Installation view
2001

Eustachy Kossakowski
Intervention
Documentation of Krasiński's
home showing the line of blue
scotch tape
1969

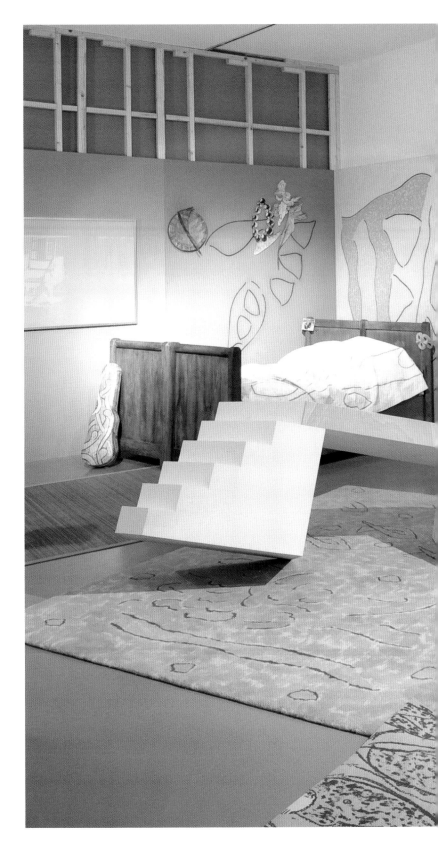

Marc Camille Chaimowicz
Table Tableau
1974

Marc Camille Chaimowicz
'*Jean Cocteau ...*'
2003–2012

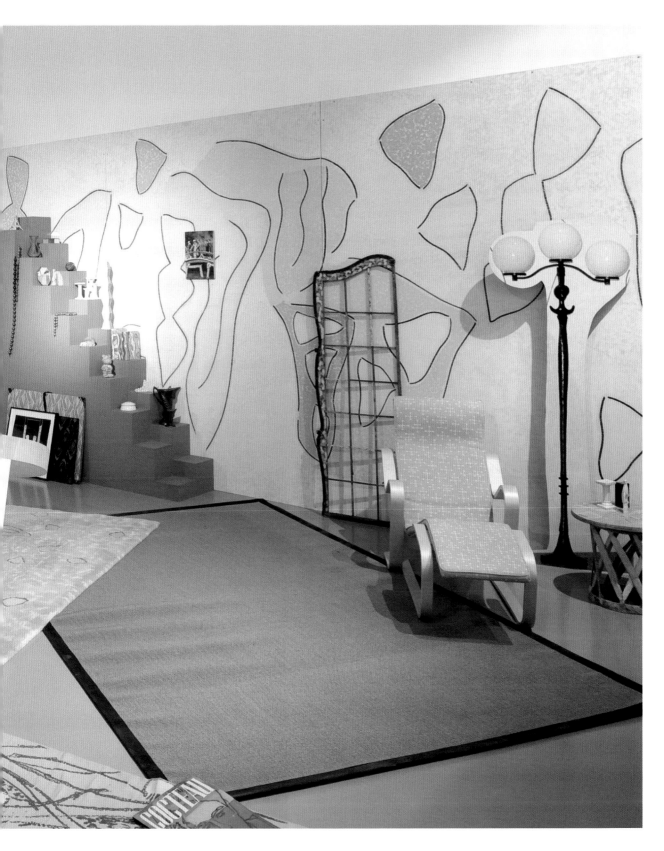

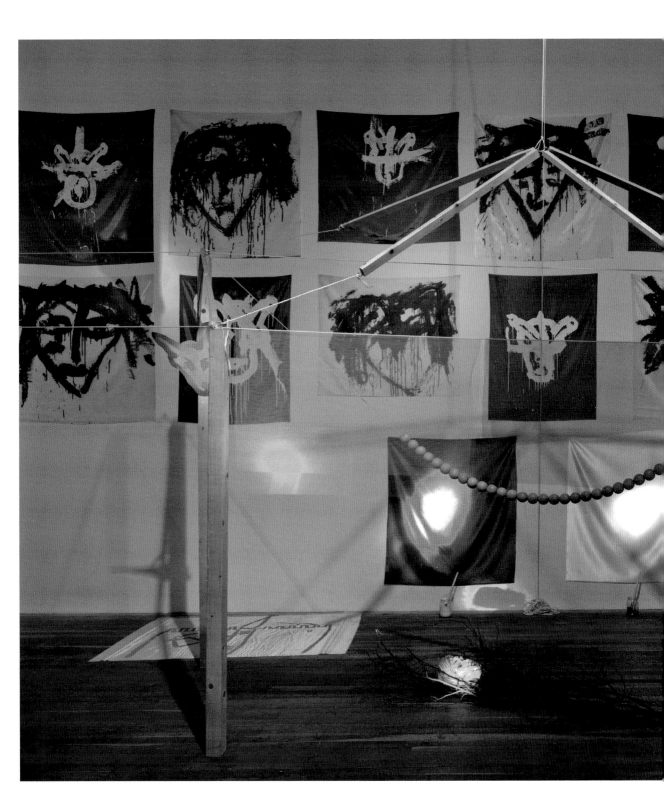

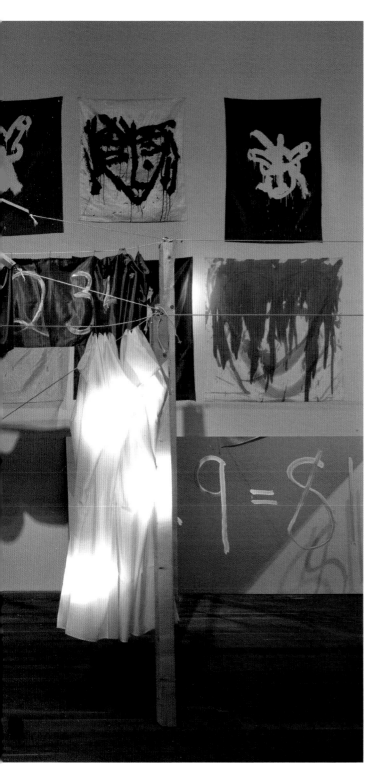

Joan Jonas
The Juniper Tree
1976 / 1994

Joan Jonas
Jonas performing *The Juniper Tree* in her loft, New York
1978

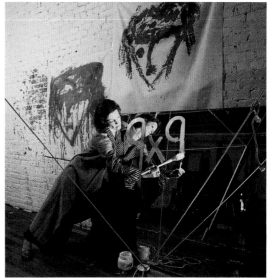

IRWIN
IRWIN in their Private View
'costumes'
1980s

IRWIN
Documentation of the exhibition
Back to the USA
1983

IRWIN
NSK Embassy Moscow / Interiors,
Left, Right, Up, Down
1992

IRWIN
NSK Embassy Moscow / Interiors,
Exorcism
1992

Karen Kilimnik
Swan Lake
1992

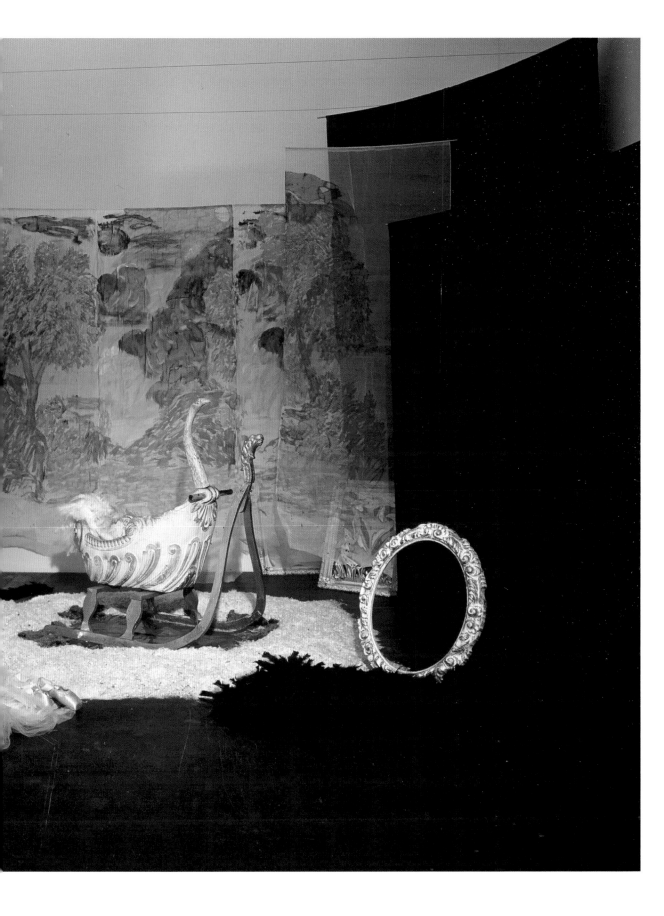

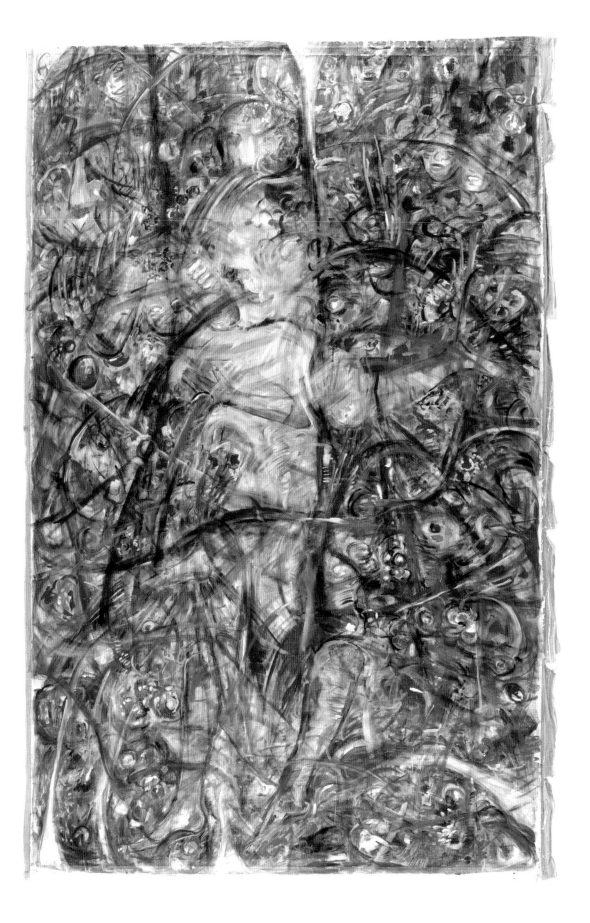

Jutta Koether
The Inside Job
(NYC, W.9th Street)
1992

Jutta Koether
The Inside Job
(NYC, W.9th Street)
Installation, New York
1992

Jutta Koether
The Inside Job /
Drawing Books I and II
1992

Grand Openings
Single's Night with Mad Garland
Documentation of performance
2011–12

Ei Arakawa and Amy Sillman
BYOF (Bring Your Own Flowers)
Documentation of performance
2007

Ei Arakawa with Jutta Koether
Single's Night
Documentation of performance
2012

Ei Arakawa
See Weeds
Documentation
of performance
2012

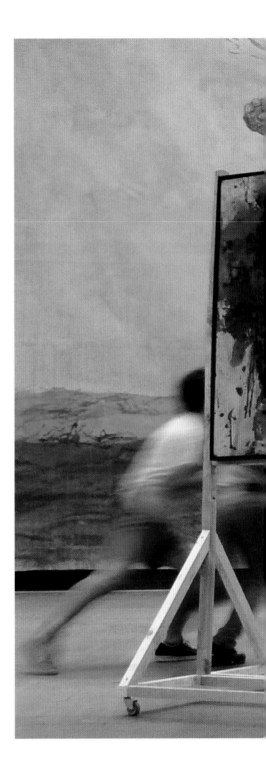

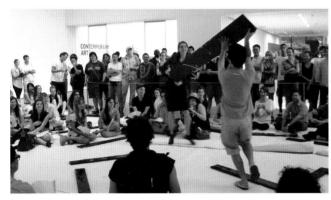

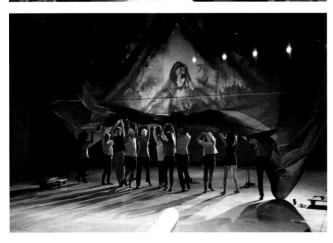

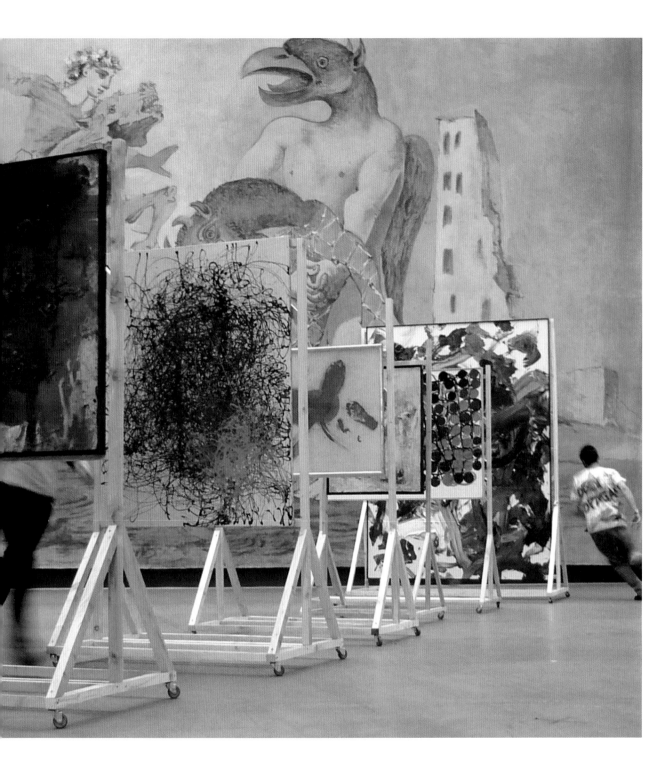

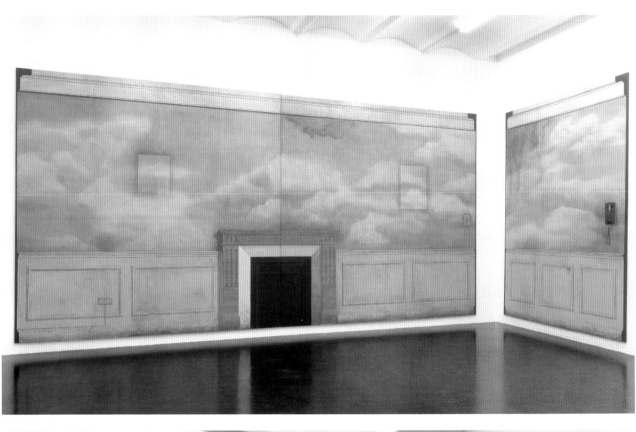
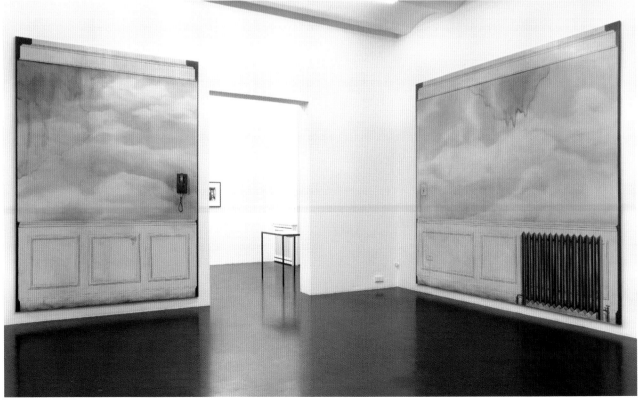

(opposite)
Lucy McKenzie
Slender Means
Installation view, Galerie Daniel
Buchholz Köln, showing paintings
May of Teck, *Kensington 2246*
and *Town/Gown Conflict*
2010

(right)
Lucy McKenzie's paintings
in Lucile Desamory's film
ABRACADABRA
2013

Lucy McKenzie
Coin de Diable Backdrop
2011

(following pages)
Lucy McKenzie
Mrs Diack
2010

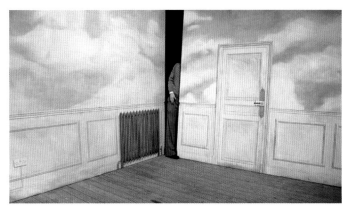

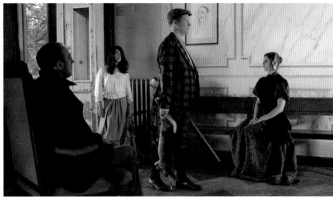

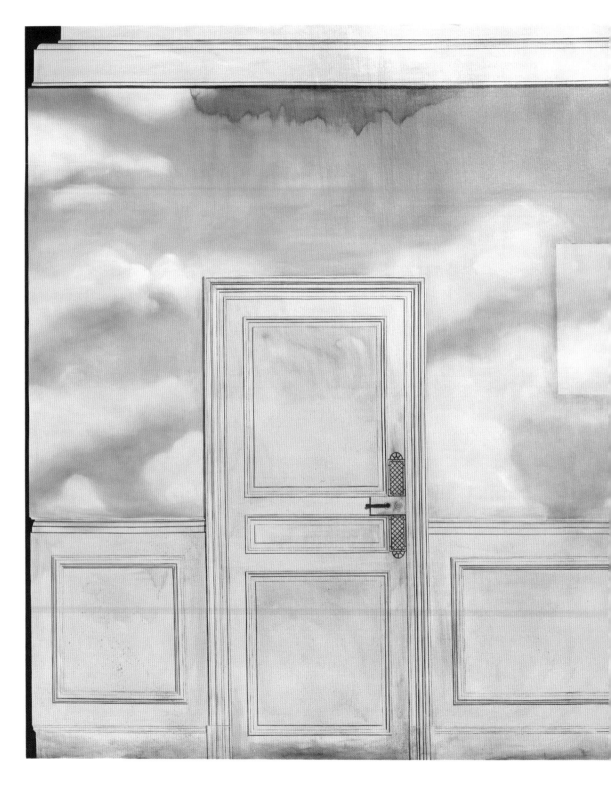

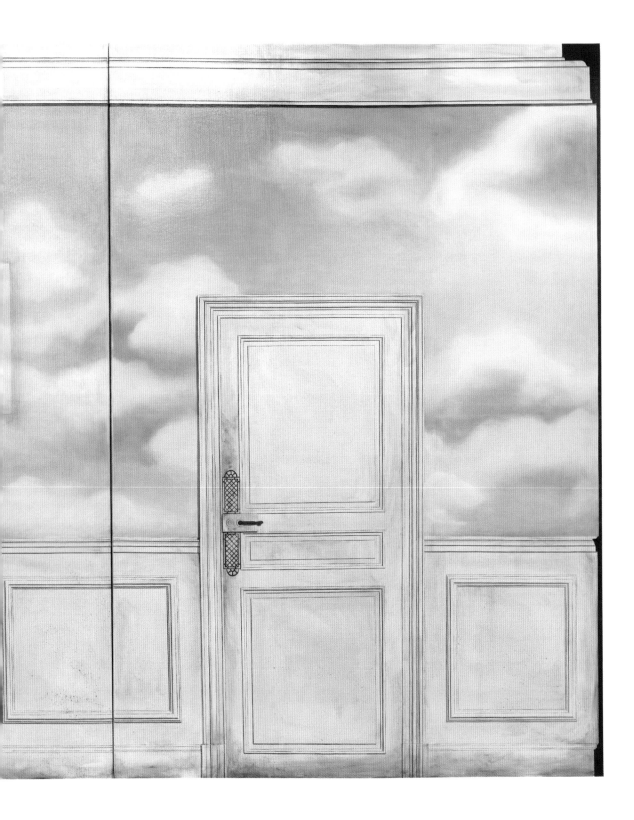

Artist Biographies

Isabella Maidment
Fiontán Moran

Helena Almeida

Born 1934 in Lisbon, Portugal.
Lives and works in Lisbon.

Since the early 1970s Helena Almeida has worked with photography as a means to explore the limits and eradicate the specificity of painting and drawing. The dominant theme throughout her practice is her own body, which appears suspended in photographic images and inscribed in vividly temporal, simulated actions. Meticulously prepared in the studio, these artificial actions are performed in front of a camera, which frames the artist's intimate interaction with a paint stroke or drawn line. Painting is imaginatively reconfigured in works such as *Inhabited Painting* 1976, in which brilliant blue acrylic paint is dislocated from the register of the artist's gestural presence to appear on the surface of the photograph itself, where it partially obscures her image. Resisting the traditional logic of the medium, painting persists in Almedia's work not as a surface, but as an act, and as a space to be lived in. [IM]

Eleanor Antin

Born 1935 in New York, USA.
Lives and works in San Diego.

Since the 1970s Eleanor Antin has explored, through performance, video, installation, and photography, the relations between art, artifice and narrative using constructed and mediated fictions. Her first videotaped performance, *Representational Painting* 1971, documents the artist engaged in the intimate ritual of applying her own make-up, and serves as a feminist critique of conventional notions of beauty and idealisation, as well as a critique of the dominance of abstract painting in relation to an emergent, alternative medium. Following this early study of self-transformation, Antin created multiple performances embedded in everyday life and based around three personae: The King, the Ballerina and the Nurse. The fictional biographies of these three alter-egos formed the substance of Antin's work for over a decade, which continues to probe issues of identity and alternative attitudes to selfhood. [IM]

Ei Arakawa

Born 1977 in Fukushima, Japan.
Lives and works in New York, USA.

Ei Arakawa's collaborative performances celebrate instability, ritual and networks of influence and exchange. Borrowing collective form and rapid construction processes from Superbowl half-time shows, Arakawa's performances are loosely choreographed within a chaotic structure. In *Eurovision 2006 as Reconstruction Mood* 2006 materials and stage were passed through the gallery window to the soundtrack of alphabetically ordered Eurovision songs, so that the production of the set became time-based architecture. Arakawa also works as a member of the New York-based artist collective Grand Openings, and the logic of group action persists in other recent collaborations with painters Jutta Koether, Silke Otto-Knapp and Amy Sillman, where the audience contributes to the work's realisation. These performances explore the 'lives of paintings inside and out', and, since these paintings are mobilised as active protagonists, 'This is,' Arakawa explains, 'painting action, not action painting'. [IM]

Geta Brătescu

Born 1926 in Ploiesti, Romania.
Lives and works in Bucharest.

Geta Brătescu was a pioneer of conceptual art and happenings in Romania, and approaches art as a subversive tool for critiquing cultural consciousness through the body and the self. The self-portrait and the studio appear as recurring themes: *Towards White* 1975 exemplifies Brătescu's ongoing exploration of the relationship between identity and space through her immediate presence: a series of nine photographs documents the artist in the process of covering the walls and contents of her studio in white paper and fabric, the final images showing her body and face camouflaged within the intimate white interior. The body is dematerialised, vanishing through and within its own abstraction – an expression of subjectivity that becomes radical in the context of a totalitarian regime. [IM]

Stuart Brisley

Born 1933 in Surrey, England.
Lives and works in London and Istanbul, Turkey.

Stuart Brisley began his career as a painter but is now considered one of the seminal figures of British performance art, as well as a key figure in the politicisation of art in the 1960s and 1970s. He was co-founder of the Artists Placement Group in 1966 and collaborated for many years with photographer Leslie Haslam, recognising the importance of documentation, because he says 'it represents a certain sort of future'. Brisley dissolves the distinction between body, painting, support, artist and viewer. For instance, in the performance *Moments of Decision/Indecision, Warsaw* 1975, he aimed to express the 'unbridgeable separation between the ideologies of East and West' by moving between pots of black and white paint – using Haslam as his eyes to direct him in 'moments of decision' – until his body and the space were covered. [FM]

Günter Brus

Born in 1938 in Ardning, Austria.
Lives and works in Graz.

Viennese Actionist Günter Brus expanded the field of expressive painting to include the body in what he termed deliberately 'artless art'. His first actions in the mid 1960s developed from an urge to give action painting a more spatial form, while directly incorporating himself. In his first public action *Vienna Walk* 1965, Brus radically subverted the conventional distinction between subject and object by painting his body and suit from head to toe in white, with a single black line as though he had been split in two, and walking through the streets of Vienna until stopped by the police. Simulated self-mutilation actions of the 1960s, such as *Self-Painting* 1964, introduced the masochistic use of an arsenal of destructive elements into painterly actions, awakening powerful associations with the horrors of the Second World War, as experienced by his father's generation. [IM]

Ivan Cardoso

Born 1952 in Rio de Janeiro, Brazil. Lives and works in Rio de Janeiro.

For over thirty years Ivan Cardoso has made films distinctive for their combination of sex, comedy and terror. Drawing on sensationalist American B-movies of the 1960s and British Hammer Horror, he illustrates his fantastical narratives with humour, gratuitous gore and nudity. Early experiments include *H.O.* 1979, a short film about the work of artist Hélio Oiticica. Here Cardoso employs surrealist film aesthetics, intercutting painted celluloid with scenes of painted faces and Oiticica's *Parangolés* to accentuate the social and painterly nature of the artworks. [FM]

Marc Camille Chaimowicz

Born 1947 in Paris, France. Lives and works in London and Burgundy.

Across his output of furniture, painting, film, wallpaper and textiles, Marc Camille Chaimowicz pursues a unifying aesthetic that references the heritage of French art, history and national identity. As a student of painting in the late 1960s, Chaimowicz sought to obscure the distinction between fine and applied arts in a series of performances and installations, which were often open-ended and exploratory. This challenge to a previously rather masculine modernism is further questioned through his use of 'feminine' pastel colours, and the playful riff on all-over abstract expressionism of his mass-produced wallpaper. In *"Jean Cocteau..."* 2003–12 Chaimowicz re-imagines the private domestic space as a dreamscape composed of fine furniture and *objets d'art*. Such compositions encourage a more intimate interaction with art objects, while drawing attention to their status as commodities and decoration. [FM]

Guy de Cointet

Born 1934 in Paris, France. Died 1983 in California, USA.

Guy de Cointet created performances and drawings that deconstructed language and recast art as a stage prop of multiple meanings. The artist began his career working as a graphic artist for Parisian fashion magazines. In the late 1960s he moved to New York, and settled in Los Angeles in 1968, in both cities working for the artist Larry Bell. His interest in the origins of language, enthused by the multi-national nature of California and popular culture, developed into works on paper that presented text through systems of cryptography as a series of shapes and forms waiting to be deciphered. This interest in the relationship between sign and language was fully realised in theatrical works such as *Tell Me* 1979 that consisted of a modernist stage set that was interacted with by glamorously attired and made-up actors, who followed non-linear narratives and performed everyday acts using abstract, painted prop-objects. [FM]

Lucile Desamory

Born 1977 in Brussels, Belgium. Lives and works in Berlin, Germany.

The films of Lucile Desamory draw on cinematic conventions to evoke the early experiments of genre film, with images humorously juxtaposed and characters slightly removed from reality. This is noticeable in early films like *Vandales et Vampires (nuits sanglantes)* 1999, which employs such strategies as silent-movie intertitles and bathing the film in a blue wash. Desamory often works in collaboration with other musicians and artists, such as Lucy McKenzie, Birgit Megerle and Luke Fowler, which has become a prominent feature in her work. She also makes collages of figures in domestic settings, often using fabric for its 'psychic, historic and sexual resonance'. In Desamory's forthcoming feature film *ABRACADABRA* 2013 Lucy McKenzie's fictive paintings serve as backdrops for imagined scenarios, creating an interesting conflation of art, design and cinema. [FM]

VALIE EXPORT

Born 1940 in Linz, Austria. Lives and works in Vienna.

In 1967 Waltraud Höllinger re-invented herself as VALIE EXPORT in order to explore identity and the role of women in society, who she considered to be a 'venue for societal relationships of power violence'. In performances of the 1960s and 1970s she turned away from her painting education and the abject experiments of the Viennese Actionists, leaving the studio for the street. Her actions were often aggressive and, like the civil disobedience that railed against conservative Viennese society at the time, subjected her body to pain and danger. Confrontational in a different way, however, *Identity Transfer* 1968 fulfilled the artist's teenage desire to act when, dressed in full 1960s regalia, she played up to the camera of Werner H. Mraz. EXPORT's recent work is less combative still, but continues her enquiries into the body by abstracting the human form via technology, drawings and text, which often develops into multi-media installations. [FM]

Pinot Gallizio
(born Giuseppe Gallizio)

Born 1902 in Alba, Italy. Died 1964 in Alba.

Following careers as an archaeologist, a botanist and a chemist, the Italian Situationist Pinot Gallizio's earliest artistic experiments led to the inception of 'industrial painting'. In 1955 Gallizio co-founded the Alba Experimental Laboratory in his family home, where industrial painting was first produced in the context of the Situationist social transformation, critiquing the labour processes of both artistic and industrial production. Produced using collaborative manufacturing processes, industrial painting expanded beyond the limits of a conventional stretcher, on rolls of canvas up to 145 metres long. In Turin in 1958 Gallizio staged an installation with models dressed in the canvases at the opening reception. Presented less as an art object than as a product and means of research, the aim was to dismantle the category of painting, supplanting it with situations capable of productively disrupting everyday life. [IM]

Sam Gilliam

Born 1933 in Mississippi, USA. Lives and works in Washington, DC.

Although Sam Gilliam's work has been associated with the experiments of abstract expressionism and, later, the Washington colour school, he was influenced by early twentieth-century experiments with form and representation in the work of Picasso, Tatlin and the German expressionists. On his move to Washington, DC in 1962, Gilliam's work developed from figuration to abstraction, and, while he used similarly vivid colours to other Washington artists, these were not set

within rigid structures, but allowed to bleed across the canvas in fluid patterns. In 1965 he became interested in how minimal artists were conflating art object and space, and so he dispensed with the stretcher and hung his wet canvas directly on to the wall, allowing the acrylic paint to drip down. Canvases were exhibited folded and distressed, taking on new sculptural and amorphous forms so that 'the surface is no longer the final plane of the work'. The dramatisation of painting as what he calls 'the beginning of an advance into the theatre of life', is evident in *Simmering* 1970, where it resembles a cape, and in the 'Jail Jungle' series of the early 1970s, where canvases are hung from clothes hangers. In later works Gilliam experimented with jazz-inspired geometric forms, collage and large draped canvases in environments that embrace 'the content of painting and sculpture through solids and veils'. [FM]

Wiktor Gutt

Born 1949 in Warsaw, The Republic of Poland (now Poland). Lives and works in Warsaw, Poland.

In the early 1970s Wiktor Gutt studied theories of Open Form under Oskar Hansen and sculpture under Jerzy Jarnuszkiewicz at the Academy of Fine Arts in Warsaw. These theories propose the replacement of traditional hierarchies of artist and viewer with inter-subjective reciprocity and interaction. Interested in non-verbal and alternative forms of communication, so-called primitive culture and its bodily expression, Gutt instigates collective projects that take conversation as a basic form of communication and creative exchange. Gutt was the first Polish avant-garde artist to treat children's artistic creation seriously and in 1972 began with Waldemar Raniszewski the 'Children's Initiations' project where he engaged children in the ritualistic and social aspects of body and face painting. In 1976 Gutt made a similar exercise with psychiatric patients in a hospital, in which he was temporarily employed. Since 1972 Gutt and Waldemar Raniszewski conducted *Grand Conversation*, a dialogic work of consecutive 'moves' between the two artists, which began with the spontaneous act of Gutt painting Raniszewski's face and have been developed to the present day with other participants, which feeds into his teaching at the Academy of Fine Arts in Warsaw. [IM]

Jack Hazan

Born 1939 in Manchester, England. Lives and works in London.

Jack Hazan's films draw on his cinematography and writing to aestheticise everyday life in a number of modes, from highly composed, abstracted scenes evocative of Hollywood cinema to deconstructive experiments associated with the French New Wave. *A Bigger Splash* 1973–4 is a semi-fictionalised account of David Hockney and his circle of friends, and was described by designer, and one of the film's co-stars, Ossie Clark as 'truer than the truth'. Scenes shot in Hockney's studio blend fact and fiction, re-imagining his paintings as a surreal artificial reality. Hockney initially disliked the film, which was made over three years and recounts his difficulty in finishing a particular painting following a break-up with his boyfriend, and it was almost banned for its frank depiction of homosexuality. Hazan's subsequent fictive reality films include *Rude Boy* 1980, about the British band The Clash, and *Comic Act* 1998, a comic-drama about the backstage antics of a group of stand-up comedians. [FM]

Lynn Hershman

Born 1941 in Cleveland, Ohio, USA. Lives and works in San Francisco.

Since the 1970s Lynn Hershman has explored the technological mediation of identity through her pioneering use of new media. Incorporating artificial intelligence and the first interactive computer-based artwork (in *Lorna* 1979–82), the works identify the individual as inscribed with social values, as well as the role of spectatorship in such constructions. In the *Roberta Breitmore Series* 1974–8 Hershman devised a fictional persona whose life she enacted for the best part of a decade. Documentation and ephemera provide an account of the contemporaneous cultural context, while tracing the various developments and foibles of 'Roberta': *Roberta's Body Language Chart* 1978 comprises annotated documents from a psychiatric session that interpret her behaviour; while *Roberta Construction Chart #1* 1975 gives detailed instructions on how to recreate her appearance. [IM]

David Hockney

Born 1937 in Bradford, England. Lives and works in London and Bradford.

As a graduate of the Royal College of Art, David Hockney was well aware of the debates around abstraction, and his early works display touches of expressionist brushwork, although these soon gave way to a crisp style on his move to California in 1963. In his iconic painting *A Bigger Splash* 1967 his adopted home of Los Angeles is depicted through an ultra-modern aesthetic, its smooth blocks of colour ruptured by a splash of carefully painted squiggles, spots and strokes. It presents a hyper-reality inflected by both mass media and singular painterly abstraction. Since then Hockney has approached representation through many media, from theatre sets to collaged photography to film to iPads. His work reflects on the 'frame' of painting, often foregrounded by theatrical curtains and edges left unpainted, while his representation of homosexuality, daring at a time when it was still illegal, exemplify how he combines fantasy and experience within the space of the canvas. [FM]

IRWIN

Collective established 1983 in Ljubljana, the Slovenian Republic of the Federal Socialist Republic of Yugoslavia (now Slovenia). Live and work in Ljubljana, Slovenia. Dušan Mandi (b. Ljubljana 1954), Miran Mohar (b. Novo Mesto 1958), Andrej Savski (b. Ljubljana, 1961), Roman Uranjek (b. Trbovlje 1961) and Borut Vogelnik (b. Kranj, 1959)

IRWIN is a collective of five painters which forms a key part of the larger artists' collective Neue Slowenische Kunst (NSK), alongside the music group Laibach, performance group Scipion Nasice Sisters (now Kozmokineticni Kabinet Noordung) and the design group New Collectivism. IRWIN work with the concept of the 'retroprinciple' by appropriating images, symbols and texts associated with the political and cultural history of Slovenia, testing the limits of art and political categories in order to reflect on global concerns. In *Back to the USA* 1984 IRWIN recreated a touring exhibition of American contemporary art that had been presented that year at several venues throughout Western Europe. The IRWIN show, however,

comprised artworks based on reproductions from the exhibition catalogue. In 1992, just after Slovenia declared itself an independent state, IRWIN (in collaboration with Eda Čufer and with the participation of most of the NSK members) established *NSK Embassy Moscow* – where, dressed in characteristic formal suits and surrounded by their art, they held court and organised public events and discussions in a private apartment in Moscow. The one-month residency concluded in *Black Square on the Red Square* 1992, a performance in which a large black cloth was laid out on Moscow's Red Square. Later that year NSK created the NSK Država v casu [NSK State in Time], a boundary free state that exists in time and not in space, and is open to any who wishes to join. [FM]

Sanja Iveković
Born 1949 in Zagreb, Socialist Republic of Croatia, Federation of Yugoslavia (now Croatia). Lives and works in Zagreb, Croatia.

Sanja Iveković graduated from her studies in the midst of the Croatian Spring, a political movement of the early 1970s instigated by poets and linguists that demanded improvements in human rights and rejected officially sanctioned art in favour of emerging conceptual practices. For Iveković, the rejection of painting led to the creation of feminist, minimal works that employed collage, video and performance to examine gender, identity and memory. In *Tragedy of a Venus* 1975–6 she demonstrates how women are represented and consumed in the media by pasting magazine clippings of the actress Marilyn Monroe next to equivalent photographs from her own life. The concept of femininity is explored in video *Make-up – Make-down* 1978, where Iveković slowly fondles make-up, without ever revealing her face. After the fall of the Berlin Wall in 1989, and the subsequent dismantling of communist states, the artist turned her attention to post-socialist politics. She installed in Luxembourg, in close proximity to a war memorial, *Lady Rosa of Luxembourg* 2001, an eight foot-high sculpture of the Marxist activist as a pregnant goddess. The statue was intended as a challenge to dominant representations of gender and historical figures, and generated public furore. [FM]

Derek Jarman
Born 1942 in Northwood, London, England. Died 1994 in London.

From 1963–7 Derek Jarman trained as a painter at the Slade School of Art and Design, but found the environment rather sterile. He subsequently sought a more collaborative way of working, which, among other projects, led to him designing the sets for Ken Russell's film *The Devils* 1971 – and it was in film that Jarman found the social and artistic integration that he craved. His own early Super8 films use the painterly devices of montage, colour filters, multiple exposures and cross-fading to document the world around him; while later films explore art, religion, history and sexuality through more representational means. *Miss Gaby – I'm Ready for my Close-up* 1972 documents a glamorous woman strutting around an elaborate set by Andrew Logan, artfully brushing her hair and dabbing at her make-up compact as if it were a paint palette; and in *Caravaggio* 1986 art is represented as an extension of life, taking the Baroque paintings as prompts for imagined scenarios and conversations. In Jarman's final film, *Blue* 1993, abstraction and real life combine, as he eloquently narrates his experience of AIDS to a screen of saturated blue. [FM]

Joan Jonas
Born 1936 in New York, USA. Lives and works in New York.

In the late 1960s, feeling that the possibilities of sculpture and painting were limited when it came to representing and transforming the female body, Joan Jonas became a pioneer of performance and new media, often repurposing traditional art media and symbolic images in a theatrical context. Her collaborative and open-ended manner of working often develops drawing, mythical narratives and minimalist gestures and poses into multi-media pieces. *The Juniper Tree* 1976/1994, considered a transitional work in her career, began as a collaborative theatrical adaptation of the Brother Grimm's fairytale, developed into a solo performance and then, finally, into an installation comprising flag-like canvases daubed with painted symbols, an elaborately embroidered Kimono, a painted mask, tree branches and a small slide projection of the performances that had taken place within this setting. [FM]

Karen Kilimnik
Born 1955 in Philadelphia, USA. Lives and works in Philadelphia.

Karen Kilimnik casts herself as a playwright creating characters, her love of ballet ushering in theatrical components, which is in turn tempered by crude painting techniques and pop-culture subjects. The combination of the real and the imagined is a key component of *The Hellfire Club Episode of the Avengers* 1989, where drawings and pop paraphernalia, arranged across the floor and walls in a haphazard array of media, become performative and painterly. This was developed further in installations such as *Paris Opera Rats* 1991 and *Swan Lake* 1992, where theatrical conventions, such as dry ice and schematised landscapes, dramatise her embrace of concepts of femininity, particularly in relation to the decorative. Kilimnik's interest in glamour, romanticism and naive forms of painting extend into small-scale drawings and paintings of fashion and celebrity figures such as Kate Moss, while her use of text and elaborate titles are used as a means of opening up the image to fantastical and excessive possibilities. [FM]

Ku-lim Kim
Born 1936 in Dae-Gu, Korea (now South Korea). Lives and works in Seoul, South Korea.

Ku-lim Kim's work questions the fundamental procedures of art making, asking that the creative act be redefined in relation to the world at large. In 1970 Kim orchestrated the painting action *From Phenomenon to Traces* – the first public conceptual artwork in Korea. Oil was poured into large, triangular ditches along the banks of the Han River then set on fire, temporarily scarring the landscape. Over time the site returned to its former state, leaving no evidence. The performance reveals a critical component of Kim's practice: the emergence of form, independent of the artist's absolute control. This strategy may be traced from his performances of the late 1960s and early 1970s, such as *Body Painting* 1969, to his painting, mail art and mixed-media work with everyday objects. Unbound by medium, art becomes a space of action, with Kim working as the instigator of situations devised to alter modes of perception. [IM]

Yves Klein
Born 1928 in Nice, France.
Died 1962 in Paris.

In 1960 Yves Klein and critic Pierre Restany founded *nouveau réalisme*, a French art movement that rejected lyrical abstraction and figuration in favour of bringing art and life closer together. For Klein making art was not solitary, but a spectacle intended to make painting active and metaphysical. Among his varied propositions was the trading of zones of immaterial space for gold and making monochrome paintings by dragging nude models, or 'living brushes', across a canvas. Klein's ranging output can be related to many developments in twentieth century art, such as abstract expressionism, institutional critique, minimalism, conceptual, performance and installation art. In 1957 he registered a bright ultramarine blue and named it International Klein Blue. Although a canny self-promoter, much of his work was influenced by Zen philosophy and the concept of the void. This was epitomised in a doctored photograph that appears to show him fearlessly leaping from a high ledge. [FM]

Jutta Koether
Born 1958 in Cologne, The Federal Republic of Germany (now Germany). Lives and works in New York, USA.

Jutta Koether works as a painter, writer, musician and critic, defying easy categorisation through her interdisciplinary approach. Her painting practice is metonymic of this, as, since the 1980s, she has challenged genres and dominant paradigms and tastes. Her paintings are often strategically deployed as independent performers within an experimental *mise-en-scène*, so that they might shape actions and produce social situations. David Joselit has described them as being 'transitive', in that they serve as nodes within a social network. *Black Bonds* 2002, a collaboration with Steven Parrino, combined noise performances with an installation of artfully destroyed 'failed paintings', which had been deemed unsuccessful and over-painted in black. For *The Inside Job (NYC W.9th Street)* 1992 Koether reconstructed a studio in an apartment in Manhattan and covered the floor with a single painting in progress. Visitors were invited, during scheduled appointments, to encounter the painting and leave their responses in a comments book. [IM]

Eustachy Kossakowski
Born 1925 in Warsaw, Poland.
Died 2001 in Paris, France.

Eustachy Kossakowski began his career as a photographer in 1957, documenting socialist Poland for national periodicals, and working for some forty-five years, first in Poland and later in France. He was instrumental in chronicling the Polish art scene in the 1960s, particularly the activities of the influential Foksal Gallery in Warsaw and seminal works such as Tadeuzs Kantor's happenings and theatrical performances. In 1964 Kossakowski began to collaborate with Edward Krasiński, documenting his spatial explorations, installations and actions in his atelier. A recurring theme in Kossakowski's photography was the capture of the 'active environment' of independent exhibitions, alternative galleries, performances and happenings, which persists today as an invaluable distillation of artistic experimentation. [IM]

Edward Krasiński
Born 1925 in Lutsk, province of Volhynia, Poland (now Ukraine). Died in Warsaw, Poland in 2004.

Oscillating between painting, sculpture and installation, Edward Krasińksi's practice playfully manipulates the conventions of representation. In the late 1960s he came across a roll of blue plastic Scotch tape, which was to become his signature material and with which he would draw lines that act or perform an operation, animating objects, spaces and circumstances that might otherwise be overlooked. In 1970 he made one of his earliest spatial interventions by sticking tape to the walls of the Musée d'Art Moderne de la Ville de Paris courtyard, leaving the windows clear. That same year, when artworks due to be exhibited at the Tokyo Biennale failed to arrive, he sent the word 'BLUE' by telex five thousand times, the exhibited perforated strip being the first conceptual artwork to be made in Poland. In *Untitled* 2001, a series of mirrors hang from the ceiling, Krasińksi's blue line going through them and the perimeter of the room: thus, the viewer is reflected in the image plane and becomes intertwined with the blue line and the space. [IM]

Kurt Kren
Born 1929 in Vienna, Republic of Austria (now Austria). Died 1998 in Vienna, Austria.

Kurt Kren began making experimental structural films in the early 1950s, deploying montage and serial flash editing to counter the illusion of narrative film. In the 1960s he collaborated with Viennese Actionists Otto Muehl and Günter Brus to produce 16mm films of their actions, such as the 1964 film of Muehl's twelfth material action, *Mama und Papa*. Here causality is disrupted by the chopping and changing of the order of sequences, liberating the film from its documentary status, so that it is no longer a representation of a prior and prioritised reality. Throughout Kren's films the reworking of fractious, repetitive imagery creates an alternative present as vivid, visceral and unsettling as the actions they relate. [IM]

Yayoi Kusama
Born 1929 in Matsumoto City, Nagano Prefecture, Japan. Lives and works in Tokyo.

While the work of Yayoi Kusama can be singularly characterised as viral fields of dots covering painting, clothing, installation and performance, it has encompassed many of the art movements of the 1960s and 1970s. Kusama studied *Nihonga*, the traditional Japanese style of painting, but, following early exhibitions in Tokyo, she felt the need for a wider audience and so moved to New York in 1957. Her practice soon adopted the dominant large canvases of the time, her 'infinity nets' comprising small painted dots spread across their surface. In the film *Flower Orgy* 1968 she is seen painting naked figures with coloured spots to create a living, expanded painting; while for *Walking Piece* 1966, documented by Eiko Hosou, the artist herself wandered the streets of New York dressed in a kimono, pressing home her outsider status as a female Japanese artist in the masculine New York art scene. Returning to Japan in 1973, Kusama worked as an art dealer. She later admitted herself to a psychiatric hospital, where she has remained ever since, establishing a literary career and, more recently, returning to making hallucinatory installations. [FM]

Kang-so Lee

Born 1943 in Daegu, Korea (now South Korea). Lives and works in Seoul, South Korea.

Kang-so Lee's search for an expressive form capable of communicating the essence of contemporary life began in the 1970s with a series of pioneering performances and installations. For his first solo exhibition in Seoul in 1973 he turned the gallery into a temporary bar for a week; at the 1975 Paris Biennale he covered the floor with plaster powder and presented a single, live chicken tied to a stake at its centre so that it created a circular pattern. Incompleteness and the anticipation of an event are recurring themes that Lee extends to painting, which, while dominant in his practice since 1985, is diversified through an emphasis on process and procedure, and the conscious invitation of spontaneity and coincidence. [IM]

Andrew Logan

Born 1945 in Oxford, England. Lives and works in London.

Shards of mirror are key to Andrew Logan's jewellery, portraiture and sculpture, as the fracturing of light and imagery that they produce reflects his sense of art and life as joyfully intermingled. In 1969 he transformed his Oxford bedroom into an outdoor garden with painted clouds, a lamp in the form of a giant papier-mâché daffodil and Astroturf flooring, and in *Reflections* 1977 performance and painting collided when a tap-dancer danced on (and cracked) a Mondrian-styled mirror. Logan subsequently became renowned for throwing theatrical parties in his glass-roofed, brightly coloured London home and studio. Many of these performative environments and events were documented by his artist friends, such as painter Johnny Dewe Mathews and photographers Mick Rock and Robyn Beeche. His Downham Road studio in East London also provided the setting for many films by Derek Jarman, and one party became the first incarnation of Logan's mass performance event *The Alternative Miss World* 1972–present, as featured in Jack Hazan's *A Bigger Splash* 1973–4. [FM]

Urs Lüthi

Born 1947 in Lucerne, Switzerland. Lives and works in Munich, Germany.

Urs Lüthi's work questions the status of portraiture through performance, installation, painting and graphic design. In 1969, after studying at the School of Applied Arts in Zurich, Lüthi turned to photography and attracted critical attention with a series of self-portraits that reference androgynous musicians and night clubbers, as well as Hollywood photography of the 1940s. Lüthi was a key artist in the influential exhibition *Transformer: Aspekte der Travestie* in Lucerne in 1974, which exhibited new experiments in performance art, glam rock and drag. In *Just another story about leaving* 1974 he reworked the idea of travestying appearance, this time by way of aging, as his still effeminate face appears weathered and framed by thinning white hair. Recent work has continued to use his own body as source material, as in *Art for a Better Life*, for instance, performed on a running machine at the 2001 Venice Biennale. [FM]

Lucy McKenzie

Born 1977 in Glasgow, Scotland. Lives and works in Brussels, Belgium.

Employing nineteenth-century *tromp-l'oeil* techniques and aesthetics, Lucy McKenzie's architecturally scaled installations are often stage set-like and incorporate furniture, such as her 'Quodlibet' table series. Her paintings, like her murals, might transform a neutral site into a fantasy dwelling; but painting for McKenzie is ultimately a means to an end, and its status varies throughout her diverse range of interdisciplinary projects and collaborations. In 2003 she ran, with Paulina Olowska, Nova Popularna, a temporary salon, illegal bar and performance space in Warsaw. Striving to exist both outside and inside the art world in new ways, McKenzie runs the record label Decemberism and is the co-founder, with fashion designer Beca Lipscombe and illustrator Bernie Reid, of the interior design company Atelier. They state that their aim is 'to bring fine art criticality to the realm of commercial design and by extension apply the expertise and practicality of the applied arts to exhibition and object making'. [IM]

Ana Mendieta

Born 1948 in Havana, Cuba. Died 1985 in New York, USA.

In 1973 Ana Mendieta turned away from painting because it was not 'real enough', instead performing to camera, as documented by her university tutor Hans Breder in the series 'Silhuetas'. As Mendieta described: 'I wanted my images to have power, to be magic. I decided that for the images to have magic qualities I had to work directly with nature.' While referencing land art, the 'Siluetas' series brings, via the performative body, feminist issues into a predominantly masculine arena. In *Self-Portrait with Blood* 1973 and *Body Tracks* 1974 Mendieta drew on her Catholic upbringing, Cuban heritage and recent exposure to the Viennese Actionists, where blood is symbolic in complex and contradictory modes. Mendieta's desire to create an art that was rooted in nature and identity eventually led her back to Cuba, where she made *Rupestrian Sculptures* 1981, semi-figurative forms carved into the soft rock caves of Jaruco Park. [FM]

Mario Montez (born René Rivera)

Born 1935 in Ponce, Puerto Rico. Lives and works in Florida, USA.

Mario Montez grew up in New York and became one of the key participants in the city's underground art scene of the 1960s and 1970s, working with Andy Warhol and Jack Smith. Montez studied print and graphic arts at the New York School of Printing, but earned his living in a series of office jobs. Montez first film role was in Smith's infamous *Flaming Creatures* 1963 (credited as Dolores Flores), where in full costume and caked-on make-up, he danced and performed at an orgiastic party. After which he christened himself 'Mario Montez' – a pun on the 1940s adventure film actress Maria Montez – who Smith and Montez greatly admired. He also worked with Theatre of the Ridiculous founder Charles Ludlum, who described Montez as 'the guru of drag … whether he is playing the wife, the mother, the whore or the virgin, Montez captures the ineffable essence of femininity'. Montez was acutely aware of the mechanics of

glamour, only appearing in drag when performing. In 1972 he starred, with artist Antonio Dias and actress Cristiny Nazareth, in Hélio Oiticica's unfinished film *Agripina é Roma-Manhattan*, where he is again shown in full drag, rolling dice in the middle of a busy Manhattan road. In January 1977 Montez moved to Florida, removing himself from the public eye; although he has reappeared in recent years in occasional performances and symposiums. [FM]

Otto Muehl
Born 1925 in Burgenland, Austria.
Lives and works in Faro, Portugal.

Otto Muehl is primarily known as a Viennese Actionist, working during the 1960s alongside Günter Brus, Hermann Nitsch and Rudolf Schwarzkogler. Muehl focused on the destruction of painting through actions that were described by him as 'like a psychosis, produced by the mingling of human bodies, objects and material … painting not as a means of colouring, but as goo, liquid, dust'. The idea of art having a therapeutic component may be connected to his experience of working as an art therapist in a home for emotionally disturbed children. At this time he also produced ironic paintings of celebrities and expressed views on art in his magazine *Zocka*. In the 1970s Muehl withdrew from art and founded a commune called the Actions Analytical Organisation (AAO). This lasted until 1991, when he was imprisoned for drug offences and 'engaging in sexual intercourse with minors, illicit sexual acts, rape'. On his release in 1997 he made a series of paintings that continued earlier parodies of fauve and pop art, and devised new electronic forms of painting. [FM]

Hans Namuth
Born 1915 in Essen, Germany.
Died 1990 in East Hampton, USA.

In the 1930s Hans Namuth fled Nazi Germany for France, where he worked at a portrait photography studio and later as a photojournalist. With the outbreak of war, he moved to the USA, where he joined the army and worked with the intelligence forces. Later, when living in New York, he returned to photography as a hobby, which developed into freelance work. On the recommendation of a teacher, he asked to take photographs of Jackson Pollock, who eventually agreed. In the images Namuth captures Pollock seemingly dancing across his canvas, slinging and dripping paint from a can – an image that is now synonymous with Pollock's paintings themselves. Following the success of these photographs Namuth made, with filmmaker and fellow German émigré Paul Falkenberg, *Jackson Pollock '51* 1951, a documentary of Pollock in and outside his studio. Namuth produced iconic photographs of many other artists too, including Willem de Kooning, Frank Lloyd Wright and Stephen Sondheim. [FM]

Hermann Nitsch
Born 1938 in Vienna, Austria.
Lives and works in Gänserndorf, Lower Austria.

Of all the Viennese Actionists Hermann Nitsch is most firmly and consistently associated with ritualistic acts of creation, which can be attributed to his training in traditional church painting, his study of psychoanalysis and admiration for the German philosopher Friedrich Nietzsche. Also inspired by the gestural violence of the abstract expressionists in America, Nitsch expanded painting into actions. In *Poured Painting* 1972 he poured bright red paint directly onto a canvas to evoke dripping blood – a motif that he has used, repeated and extended to the use of animal blood in his actions. After having exhibitions closed and being repeatedly arrested and imprisoned for his actions, Nitsch moved to Germany until 1973, where his exhibitions and performances continued to be challenged by authorities. During this period he finally found a home in Prizendorf Castle for his ongoing *Orgien Mysterien Theatre*, conceived in 1957. This ritualistic performance has been staged in different forms, but is ostensibly a mass spectacle involving intoxicated participants trampling through animal carcases and performing sacrificial bloody actions. Nitsch also worked with more traditional forms of theatre in 1995, when he directed and designed sets and costumes for Jules Massenet's *Hérodiade* at the Vienna State Opera. [FM]

Hélio Oiticica
Born 1937 in Rio de Janeiro, Brazil.
Died 1980 in Rio de Janeiro.

Hélio Oiticica was a key figure in Latin American art and the *Tropicália* movement, which revolutionised popular music and the arts in the 1970s. Influenced by modernism, Oiticica's work of the 1950s used bright, primary and secondary colours in geometric formations, and he further developed his interest in colour theory and theatre in installations that invited viewers to walk through deconstructed abstract paintings. In 1964 Oiticica created his *Parangolés* – painted capes to be worn, as featured in Ivan Cardoso's 1979 film *H.O.* In 1970 Oiticica moved to New York, where he met Jack Smith, who was experimenting with drag, performance and art. Oiticica coined the term 'tropicamp' to characterise the work of Smith and his drag-star Mario Montez, and subsequently developed his own interest in painting as a social activity through performance and film. [FM]

Luigi Ontani

Born 1943 in Grizzana Morandi, Italy. Lives and works in Rome.

Luigi Ontani began his career just as *arte povera* was emerging in Italy to challenge traditional art forms. But whereas *arte povera* employed found industrial materials and a minimalist aesthetic, Ontani used his training as a painter and sculptor at the Academy of Fine Art in Bologna to explore the male form through a series of performances and painted photographs. In a series of *tableau vivants*, made between 1969 and 1989, he photographed himself as hero, deity or martyr in imaginary landscapes, often adding paint to enhance the artificial nature of the scene. In 1974 he participated in the influential exhibition *Transformer: Aspekte der Travestie*, where he performed *Tarzan*, lying half-naked on a pedestal with Tarzan books and a tape recorder playing the noise of wild beasts. In later years Ontani has continued to explore representation through installations that include painted masks, porcelain casts and photographic recreations of famous artworks in gilded Italianate frames. [FM]

Ewa Partum

Born 1945 in Grodzisk Mazowiecki, The Republic of Poland (now Poland). Lives and works in Berlin, Germany.

Ewa Partum's conceptual, feminist performances, films and installations developed from a training in painting to address issues of representation and language in what she calls 'active poetry'. In *Change – My Problem is the Problem of a Woman* 1979 one half of the artist's body is painted as if aged, the other left in its younger state. Such comments on beauty, the nude and the status of the female artist continued in Partum's controversial 1980 exhibition *Self-identification* in Warsaw's Mala Gallery, where, in a series of photographs of the host city, Partum superimposed her body to create a strange disjunction between real and imagined environments. Following the imposition of martial law in the 1980s in Poland, Partum moved to Berlin, where she has remained ever since. [FM]

Wang Peng

Born 1964 in Shangdong Province, China. Lives and works in Beijing.

Working with installation, performance, photography and the internet, Wang Peng challenges perceptual habits and assumptions, and, in 1984, created the first performance to be made in China. He poured ink onto his naked body and imprinted it onto sheets of rice paper – an act which, executed in a context where this was considered politically subversive, served to counter systemic structures and aesthetic conventions. Avoiding the use of political slogans and explicit narrative, Peng's practice is characterised by concisely executed visual abstraction and the analysis of social rhythms. For his solo exhibition at the Gallery of Contemporary Art in Beijing in 1993 he bricked up the entrance to the gallery, creating a single, simple work that directly confronted the intense cultural and political atmosphere in China at the time. [IM]

Jackson Pollock

Born 1912 in Wyoming, USA. Died 1956 in East Hampton, New York.

In post-war New York new forms of representation gradually developed into abstract expressionism, characterised as large canvases with expressive paintwork. Jackson Pollock's painting was also informed by Pablo Picasso and Mexican mural painters, and so, through the introduction of liquid paint in 1936, and with the encouragement of art critics and collectors like Clement Greenberg and patron Peggy Guggenheim, he developed an 'all-over' painting style that drew attention to the painting as an object. His new technique of dripping and pouring paint was considered a breakthrough, his large-scale, intricate webs of line and colour creating a sensation. Cecil Beaton used them as backdrops for a fashion shoot, while *Life* magazine asked: 'Is this the greatest living painter in the United States?' Pollock himself described his manner of working as 'expressing an inner world', which encouraged interpretations of American freedom and existential angst. His influence spread by way of Hans Namuth's magazine photographs, which captured the artist 'dancing' around the canvas and prompted critic Harold Rosenberg to suggest that Pollock had inadvertently recast the canvas as an 'arena in which to act'. For Pollock all this distracted from his primary concern – the painting as an object – and so he moved away from the drip technique in later work. [FM]

Waldemar Raniszewski

Born 1947 in Warsaw, The Republic of Poland (now Poland). Died 2005 in Warsaw.

Waldemar Raniszewski studied in the early 1970s at Warsaw Academy of Fine Arts as a student in Jerzy Jarnuszkiewicz and Oskars Hansen's atelier. In 1974 he received his degree, on 'The Body as a Medium of Aesthetic Message', a subject that came to define his field of interest. From 1972 to 1980 with Wiktor Gutt and others, he devised *Destructive Culture*, *Great Conversation*, and the project 'Children's Initiations' where he drew upon the rituals and imagery of so called primitive and tribal culture in order to develop a new open ended form of communication. In *Great Conversation* Raniszewski responded to Gutt painting on his face by making a precise replica on a wooden mask, transferring this personal action into one that can be experienced by others. This interest in creating a collective experience of art was further developed in the 1981 action, *Expression on a Face*, which involved Raniszewski, Gutt and many of their friends painting people at the Rockowisko music festival, leading to some participants being arrested and forced by the police to wash it off. [FM]

Niki de Saint Phalle

Born 1930 in Neuilly-sur-Seine, France. Died 2002 in California, USA.

For Niki de Saint Phalle action was of prime importance, since it 'is the only thing that lives because everything is dead afterwards'. She intuitively employed a range of media and imagery that drew on autobiographical and wider social sources, while assimilating some of the new experiments of the *nouveau réalists* and recent American art. In *Saint Sébastien/Portrait of my Lover* 1961 Saint Phalle used an archery target for a head and parodied the drip technique of Pollock over a man's shirt. Her renowned series of shooting paintings – canvases embedded with sacks of paint that 'bled' as she shot them – also served to anthropomorphise the work. Plastic toys incorporated into canvases anticipated some of the feminist tropes of the late 1960s, but Saint Phalle then turned away from aggressive experiments, in favour of boldly coloured female figures, called Nanas, as well as films, books, set design and the mosaic sculpture garden *Tarot Garden* 1998. [FM]

Rudolf Schwarzkogler
Born 1940 in Vienna, Austria.
Died 1969 in Vienna.

Unlike other members of the Viennese Actionists who performed very public actions that resulted in painterly, messy environments, Rudolf Schwarzkogler created private actions that were highly composed and drew on his appreciation for early Austrian expressionism, Romanticism and symbolism. This restraint was present in his early graphic works and paintings, and continued into his minimal approach of using found materials in his paintings and actions. Schwarzkogler was not comfortable with performing his actions in public, with only *Hochzeit* [Wedding] 1965 being performed to a select audience. This meant he was able to fully control the aesthetic and symbolic meaning behind his actions, and insisted that they be documented in black and white photographs. Many of the actions took place in a white environment evocative of an operation room and depicted gutted fish, razor blades and bound body parts that were juxtaposed to suggest violence and painful psychological states. Schwarzkogler only made six actions in total, later drafting scores for future actions and panorama-style environments that were never realised. After a long period of depression and anxiety he died from falling from his apartment window. [FM]

Wu Shanzhuan
Born 1960 in Zhoushan, Zhejiang Province, China. Lives and works in Hamburg, Germany and Shanghai, China.

Wu Shanzhuan is considered one of the leading Chinese conceptual artists of the 1980s. His paintings and performances rethought the relationship between text and image, and have been compared to action painting and graffiti. Shanzhuan finished his studies at the Chinese Academy of Fine Arts at a rare time when the state was allowing and enabling students' experimentation. In 1986 Shanzhuan began his 'Red Humour' series of installations, which played on the large-format iconography of the Chinese Cultural Revolution. In *Today No Water* 1986 he covered walls with words associated with the Revolution, Buddhist scripture, advertising and Western art history and in doing so stripped them of their meaning. China's return to a more repressive system of governance was immediately evident when Shanzhaun's performance *Big Business* 1989 – where he sold prawns at the National Art Museum as a comment on the value of artistic labour – was shut down. He then went to live and work in Germany and Iceland, where he collaborated with the Icelandic artist Inga Svala Thorsdottir on performances and installations. His interest in the relationship between image and text continued in his painted graphic novel series *Today No Water* 2007, where each canvas is made up of fragments of images that obscure any narrative. [FM]

Cindy Sherman
Born 1954 in New Jersey, USA. Lives and works in New York.

Cindy Sherman is associated with the 'Pictures' generation – a group of artists using minimalist and conceptual practices to examine photographic or media imagery in the late 1970s in New York – and achieved critical and commercial success with her series *Untitled Film Stills* 1977–80. Here over one hundred photographs depict Sherman in various settings and costumes, evocative of, but not directly based on, cinematic scenes. Made at a time when photography as an art form was being reconsidered, the images examine how women are represented in popular culture. Sherman had abandoned painting in favour of the immediacy of photography while still at university, her early work exploring role play in studio portraits based on people seen on the street, and often involving make-up and costume to explore issues of gender, class, masquerade and performance. In the 1980s she explored colour in grotesque landscapes and made crude reconstructions of art-historical paintings, while her interests in women and horror coalesced in her only feature film to date, *Office Killer* 1997. [FM]

Shozo Shimamoto
Born 1928 in Osaka, Japan. Lives and works in Nishinomiya.

Shozo Shimamoto, a prominent member of the Gutai group from 1954–71, created high-velocity action paintings in dynamic performances that emphasised the aspect of chance. Time, too, has been important for Shimamoto as a means to move painting beyond the conventions of geometric abstraction. At the first open-air Gutai art exhibition in Tokyo in 1955 he performed *Work (Created by Canon)*, in which he shot oil paint from a canon onto a canvas, bringing paint and the pictorial plane explosively together. In 1956 he developed his signature technique of hurling glass jars of paint at an unstretched canvas laid on the ground. The visceral, glass-encrusted paintings become a record of the physical performance, emphasising the primacy of the act over the eventual object. [IM]

Kazuo Shiraga
Born 1924 in Amagasaki, Japan. Died 2008 in Japan.

Kazuo Shiraga trained in traditional Japanese and oil painting techniques, and went on to become a prominent member of the Gutai Art Association, redefining the space of painting as a 'splendid playground' for experimentation. In the early 1950s he laid aside the paintbrush and began to paint with his feet in dynamic, strenuous actions, while swinging from a rope over unstretched canvas on the floor. As records of the process of their making, the paintings privilege the materiality of paint and corporeal action. At the first Gutai Art Exhibition in Tokyo in 1955 he performed *Challenging Mud*, wrestling half naked in clay mixed with cement, for a Mainichi Hoso TV crew. Beyond formal experimentation, this violent and visceral act exemplified Shiraga's central concern with preserving subjective autonomy and political freedom. In 1971 he entered the Buddhist priesthood and continued to paint until the end of his life. [IM]

Jack Smith

Born 1932 in Ohio, USA. Died 1989 in New York.

Jack Smith was a highly influential figure in the 1960s New York underground scene. His low-fi, improvisatory experiments created a world in which performance, art and life were intermingled in new possibilities for transformation and collaboration. Although Smith did not paint canvases, he made painterly sets and costumes from debris found around New York for performances to camera that embraced camp and artificiality. These films and slide documentation were often projected onto sets of new productions and set to music, with Smith himself creating live, multi-layered events. Smith's exploration of gender, artifice and glamour is manifest in the infamous film *Flaming Creatures* 1963. Praised by writer Susan Sontag for its extrapolation of the surrealists' mode of shock, it depicts an orgy where the bodies of dragged-up men and women are confused and make-up is pointedly reapplied. The use of low-quality film and an Arabian soundtrack creates an exoticised and multi-sensory work that attracts and repels viewers in equal measure. Years later Judith Malina, one of the participants in the film reflected, 'He used actors the way painters used paint ... he painted with us.' [FM]

Zsuzsanna Ujj

Born 1959 in Veszprém, The People's Republic of Hungary (now Hungary). Lives and works in Budapest, Hungary.

Since the 1980s Zsuzsanna Ujj has worked with performance, poetry and photography to viscerally critique cultural constructions of female sexuality. Although Hungary was considered a relaxed communist state, most art institutions were either state controlled or considered out of touch, leading to many artists forming their own creative communities. Emerging, self-taught, from this context, Ujj turned to her own body as the basis of her work, painting and photographing it in anonymous settings to appear abstracted and distorted. The public exhibition of these private actions prompts a more intimate mode of identification from the viewer. In *Untitled* 1986, a series of black-and-white photographs taken over four days, Ujj, alone in an anonymous space, adopts a number of disquieting poses; her naked body, crudely painted to resemble a skeleton, transforms the traditionally passive female nude into a site of physical conflict. As she gazes menacingly beyond the picture's frame, the viewer is directly implicated as a voyeur of a scene that oscillates between vulnerability and violence. In 1992 Ujj stopped working with visual art forms, turning instead to writing private poetry and texts and heading the band Csókolom (Küss die Hand). [IM]

Andy Warhol

Born 1928 in Pittsburgh, USA. Died 1987 in New York.

Born Andrew Warhola into a poor immigrant family, Andy Warhol came to be one of the most important artists of the twentieth century. On graduating in 1949 with a degree in pictorial design from the Carnegie Institute of Technology, Pittsburgh, he moved to New York and established a successful career as a commercial illustrator. His first one-man exhibition comprised thirty-two pristinely painted reproductions of Campbell soup cans, which created a sensation. Warhol's output of the 1960s – silk-screens based on celebrities, disaster images and magazine clippings – soon became integrally linked to the emerging pop art movement. Always enthusiastic about new possibilities for creating work, Warhol began to experiment with film, and was notable in his testing of the limits of the medium and in his depiction of the colourful characters – from artists, poets and musicians to socialites, drag queens and hustlers – that passed through his studio, the Factory. After being shot by a radical feminist in 1968, Warhol became more entrepreneurial, taking on portrait commissions, producing and endorsing commercial products and socialising with celebrities. Warhol played with the heritage of American abstract painting: his commissioned portraits employed expressionistic brushwork; *Dance Diagram* 1962 was made by placing the canvas on the floor, and large abstract canvases of the late seventies were produced by pissing on copper paint. In the decade before his death Warhol continued to work relentlessly, collaborating with younger artists and continuing to use photography and audiotapes to document his experiences. In 1981 he made a series of drag self-portraits that combined his own iconic image with the glamorous women he adored. [FM]

Karla Woisnitza

Born 1952 in Rüdersdorf, Brandenburg, The Federal Republic of Germany (now Germany). Lives and works in Berlin, Germany.

The work of Karla Woisnitza is influenced by her interest in collaboration and new media, as well as her upbringing and art education in East Germany in the 1970s. After studying Bauhaus design and working in the theatre, Woisnitza organised a series of actions that often involved other female artists, and developed objects and abstract motifs into fragile environments. Her second action, *Face Painting Action* 1978–9 involved seven female artists – Marie-Luise Bauerschmidt, Sabine Gumnitz, Monika Hanske, Christine Schlegel, Cornelia Schleime, Angela Schumann – who painted their faces with abstract shapes similar to those of women in pre-Columbian America. In the documentary photographs the artists are transformed into grimacing figures that resist Western ideals of femininity. [FM]

Select Bibliography

General bibliography

Jean-Christophe Ammann, Marianne Eigenheer (eds.), *Transformer: Aspekte der Travestie*, exh. cat., Kunstmuseum, Lucerne 1974

Xabier Arakistain et al., (ed.), *Kiss Kiss Bang Bang: 45 Years of Art and Feminism*, exh. cat., Museo de Bellas Artes de Bilbao, Bilbao 2007

Charles Baudelaire, *The Painter of Modern Life and other Essays*, London 2001

Thomas J. Berghuis, *Performance Art in China*, Hong Kong 2006

Jennifer Blessing (ed.), *Rrose is a Rrose is a Rrose: Gender Performance in Photography*, exh. cat., Guggenheim Museum of Art, New York 1997

Achille Bonito Oliva, Danilo Eccher (eds.), *Appearance*, exh. cat., Galleria d'Art Moderna Bologna, Milan 2000

Manuel J. Borja-Villel et al., *A Theater Without Theater*, exh. cat., MACBA Museu d'Art Contemporani de Barcelona, Barcelona 2007

Sabine Breitwieser (ed.), *Double Life: Identity and Transformation in Contemporary Arts*, exh. cat., Generali Foundation, Vienna 2001

Judith Butler, 'Performative Acts and Gender Constitution: An Essay in Phenomenology and Feminist Theory', *Theatre Journal*, vol.40, no.4, December 1988, pp.519–31

T.J. Clark, 'In Defense of Abstract Expressionism', *October*, no.69, Summer 1994, pp.24–48

Simon Groom, Karen Smith and Xu Zhen, *The Real Thing: Contemporary Art from China*, exh. cat., Tate Liverpool, London 2007

Wu Hung, *Contemporary Chinese Art: Primary Documents*, New York 2010

Allan Kaprow, Jeff Kelley (eds.), *Essays on the Blurring of Art and Life*, London 1993

Kyoung-woon Kim, *Performance Art of Korea 1967–2007*, exh. cat., National Museum of Contemporary Art, Korea 2007

Barbara Klausen (eds.), *After the Act: the (re)presentation of performance art*, Nuremberg 2007

Ulf Küster (ed.), *Action Painting*, exh. cat., Fondation Beyeler, Basel 2008

Thomas Lawson, 'Last Exit Painting', *Mining for Gold: Selected Writings (1979–1996)*, Zurich 2004

Jean-François Lyotard, 'La Peinture comme dispositif libidinal', *Les Dispositifs pulsionnels*, Paris 1973

Alice Maude-Roxby (ed.), *Live Art on Camera: Performance and Photography*, exh. cat., John Hansard Gallery, Southampton 2007

Terry R. Myers (ed.), *Painting*, London 2010

Bojana Pejić, Rainer Fuchs, Susanne Koppensteiner, Christine Böhler, *Gender Check: Femininity and Masculinity in the Art of Eastern Europe*, exh. cat., MuMoK, Vienna 2009

Magnus af Petersens (ed.), *Explosion! Painting as Action*, exh. cat., Moderna Museet, Stockholm 2012

Patricia Phillippy, *Painting Woman: Cosmetics, Canvases and Early Modern Culture*, Baltimore 2006

Łukasz Ronduda, *Polish Art of the 70s*, Warsaw 2009

Łukasz Ronduda, Florian Zeyfang (eds.), *1,2,3... Avant-Gardes: Film/Art between Experiment and Archive*, exh. cat., CCA Ujazdowski Castle, Warsaw 2006

Harold Rosenberg, 'The American Action Painters', *The Tradition of the New*, originally in *Art News* 51/8, December 1952, p.22

Paul Schimmel (ed.), *Out of Actions*, exh. cat., The Museum of Contemporary Art, Los Angeles 1998

Gabriela Świtek (ed.), *Avant-garde in the Bloc*, Warsaw 2009

Mattijs Visser, David Leiber (ed.), *ZERO: internationale Künstler-Avantgarde der 50er/60er Jahre*, exh. cat., Museum Kunst Palast, Düsseldorf 2006

Nicholas Zurbrugg, (ed.), *Jean Baudrillard: Art and Artefact*, London 1997

Artist bibliographies by author/editor

Daniel Abadie et al., *Jackson Pollock*, exh. cat., Musée National d'Art Moderne, Paris 1982

Helena Almeida et al., *Helena Almeida*, exh. cat., Centro Galego de Arte Contemporánea, Galicia 2000

Melissa Anderson, 'The Return of Mario Montez, Warhol Legend', *Villagevoice. com*, 9 November 2011. http://www.villagevoice.com/2011-11-09/film/the-return-of-mario-montez-warhol-legend/ accessed 2012

Ei Arakawa, 'The Ab-Ex Effect', *Artforum*, Summer 2011

Inke Arns (ed.), *IRWIN: Retroprincip 1983–2003*, exh. cat., Künstlerhaus Bethanien, Berlin 2003

Eva Badura-Triska, Hubert Klocker (eds.), *Vienna Actionism: Art and Upheaval in 1960s Vienna*, exh. cat., MuMoK, Vienna 2012

Ruzandra Balaci, Geta Brătescu (eds.), *Geta Brătescu*, exh. cat., The National Museum of Art, Romania 1999

Renato Barilii, *Ontani*, exh. cat., Accademia Italiana, London 1991

Stephanie Barron, Maurice Tuchman (eds.), *David Hockney: A Retrospective*, exh. cat., Los Angeles County Museum, Los Angeles 1988

Jonathan P. Binstock, *Sam Gilliam: A Retrospective*, exh. cat., Corcoran Gallery of Art, Washington, DC 2005

Yves-Alain Bois, 'Klein's Relevance for Today', *October* 119, Winter 2007, pp.75–93

Lionel Bovier (ed.), *Karen Kilimnik*, exh. cat., Musée d'Art moderne de la Ville de Paris and Serpentine Gallery, London 2006

Dominique Bozo (ed.), *Les Nouveaux Réalistes*, exh. cat., Centre Georges Pompidou, Paris 1992

Michael Bracewell, 'No Ordinary Cats', *Frieze*, no.146, April 2012 (Lucy McKenzie article)

Stuart Brisley, Stephen Foster, Andrew Wilson, Anders Härm, *Stuart Brisley: Crossings*, exh. cat., John Hansard Gallery, Southampton 2008

Marie de Brogerolle (ed.), *Guy de Cointet*, Zürich 2011

Kerry Brougher (ed.), *Yves Klein: with the Void, Full Powers*, exh. cat., Hirshhorn Museum and Sculpture Garden, Washington, DC 2010

Norman Bryson et al., *Wu Shanzhuan: Red Humour International*, Hong Kong 2005

Benjamin H. D. Buchloh (ed.), 'Andy Warhol: A Special Issue', *October* 132, Spring 2010

Caroline Busta, 'The Actor's Studio: Caroline Busta on Ei Arakawa', *Artforum*, February 2008

Vincent Canby, Lawrence van Gelder, 'At Film Festival: "A Bigger Splash"', *New York Times*, 4 October 1974

Roberta Carasso, *Ku-lim Kim*, exh. cat., The Modern Museum of Art, California 1991

Carolyn Christov-Bakargiev, *Luigi Ontani 1965–2001*, exh. cat., PS1, New York 2001

Eda Čufer (ed.), *NSK Embassy Moscow: How the East Sees the West*, Koper 1992

Hugh M. Davies, Jay Kloner, *Sam Gilliam: Indoor and Outdoor Paintings 1967–1978*, exh. cat., University Gallery, Massachusetts 1978

Barbara Engelbach, Kasper König, Lucy McKenzie, *Lucy McKenzie: chêne de weekend: 2006–2009*, exh. cat., Museum Ludwig, Cologne 2009

Robert Fleck, Chrissie Iles, Gary Indiana, Kristine Stiles, *VALIE EXPORT: Ob/De+Con(Struction)*, exh. cat,. Moore College of Art and Design, Philadelphia 1999

Howard N. Fox, Lisa E. Bloom, *Eleanor Antin*, exh. cat., Los Angeles County Museum of Art, Los Angeles 1999

Francis Frascina (ed.), *Pollock and After: The Critical Debate*, 2nd edn, London and New York 2000

Marco Franciolli et al. (eds.), *Gutai: Painting with Time and Space*, exh. cat., Museo Cantonale d'Arte, Lugano 2010

Philip French, 'A Bigger Splash reviewed', *Sight and Sound*, vol.44, no.2, Spring 1975

Anette Freudenberger et al., *Marc Camille Chaimowicz*, exh. cat., Kunstverein fur die Rheinlande und Westfalen, Dusseldorf 2005

Martin Friedman (ed.), *Hockney Paints the Stage*, exh. cat., Walker Art Center & Abbeville Press, Minneapolis, MN & New York, 1983

Philipp Fürnkäs et al., *Derek Jarman Super8*, exh. cat., Julia Stoschek Foundation, Dusseldorf 2010

Michel de Grèce et al., *Niki de Saint Phalle, Monograph: Paintings, Tirs, Assemblages, Reliefs, 1949–2000*, Lausanne 2001

Wiktor Gutt, *Dzikość Dziecka: Kreacje dziecięce – Matowanie ciała 1972–2008*, exh. cat., Academy of Fine Arts, Warsaw 2009

Max Jorge Hinderer Cruz , 'TROPICAMP: PRE- and POST-TROPICÁLIA at Once: Some Contextual Notes on Hélio Oiticica's 1971 Text', *Afterall* 28, Autumn/Winter 2011

J. Hoberman and Edward Leffingwell (eds.), *Wait for Me at the Bottom of the Pool: The Writings of Jack Smith*, New York/London 1997

Achim Hochdörfer with Barbara Schröder (eds.), *Claes Oldenburg: The Sixties*, exh. cat, MuMoK, Vienna 2012

Tom Holert, *Marc Camille Chaimowicz: Celebration? Realife*, London 2007

Anthony Huberman, 'Frantic: The Performative Instability of Ei Arakawa', *Mousse*, no.19, June 2009

Julius Hummel, *Wiener Aktionismus*, Milan 2005

Julius Hummel, Pilar Parcerisas (eds.), *Viennese Actionism: Günter Brus, Otto Muehl, Hermann Nitsch, Rudolf Schwarzkogler*, exh. cat., Centro Andaluz de Arte Contemporáneo, Seville 2008

Agnes Husslein-Arco, Angelika Nollert and Stella Rollig (eds.), *VALIE EXPORT: Zeit und Gegenzeit/Time and Countertime*, exh. cat., Lentos Kunstmuseum, Linz 2010

John P. Jacob, 'The Enigma of Meaning/ Transforming Reality', John P. Jacob, Larry J. Feinberg, *The Metamorphic Medium: New photography from Hungary*, exh. cat., the Allen Memorial Art Museum, Oberlin College 1989, http://www.ligetgaleria.c3.hu/92+1. htm#Ujj, accessed 2012

John P. Jacob, 'Recalling Hajas', Tibor Hajas, Steven High (eds.), *Nightmare Works*, exh. cat., Anderson Gallery, School of the Arts Virginia Commonwealth University 1990, http:// www.ligetgaleria.c3.hu/CafeHajas. htm#Ujj, accessed 2012

David Joselit, 'Painting Beside Itself', *October* 130, Fall 2009, pp.125–34

Isaac Julien et al., *Derek Jarman: Brutal Beauty*, exh. cat., London 2008

Pepe Karmel, Kirk Varnedoe, *Jackson Pollock*, exh. cat., Museum of Modern Art, New York, 1998

Chan-dong Kim, Hey-kyoung Kim, *Kim, Ku-lim: Traces of Existence*, exh. cat., The Korean Culture and Arts Foundation, 2000

Katie Kitamura, 'Ei Arakawa & Sam Lewitt', *Frieze*, no.125, September 2009, London

Rosalind Krauss, Francis V. O'Connor, *L'Atelier de Jackson Pollock*, Paris 1978

Edward Leffingwell, Carole Kismaric, Marvin Heiferman (eds.), *Flaming Creature: Jack Smith, his Amazing Life and Times*, exh. cat., PSI, New York 1997

Christoph Lichtin, Flurina & Gianni Paravicini, *Urs Lüthi: Art is the Better Life*, exh. cat., Kunstmuseum, Lucerne 2009

Andrew Logan, Fennah Podschies, Marina Vaizey, *Andrew Logan: An Artistic Adventure*, exh. cat., Ruthin Craft Centre, The Harley Gallery, Nottinghamshire 2008

Caoimhín Mac Giolla Léigh, 'What do you know About My Image Duplicator?', *Afterall*, no.3, Spring/Summer 2001, pp.10–16 (Karen Kilimnik article)

Colin MacCabe, Mark Francis, Peter Wollen (eds.), *Who Is Andy Warhol?*, London 1997

Alyce Mahon, Filipa Oliveira, Lilian Tone, *Helena Almeida: Inside Me*, exh. cat., Kettle's Yard, Cambridge 2009

Roxana Maroci (ed.), *Sanja Ivekovič: Sweet Violence*, exh. cat., Museum of Modern Art, New York 2011

Sandrine Meats, *Stuart Brisley: Works 1958–2006*, exh. cat., London & Co., London 2006

Eva Meyer-Hermann (ed.), *Andy Warhol: A Guide to 706 Items in 2 Hours 56 Minutes*, exh. cat., Stedelijk Museum, Amsterdam 2007

Annette Michelson (ed.), *Andy Warhol*, London 2001

Dorota Monkiewicz (ed.), *Ewa Partum: 1965–2001*, exh. cat., Muzeum Narodowe, Warsaw 2006

Mario Montez, 'Mario Montez Underground Film Star', *YouTube: Let Them Talk*, http://youtu. be/8VYHbmAxXLQ, accessed 2012

Camille Morineau, *Yves Klein: corps, couleur, immateriel*, exh. cat., Centre Pompidou, Paris 2006

Francis Morris (ed.), *Yayoi Kusama*, exh. cat., Tate Modern, London 2011

Iris Müller-Westermann (ed.), *Jutta Koether: The Thirst*, exh. cat., Moderna Museet, Stockholm 2011

New Collectivism (ed.) Marjan Golobič (trans.), *Neue Slowenische Kunst*, Los Angeles 1991

Hélio Oiticica, 'MARIO MONTEZ, TROPICAMP', *Presença*, no.2, Rio de Janeiro, December 1971, reprinted in *Afterall*, no.28, Autumn/Winter 2011, pp.16–21, translated by Max Jorge Hinderer Cruz

Philippe Pirotte, Kathrin Rhomberg (eds.), *Jutta Koether*, exh. cat., Kunsthalle Bern 2006

Pawet Polit (ed.), *Edward Krasiński: Elementarz/ABC*, exh. cat., The Bunkier Stuki Contemporary Art Gallery, Kraków 2008

Mari Carmen Ramírez et al., *Hélio Oiticica: the Body of Colour*, exh. cat., Tate Modern, London 2007

Eva Respina et al., *Cindy Sherman*, exh. cat., Museum of Modern Art, New York 2012

Maria Teresa Roberto, Francesca Comisso, Giorgina Bertolino, *Pinot Gallizio: Catalogo generale delle opere 1953–64*, Milan 2001

Julie Rouart, Clément Dirié, *Cindy Sherman*, exh. cat., Jeu de Paume, Paris 2006

Delfim Sardo, *Helena Almeida: Feet on the Ground, Head in the Sky*, exh. cat., Centro Cultural de Belém 2004

Johann-Karl Schmidt, *Joan Jonas: Performance Video Installation 1968 –2000*, exh. cat., Galerie de Stadt Stuttgart, Stuttgart, 2000

Britta Schmitz, *Hermann Nitsch: Orgien Mysterien Theater Retrospektive*, exh. cat., Nationalgalerie im Martin-Gropius-Bau, Berlin 2006

Gabriele Schor, *Cindy Sherman: the Early Works 1975–1977*, catalogue raisonné, Sammlung Verbund, Vienna 2012

Jan Seewald, Stephan Urbaschek, Paulina Olowska, Lucy McKenzie: *Nöel sur le balcon – Hold the Colour*, exh. cat., Sammlung Goetz, Munich 2007

Marc Siegel, 'Doing It for Andy', *Art Journal*, vol.62, no.1, Spring 2003, pp.6–13

Yong-Duk Sinn, *Lee, Kang-so: the River is Moving*, exh. cat., Artsonje Museum, Korea 2003

Valerie Smith, Warren Niesluchowski (eds.), *Joan Jonas: Five Works*, exh. cat., Queens Museum of Art, New York 2003

Josef Strau, 'Ei Arakawa: A Non-Administrative Performance Mystery', *Parkett*, no.84, Spring 2009, Zurich/NY, p.158

Barbara Steiner, 'The Good Enough', *Afterall*, no.3, Spring/Summer 2001, pp.21–4

Juan A. Suárez, 'The Puerto Rican Lower East Side and the Queer Underground', *Grey Room*, no.32, Summer, 2008, pp.6–37

Reiko Tomii, Fergus McCaffrey (eds.), *Kazuo Shiraga: Six Decades*, exh. cat., McCaffrey Fine Art, New York 2009

Meredith Tromble, Lynn Herschman (eds.), *The Art and Films of Lynn Herschman Leeson: Secret Agents, Private I*, exh. cat., Henry Art Gallery, Seattle 2005

Thomas Trummer (ed.), *Kurt Kren: das Unbehagen am Film*, exh. cat., Österreichische Galerie Belvedere, Vienna 2006

Olga M. Viso, *Ana Mendieta: Earth Body, Sculpture and Performance, 1972–1985*, exh. cat., Hirschhorn Museum and Sculpture Garden, Smithsonian Institution, Washington DC, 2004

Olga Viso, *Unseen Mendieta: the unpublished works of Ana Mendieta*, New York 2008

Jan Verwoert, 'Objects of Pleasure for the Psyche', K Grässlin (ed.), *Yayoi Kusama: Arbeiten aus den Jahren 1949 bis 2003*, exh. cat., Kunstverein Braunschweig, Braunschweig 2004

John Wyner, 'Ways of Looking: Jack Hazan's A Bigger Splash', *A Bigger Splash* BFI DVD booklet, pp.1–5

Inge Zimmermann (ed.), *Karla Woisnitza: Käthe-Kollwitz-Preis*, exh. cat., Akademie der Künste, Berlin 1994

Exhibited Works

Sorted by artwork date, then alphabetical according to artist.
All measurements are in centimetres, height before width and depth.
Where an artwork is illustrated the page number is given at the end of the entry.

Jackson Pollock 1912–1956
Summertime: Number 9A
1948
Oil, enamel and house paint on canvas
84.8 x 555
Framed 88.5 x 559 x 7.3
Tate. Purchased 1988
38–9

Paul Falkenberg 1903–1986
Hans Namuth 1915–1990
Jackson Pollock '51
1950
Film, 16mm transferred to DVD, colour, sound, 10 minutes
The Museum of Modern Art, New York / Circulating Film and Video Library

Associated with Shozo Shimamoto born 1928 and Kazuo Shiraga 1924–2008
GUTAI 1960 FEB
1959
Film, 8mm transferred to DVD, colour, 10 min. 12 sec. (excerpt 4 min. 55 sec.)
© The former members of the Gutai Art Association. Courtesy Museum of Osaka University

Shozo Shimamoto born 1928
Holes
Ana
1954
Oil paint on paper
89.2 x 69.9
Framed 116.9 x 91.2
Tate. Presented by the artist 2002
44

Pinot Gallizio 1902–1964
Industrial Painting
1958
Monoprinted oil and acrylic paint on canvas
70 x 7400
Courtesy Archivio Gallizio, Turin
42

Associated with Pinot Gallizio
Senza titolo 1958
Photograph, black and white on paper (copy)
20.3 x 12.7
Courtesy Archivio Gallizio, Turin

Industrial Painting at Galleria Notizie, Turin 1958
Photograph, black and white on paper (copy)
20.3 x 12.7
Photographer: Franco Castelli
Courtesy Archivio Gallizio, Turin
43

Models dressed in Industrial Painting *at Galleria Notizie, Turin* 1958
Photograph, black and white on paper (copy)
20.3 x 12.7
Photographer: Franco Castelli
Courtesy Archivio Gallizio, Turin
43

Art critic Angelo Dragone and a visitor inspect a roll of Industrial Painting *at Galleria Notizie, Turin* 1958
Photograph, black and white on paper (copy)
20.3 x 12.7
Photographer: Franco Castelli
Courtesy Archivio Gallizio, Turin

Contact sheet of Industrial Painting *at Munich, Galerie Van de Loo* 1959
Photograph, black and white on paper (copy)
Overall 20.3 x 20.3
Courtesy Archivio Gallizio, Turin
43

Yves Klein 1928–1962
IKB 79
1959
Paint on canvas on wood
139.7 x 119.7 x 3.2
Tate. Purchased 1972
40

Günter Brus born 1938
Untitled
Ohne Titel
1960
Drawing on paper
125.7 x 90
Framed 139.5 x 104 x 4.5
Tate. Purchased 1987
47

Associated with Yves Klein 1928–1962
Anthropometry of the Blue Era
Anthropométrie de l'époque bleue
1960
Film transferred to DVD, black and white, 2 min. 26 sec.
Private collection
© Yves Klein
40

Kazuo Shiraga 1924–2009
Chizensei Kouseimao
Planète Nature
1960
Oil paint on canvas
161.5 x 130
Centre Pompidou, Musée national d'art moderne / Centre de création industrielle, Paris
45

Associated with Niki de Saint Phalle 1930–2002
The Least Effort
Le moindre effort
1961
Film, 35mm transferred to DVD, black and white (30 seconds excerpt)
Realisation: Lendi
Filmmaker unknown
Courtesy Niki Charitable Art Foundation

Niki de Saint Phalle 1930–2002
Shooting Picture
Tirage
1961
Plaster, paint, string, polythene and wire on wood
143 x 78 x 8.1
Tate. Purchased 1984
41

Jack Smith 1932–1989
Untitled
c.1958–62, printed 2011
10 analog C-prints hand printed from original colour negatives on paper
Each 35.6 x 27.9
Framed, each 43.2 x 39.4 x 3.5
Edition of 10. Stamped recto and editioned verso
Courtesy Jack Smith Archive and Gladstone Gallery, New York and Brussels
64

Hermann Nitsch born 1938
Poured Painting
Schüttbild
1963
Oil paint on canvas
104.8 x 80.6
Framed 122.5 x 98.6 x 9.5
Tate. Purchased 1981
50

Festival of Psycho Physical Naturalism (3rd Action)
1963
Photograph, colour on paper
50 x 70
Carter Presents
50

Günter Brus born 1938
Self-Painting
Selbstbemalung
1964
12 photographs, black and white on paper
Each 30 x 30
Framed, each 36 x 36
Museum moderner Kunst Stiftung Ludwig Vienna. Gift of the artist
46

Kurt Kren 1929–1998
9/64 Oh Christmas Tree
9/64 O Tannenbaum
1964
Film, 16mm transferred to DVD, colour, 3 minutes
Museum moderner Kunst Stiftung Ludwig Vienna
48

8/64 Ana – Aktion Brus
1964
Film, 16mm transferred to DVD, black and white, 2 minutes 40 seconds
Museum moderner Kunst Stiftung Ludwig Vienna
48

Günter Brus born 1938
Vienna Walk
1965
Film 8 mm transferred to DVD, black and white, 1 minute 50 seconds
Museum moderner Kunst Stiftung Ludwig Vienna. Gift of the artist, 2010
47

Run-through of an Action
Ablauf einer Aktion
1966
Drawing on 17 sheets of paper
Each, 40 x 122
Tate. Purchased 1983

Rudolf Schwarzkogler 1940–1969
3rd Action
3rd Aktion
1965, printed early 1970s
Photograph on paper
60 x 50
Tate. Purchased 2002
48

Otto Muehl born 1925 with Günter Brus born 1938
'1. Total Action. Ornament is a crime' / Material Action No.26
'1. Totalaktion. Ornament ist ein verbrechen' / Materialaktion Nr. 26
1966
8 photographs, colour on paper
Each 90 x 90
Karlheinz and Renate Hein
49

Rudolf Schwarzkogler 1940–1969
47 S/W – Negative of the Action 5a
47 S/W – Negative van der Aktion 5a
1966
Photograph, black and white on paper (copy)
30 x 30
Museum moderner Stiftung Ludwig Vienna. On loan from the Austrian Ludwig Foundation since 1984

David Hockney born 1937
A Bigger Splash
1967
Acrylic paint on canvas
242.5 x 243.9
Tate. Purchased 1981
36

Yayoi Kusama born 1929
Flower Orgy
1968
Film, 16mm transferred to DVD, colour, 1 minute 44 seconds
© Yayoi Kusama
63

Bruce Nauman born 1941
Flesh to White to Black to Flesh
1968
Video, black and white, sound, 51 minutes
Courtesy Electronic Arts Intermix (EAI)
63

VALIE EXPORT born 1940
Identity Transfer 1
Identitätstransfer 1
1968, printed late 1990s
Photograph, black and white on paper
96 x 69.2
Framed 100.6 x 73.8 x 3.5
Tate. Purchased 2006
51

Identity Transfer 2
Identitätstransfer 2
1968, printed late 1990s
Photograph on paper
95.4 x 70.7
Framed 100.6 x 73.8 x 3.6
Tate. Purchased 2006

Associated with Ku-lim Kim born 1936
Body Painting Performance
1969
Print on paper
25.3 x 19.6
Ku-lim Kim
62

Eustachy Kossakowski 1925–2001
Intervention
1969
5 photographs, black and white on paper (copy)
Each 30.3 x 23.8
Courtesy Hanna Ptaszkowska and Foksal Gallery Foundation
85

Andrew Logan born 1945 with Ben Campbell
Andrew Logan's Bedroom, Outfit and Flower Sculpture, 10 Denmark Street, Oxford
1969
Photograph, colour on paper
8.8 x 12.7
Courtesy Andrew Logan
77

Sam Gilliam born 1933
Simmering
1970
Acrylic paint on canvas
215.9 x 135.3
Presented by Mrs Nesta Dorrance
through the American Federation
of Arts 1974
67

Eleanor Antin born 1935
Representational Painting
1971
Video transferred to DVD,
black and white, 38 minutes
Courtesy Electronic Arts Intermix (EAI)
78

Stuart Brisley born 1933
Artist as Whore
1972
5 photographs, colour on paper
Dimensions variable
Courtesy the artist, Domo Baal
and Andrew Mummery
56

Derek Jarman 1942–1994
Miss Gaby – I'm Ready for My Close-Up
1972
Film, Super8 transferred to HD digital
media, colour, approx. 6 minutes
Courtesy LUMA Foundation
76

Hélio Oiticica 1937–1980
associated with Mario Montez born
1935
Stills of Agrippina é Roma Manhattan
1972
5 photographs, black and white
on paper (copy)
Each 24.8 x 17.1
Mario Montez (born René Rivera)
66

Associated with Andrew Logan
born 1945
Johnny Dewe Mathews born 1945
Andrew Logan and Derek Jarman in
the Downham Road studio, London for
Interview *Magazine*
1973
Photograph, black and white on paper
20.3 x 25.5
Courtesy Andrew Logan
77

Ana Mendieta 1948–1985
Untitled (Self Portrait with Blood)
1973
Photograph, colour on paper
24.2 x 19.4
Framed 39.8 x 31 x 3.2
Tate. Presented by the American Patrons
of Tate, courtesy of the Latin American
Acquisitions Committee 2010
58

Wiktor Gutt born 1949
and Waldemar Raniszewski 1947–2005
The Hexagon Mask
1974
Paint on wood
40 x 24 x 8
Courtesy Wiktor Gutt
61

The Great Conversation
1974
Slides, colour, transferred to disc
Courtesy Wiktor Gutt
60

Jack Hazan born 1939
A Bigger Splash
1973–4
Film, 35mm transferred to DVD,
colour, screen ratio 1.85:1, sound, 4 min.
37 sec. excerpt from original 104 minutes
Courtesy Jack Hazan and David Mingay,
distributed by the British Film Institute.
© Buzzy Enterprises Ltd
37

Ana Mendieta 1948–1985
Untitled (Body Print)
1974, printed 1997
5 photographs, colour on paper
Each, 24 x 19
Courtesy Alison Jacques Gallery,
London and Galerie Lelong, New York
59

Urs Lüthi born 1947
Just another story about leaving
1974, printed 2006
10 ultrachrome prints on paper
Each 59.4 x 42
Courtesy gallery S O
81

Helena Almeida born 1934
Inhabited Painting
Pintura habitada
1975
Acrylic paint on photograph on paper
46 x 51.5
Collection Banco Priuado, in deposit
Fundação de Serralves Contemporary
Art Museum Porto

Inhabited Painting
Pintura habitada
1975
Acrylic paint on photograph on paper
52.5 x 62.6
Collection Banco Priuado, in deposit
Fundação de Serralves Contemporary
Art Museum Porto

Inhabited Painting
Pintura habitada
1975
Acrylic paint on photograph on paper
52.5 x 62.6
Collection Banco Priuado, in deposit
Fundação de Serralves Contemporary
Art Museum Porto

Inhabited Painting
Pintura habitada
1975
Acrylic paint on photograph on paper
46 x 50
Collection Banco Priuado, in deposit
Fundação de Serralves Contemporary
Art Museum Porto
83

Geta Brătescu born 1926
Towards White
1975
9 photographs, silver bromide on paper
Overall 81 x 80.9
MNAC / National Museum of
Contemporary Art, Bucharest
52

Stuart Brisley born 1933
Moments of Decision/Indecision, Warsaw
1975
18 photographs, black and white on paper
Each 54.6 x 42.5
Tate. Purchased 1981
54–5

Edward Krasiński 1925–2004
Intervention 15
Interwencja 15
1975
Blue 'Scotch' tape and black paint
on white primed hardboard panel.
Part of installation with tape continuing
onto gallery wall.
69.9 x 50 x 3.3
Tate. Presented by Tate International
Council 2007
84

Intervention 27
Interwencja 27
1975
Blue 'Scotch' tape and black paint
on white primed hardboard panel.
Part of installation with tape continuing
onto gallery wall.
69.9 x 50 x 2.8
Tate. Presented by Tate International
Council 2007
84

Cindy Sherman born 1954
Untitled A
1975
Photograph, black and white on paper
Support: 43 x 36
Image: 41.4 x 28.3
Tate. Presented by Janet Wolfson de
Botton 1996
72

Untitled B
1975
Photograph, black and white on paper
Support: 43 x 35.5
Image: 41.8 x 28.2
Tate. Presented by Janet Wolfson
de Botton 1996

Untitled C
1975
Photograph, black and white on paper
Support: 43 x 35.5
Image: 41.8 x 28.3
Tate. Presented by Janet Wolfson
de Botton 1996

Untitled D
1975
Photograph, black and white on paper
Support: 43 x 35.5
Image: 41.8 x 28.4
56 x 43
Tate. Presented by Janet Wolfson
de Botton 1996

Lynn Hershman born 1941
Roberta Construction Chart #1
1975, printed 2009
Photograph, colour on paper
101.5 x 76
Tate. Presented anonymously 2010
71

Helena Almeida born 1934
Inhabited Canvas
Tela habitada
1976
9 photographs, gelatin silver
print on paper
Each 43 x 33
Overall 130 x 100
Tate. Purchased with the assistance
of Armando Cabral, Manuel Rios and
Manuel Fernando da Silva Santos 2012
82

Hermann Nitsch born 1938
53rd Action
1976
Print on paper
50 x 70
Carter Presents
50

53rd Action
1976
Print on paper
50 x 70
Carter Presents

Luigi Ontani born 1943
San Sebastiano Indiano
1976
Watercolour paint on photograph,
black and white on paper
32 x 26
Courtesy the artist and Galleria Lorcan
O'Neill Roma
80

Krishna. Jaipur
1976
Watercolour paint on photograph,
black and white on paper
51.5 x 61 x 2.5
Courtesy the artist and Galleria Lorcan
O'Neill Roma

Jack Smith 1932–1989
The Secret of Rented Island
1976
80 slides mounted, colour, projection
Courtesy Jack Smith Archive
and Gladstone Gallery, New York
and Brussels
65

Cindy Sherman born 1954
Untitled
1976, printed 2000
Photograph, black and white on paper
Support: 25.2 x 20.3
Image: 18.9 x 12.7
Tate. Purchased with funds
provided by the American Fund
for the Tate Gallery 2001
73

Untitled
1976, printed 2000
Photograph, black and white on paper
Support: 25.2 x 20.3
Image: 18.9 x 12.7
Tate. Purchased with funds provided
by the American Fund for the Tate
Gallery 2001
73

Untitled
1976, printed 2000
Photograph, black and white on paper
Support: 25.2 x 20.3
Image: 18.9 x 12.7
Tate. Purchased with funds
provided by the American Fund
for the Tate Gallery 2001
73

Untitled
1976, printed 2000
Photograph, black and white on paper
Support: 25.2 x 20.3
Image: 18.9 x 12.7
Tate. Purchased with funds
provided by the American Fund
for the Tate Gallery 2001
73

Untitled
1976, printed 2000
Photograph, black and white on paper
Support: 25.2 x 20.3
Image: 18.95 x 12.7
Tate. Purchased with funds
provided by the American Fund
for the Tate Gallery 2001
73

Untitled
1976, printed 2000
Photograph, black and white on paper
Support: 25.2 x 20.3
Image: 18.9 x 12.7
Tate. Purchased with funds
provided by the American Fund
for the Tate Gallery 2001
73

Untitled
1976, printed 2000
Photograph, black and white on paper
Support: 25.2 x 20.3
Image: 18.9 x 12.7
Tate. Purchased with funds
provided by the American Fund
for the Tate Gallery 2001
73

Untitled
1976, printed 2000
Photograph, black and white on paper
Support: 25.2 x 20.3
Image: 18.9 x 12.7
Tate. Purchased with funds
provided by the American Fund
for the Tate Gallery 2001
73

Untitled
1976, printed 2000
Photograph, black and white on paper
Support: 25.2 x 20.3
Image: 18.95 x 12.7
Tate. Purchased with funds
provided by the American Fund
for the Tate Gallery 2001
73

Untitled
1976, printed 2000
Photograph, black and white on paper
Support: 25.2 x 20.3
Image: 18.9 x 12.7
Tate. Purchased with funds
provided by the American Fund
for the Tate Gallery 2001
73

Untitled
1976, printed 2000
Photograph, black and white on paper
Support: 25.2 x 20.5
Image: 18.9 x 12.7
Tate. Purchased with funds
provided by the American Fund
for the Tate Gallery 2001
73

Untitled
1976, printed 2000
Photograph, black and white on paper
Support: 25.2 x 20.5
Image: 18.95 x 12.7
Tate. Purchased with funds
provided by the American Fund
for the Tate Gallery 2001

Untitled
1976, printed 2000
Photograph, black and white on paper
Support: 25.2 x 20.3
Image: 18.95 x 12.7
Tate. Purchased with funds
provided by the American Fund
for the Tate Gallery 2001

Untitled
1976, printed 2000
Photograph, black and white on paper
Support: 25.2 x 20.3
Image: 18.95 x 12.7
Tate. Purchased with funds
provided by the American Fund
for the Tate Gallery 2001

Untitled
1976, printed 2000
Photograph, black and white on paper
Support: 25.2 x 20.3
Image: 18.9 x 12.7
Tate. Purchased with funds
provided by the American Fund
for the Tate Gallery 2001

Joan Jonas born 1936
The Juniper Tree
1976/1994
Mixed media
Dimensions variable
Tate. Purchased with funds
provided by American Fund
for the Tate Gallery 2008
88–9

Sanja Iveković born 1949
Make-up – Make-down
1978
Video, colour, sound, 9 minutes
Purchased 2008
79

Kang-so Lee born 1943
Painting
1978
15 photographs, black and white,
and colour on paper
Dimensions variable
Kang-so, Lee
57

Lynn Hershman born 1941
Roberta's Body Language Chart
1978; printed 2009
Photograph on paper
102.6 x 85.3
Tate. Presented anonymously 2010

Karla Woisnitza born 1952
Face Painting Action
1978–1979
Photographs, black and white on paper,
mounted on 2 sheets of paper
Each 400 x 293
Karla Woisnitza
88–9

Ivan Cardoso born 1952
H.O.
1979
Film, 35mm transferred to DVD,
colour, sound, 12 minutes 24 seconds
Courtesy Topazio Films
66

Guy de Cointet 1934–1983
Stage sketches for All Colours/De Toutes
Les Couleurs
1981
2 digital prints on paper, from original
drawing
© Estate Guy de Cointet/Air de Paris,
Paris

**Guy de Cointet 1934–1983
and Olivier de Bouchony born 1948**
*All Colours
De Toutes Les Couleurs*
1981
Photograph, colour on paper
© Estate Guy de Cointet/Air de Paris,
Paris

*All Colours
De Toutes Les Couleurs*
1982
7 digital prints, colour on paper from
original black and white photographs
Performance directed by Yves Lefebvre,
performed by Fabrice Lucchini, Violeta
Sanchez, Sabine Haudepin, Véronique
Silver at Théâtre du Rond-Point in Paris,
January - February 1982.
© Estate Guy de Cointet/Air de Paris,
Paris

Ewa Partum born 1945
*Change – My Problem is the
Problem of a Woman*
1979
Film, 16mm transferred to DVD,
7 minutes 18 seconds
Muzeum Sztuki, Lodz
79

Geta Brătescu born 1926
The Pillars
1985
Mixed media
3 objects, each 45 x 8.7 x 6.5
MNAC / National Museum of
Contemporary Art, Bucharest
53

Andy Warhol 1928–1987
Self-Portrait in Drag
1981
Facsimile of original Polaroid™
Polacolor 2
10.8 x 8.6
The Andy Warhol Museum, Pittsburgh;
Founding Collection, Contribution The
Andy Warhol Foundation for the Visual
Arts, Inc.
75

IRWIN founded 1983
Back to the USA
1984
Film on media player, photographs,
catalogue
Dimensions variable
IRWIN (Courtesy Galerija
Gregor Podnar)
92

Cindy Sherman born 1954
Untitled
1983
C-print, colour on paper
Framed 59.9 x 49.6 x 1.5
© Cindy Sherman / SAMMLUNG
VERBUND, Vienna
74

Wang Peng born 1964
84 Performance
1984
12 photographs, black and white
on paper
Each 60 x 50
5th Edition out of 7
Sigg Collection
62

Andrew Logan born 1945
*Andrew Logan and The Alternative
Miss World*
1972–86
11 photographs, colour, black and white
on paper
Overall dimensions variable
Various photographers
Courtesy Andrew Logan
77

Zsuzsanna Ujj born 1959
With a Throne
1986
Photograph, black and white on paper
71.5 x 50.5
Courtesy the artist and Mission
Art Gallery Collection, Budapest
70

Wu Shanzhuan born 1960
Public Ink Washing
1987
4 photographs, colour on paper (copy)
16 x 24
Wu Shanzhuan and Asia Art Archive
57

Jutta Koether born 1958
The Inside Job (NYC, W.9th Street)
1991
Oil paint on canvas
311 x 196
Courtesy Thomas Borgmann, Berlin
96

IRWIN founded 1983
*NSK Embassy Moscow /
Interiors, Left, Right, Up, Down*
1992
Wood, Plexiglas, oil paint on canvas,
paper, glass, ceramics, black and
white photographs on paper
210 x 100 x 20
Iggy Private Collection
93

*NSK Embassy Moscow /
Interiors, Exorcism*
1992
Wood, Plexiglas, oil paint on wood,
rubber, metal, paper, black and
white photographs on paper
210 x 100 x 20
Iggy Private Collection
93

*NSK Embassy Moscow /
Interiors, New Europe*
1992
Wood, Plexiglas, lead, glass, fabric,
paper, black and white photographs
on paper
120 x 100 x 22
Framed 120 x 100 x 26
RANDL Collection

NSK Moscow Embassy
1992
Film on media player, photographs,
books and paper
Dimensions variable
IRWIN (Courtesy Galerija
Gregor Podnar)

Karen Kilimnik born 1955
Swan Lake
1992
Fabric, gauze, paint, sled, confetti,
2 tutus, 3 ballet shoes and other objects
Approx. 5 x 5 metres
Courtesy Ringier Collection
94–5

Jutta Koether born 1958
*The Inside Job / Drawing Book
I and II 1992*
Projection and touch screen of original
books
Courtesy the artist and Galerie
Buchholz, Berlin/Cologne
97

IRWIN founded 1983
*NSK Embassy Moscow /
Interiors, Leçon Russe*
1993
Wood, Plexiglas, lead, glass, fabric,
paper, black and white photographs
on paper
210 x 100 x 12.9
Čuček collection

*NSK Embassy Moscow /
Interiors, Paris Moscow*
1993
Wood, Plexiglas, oil paint on wood and
canvas, rubber, paper, black and white
photographs on paper
210 x 100 x 12.9
Property of the artist

Edward Krasiński 1925–2004
*Untitled
Bez tytulu*
2001
12 mirrors and tape
Each mirror 50 x 60 x 0.4, installation
dimensions variable
Tate. Presented by Tate Members 2007
84

Lucy McKenzie born 1977
May of Teck
2010
Oil paint on canvas, diptych
Overall 290 x 600, each 290 x 300
Collection Charles Asprey
100

Mrs Diack
2010
Oil paint on canvas
2 parts: 290 x 300 and 290 x 200
Ivan Moskowitz, Chicago Illinois
102–3

Kensington 2246
2010
Oil paint on canvas
290 x 200
Goetz Collection
100

Town/Gown Conflict
2010
Oil paint on canvas
290 x 300
Goetz Collection
100

Jutta Koether born 1958
Mad Garland (Plank Paintings Set #3)
2011
Acrylic paint, liquid glass and
other materials on canvas
5 paintings, each 20 x 150
Courtesy Campoli Presti, London/Paris

Lucy McKenzie born 1977
Coin de Diable Backdrop
2011
Oil paint on canvas
250 x 276
Goetz Collection
101

Coin de Diable Corner Backdrop
2011
Oil paint on canvas
258.5 x 78.5
Cabinet, London

Emmaus
2011
Oil paint and water based pigment
on primed wooden board
77.8 x 82.4
Cabinet, London

Ei Arakawa born 1977
*Reorienting Orientationalism,
New Directions (Haircolour)
International Class*
2012
Paint on Chinese silk, 6 flatscreens,
6 films on DVD
Dimensions variable
Courtesy the artist and Taka Ishii
Gallery, Tokyo; Reena Spaulings
Fine Art, New York

Installation composed
of the following artworks:
**Ei Arakawa born 1977
Amy Sillman born 1966**
BYOF (Bring Your Own Flowers)
2007
Slide show transferred to DVD
Courtesy the artist and Taka Ishii
Gallery, Tokyo; Reena Spaulings
Fine Art, New York
98

**Ei Arakawa born 1977
with Silke Otto Knapp**
Lives of Performers
2010
Film on DVD
Courtesy the artist and Taka Ishii
Gallery, Tokyo; Reena Spaulings
Fine Art, New York

**Ei Arakawa born 1977
Henning Bohl born 1975
Sergei Tcherepnin born 1981**
*Reorienting Orientationalism,
New Directions (Haircolour)
International Class*
2011
Film on DVD
Courtesy the artist and Taka Ishii
Gallery, Tokyo; Reena Spaulings
Fine Art, New York

Ei Arakawa born 1977
See Weeds
2011
Film on DVD
Courtesy the artist and Taka Ishii
Gallery, Tokyo; Reena Spaulings
Fine Art, New York
98–9

**Ei Arakawa born 1977
Nikolas Gambaroff born 1979**
Two Alphabet Monograms
2009–12
Slides transferred to DVD
Courtesy the artist and Taka Ishii
Gallery, Tokyo; Reena Spaulings
Fine Art, New York

**UNITED BROTHERS, founded 2011
DAS INSTITUT, founded 2007**
HULA & LIGHT (JOY OF LIFE)
2012
DVD
Courtesy the artist and Taka Ishii
Gallery, Tokyo; Reena Spaulings
Fine Art, New York

Grand Openings
Single's Night with Mad Garland
2011–12
DVD
Courtesy the artist and Taka Ishii
Gallery, Tokyo; Reena Spaulings
Fine Art, New York
98

Marc Camille Chaimowicz born 1947
"Jean Cocteau …"
2003–12
Mixed media
260 x 1012 x 53.2
Courtesy the artists and Cabinet,
London
86–7

'Guest' artworks within *"Jean Cocteau
…"* installation
Duncan Grant 1885–1978
Football
1911
Oil paint on canvas
227.7 x 197.5 x 2.5
Tate. Purchased 1931

Marie Laurencin 1885–1956
*The Fan
L'Eventail*
c.1919
Oil paint on canvas
44 x 43.5 x 4.6
30.5 x 30
Tate. Bequeathed by Elly Kahnweiler
1991, accessioned 1994

Edouard Vuillard 1868–1940
*Sunlit Interior
Intérieur ensoleillé*
c.1920
Distemper paint on paper laid on
canvas
83.2 x 63.8
101 x 81 x 10.5
Tate. Bequeathed by the Hon. Mrs A.E.
Pleydell Bouverie through the Friends
of the Tate Gallery 1968

Andy Warhol 1928–1987
[no title] (Electric Chair)
1971
Screenprint on paper
90 x 121.6
Tate. Purchased 1982

Wolfgang Tillmans born 1968
like praying (faded fax)
2005
Photocopy on paper
29.7 x 42
Courtesy the artist
and Maureen Paley

Marc Camille Chaimowicz born 1947
"After image …"
2012
Slides, 2 slide projectors,
dataton slide dissolve and plinth
Courtesy the artist and Cabinet, London

Untitled
2012
Wallpaper
Courtesy the artist, Cabinet, London,
and the Art of Wallpaper

Lucile Desamory born 1977
ABRACADABRA
2012
8 digital prints, colour on paper
Each approx. 30 x 45
Actors: Damien Desamory,
Antonia Baehr, Frédérique Franke,
Lucy Mckenzie
Director of photography:
Artur Castro Freire
Courtesy the artist
101

IRWIN founded 1983
29 Years
2012
Photographs, black and white,
and colour on paper
Framed each 53 x 43
IRWIN (Courtesy Galerija
Gregor Podnar)
92

Lenders and Credits

Lenders

Air de Paris, Paris
Asia Art Archive (AAA), Hong Kong
Alison Jacques Gallery, London
Ei Arakawa
Archivio Gallizio, Turin
Charles Asprey
Thomas Borgmann
Stuart Brisley
British Film Institute (BFI)
Buchholz Galerie, Cologne
Cabinet Gallery, London
Campoli Presti, Paris
Ivan Cardoso
Carter Presents, London
Centre Pompidou, Paris
Le Consortium, Paris
Cuček Collection
Electronic Arts Intermix (EAI),
 New York
Foksal Gallery Foundation, Warsaw
Fundação de Serralves, Porto
Galleria Lorcan O'Neill, Rome
Galerie Lelong, New York
gallery S O, Solothurn
Barbara Gladstone, New York
Ingvild Goetz, Munich
Wiktor Gutt
Jack Hazan
Karlheinz and Renate Hein
Hermann Nitsch Foundation
Iggy Private Collection
IRWIN, Slovenia
Ku-lim Kim
Jutta Koether
Yayoi Kusama
Kang-so Lee
Andrew Logan
LUMA Foundation
Lucy McKenzie
MoMA Circulating Film and Video
 Library, New York
Mario Montez (born René Rivera)
Maureen Paley
MissionArt Gallery, Hungary
Ivan Moskowitz
Museum Moderner Kunst Stiftung
 Ludwig (MuMoK), Vienna
Museum of Osaka University
Muzeul National de Arta Contemporana
 (MNAC), Bucharest
Muzeum Sztuki, Warsaw
National Museum of Contemporary
 Art, Korea
Niki Charitable Art Foundation,
 Los Angeles
RANDL Collection
Ringier AG/Sammlung Ringier
Wu Shanzhuan
Sigg Collection, Munich
Wolfgang Tillmans
The Andy Warhol Museum, Pittsburgh
Zsuzsanna Ujj
Roman Uranjek
Verbund Collection, Vienna
Nadia Wallis
Karla Woisnitza
Yves Klein Archives, Paris

Special thanks

Alison Jacques, Louise O'Kelly,
 Rory Mitchell of Alison
 Jacques Gallery
Liliana Dematteis and Anna Follo
 of the Archivio Gallizio
Ashiya City Museum of Art & History
Domo Baal
Claire Beltz-Wüest of the
 Museum Tinguely
Jes Benstock
Florence Bonnefous of
 Air de Paris Gallery
Céline Breton and Valentina Valentini
 of the Bibliothèque Kandinsky
Bibliothèque municipale de Lyon
Erica Bolton
Maya and Stuart Brisley
British Film Institute (BFI)
 National Archive

Andrew Wheatley, Martin McGeown
 and Anna Clifford of Cabinet Gallery
Véronique Cardon of the Archives
 de l'Art contemporain en Belgique
Ivan Cardoso
Evelyne Blanc and Olga Makhroff
 of the Centre Pompidou
Kitty Cleary of MoMA, The Circulating
 Film & Video Library
Hugh de Cointet
Xavier Douroux and Irène Bony
 of Le Consortium
Marie-Jeanne Dypréau
Nick Lesley and Juliet Myers
 of Electronic Arts Intermix (EAI)
Andras Edit
Aniko Erdosi of BROADWAY 1602
Ariane Figueiredo of Projeto
 Hélio Oiticica
Andrzej Przywara and Aleksandra
 Sciegienna of Foksal Gallery Warsaw
Felix Flury of gallery S O
Bruno Ramos Múrias and Daniela
 Oliveira of Galeria Filomena Soares
Lorcan O'Neill, Laura Chiari and Serena
 Basso of Galleria Lorcan O'Neill
Gurcius Gewdner
Barbara Gladstone and Daniel Feinberg
 of Gladstone Gallery
Jack Hazan
Claudia Hein
Marianne Heller of the Sigg Collection
Gudrun Kutschi and Rita Nitsch
 of the Hermann Nitsch Foundation
Vera Hoffman of Maureen Paley Gallery
Maja Hoffman
Jenny Jaskey of The Artist's Institute,
 New York
Alexander Kammerhoff
 of Sammlung Goetz
Mizuho Kato of Museum
 of Osaka University
Koichi Kawasaki
Kyoung-woon Kim of the National
 Museum of Contemporary Art Korea
Yayoi Kusama and Etsuko Sakurai
 of Kusama Studios
Andrew Logan
James McKay
Marsha Mateyka and Annie Gawlak
 of Marsha Mateyka Gallery
Johnny Dewe Mathews
Raluca Velisar and Ruxandra Balaci
 at National Museum of Contemporary
 Art (MNAC), Bucharest
Miran Mohar of IRWIN
Mario Montez
Maria Morzuch of Museum Sztuki
Eva Badura-Triska, Sophie Haaser
 and Alexandra Pinter of MuMoK
Kata Oltai
Laurence Le Poupon of Archives
 de la critique d'art.
Jane Pritchard of the Victoria and
 Albert Museum, London
Al Riches of the English National Ballet
Christina Ruf and Markus Edelmann
 of Ringier AG/Sammlung Ringier
Jamie Robinson of Carter Presents
Łukasz Ronduda of the Muzeum
 Sztuki Nowoczesnej Warsaw
Gabriele Schor and Ema Rajkovic
 of the Sammlung Verbund
Charlie Scheips
Belynda Sharples of the Art of Wallpaper
Jana Shenefield, Archivist of
 Niki Charitable Art Foundation
Philippe Siauve of the Yves
 Kein Archives
Marc Siegel
Heather Kowalski and Matt Wrbican
 of the Andy Warhol Museum
Zhang Wei of Vitamin Creative Space
Anthony Yung of the Asia Art Archive

We reuse our exhibition walling as
much as possible: since 2009 this
has saved over 4,500 square metres
of MDF from landfill.

Credits

All images courtesy the artist unless
stated otherwise.

akg-images 30 (left), 33 (top)
Arcaid Images / Alamy 12
Robyn Beeche; Make-up by
 Richard Sharah 19
Courtesy Galerie Buchholz, Berlin /
 Cologne 102–3
Filipe Braga 83
Mihai Brătescu 52
Courtesy the artists and Cabinet,
 London 11, 86
Courtesy Campoli Presti London/
 Paris 96, 97
Centre Pompidou, MNAM-CCI, Dist.
 RMN / Georges Meguerditchian 10
Centre Pompidou, MNAM-CCI, Dist.
 RMN / Philippe Migeat 45 (top)
Robert Cohen 41 (bottom)
Electronic Arts Intermix (EAI),
 New York 63 (right), 78
J. Paul Getty Trust 26
Courtesy Galerija Gregor Podnar
 92, 93
Courtesy the Archivio Gallizio,
 Torino 42, 43
The Internet Archive, scanned
 by Becky Simmons 25
Josef Konczak/ Tate Photography 98
 (bottom)
Courtesy The Laban Archive 28
Courtesy Galleria Lorcan O'Neill
 Roma 80
Andrew Logan 77
Jack Mitchell 23
Robert McElroy 16
Museum Moderner kunst Stiftung
 Ludwig Wien, donation of the artist
 46, 47 (top), 48 (top and middle)
Museum of Modern Art, Warsaw
 60, 61
National Portrait Gallery Smithsonian/
 Art Resource/Scala, Florence 39
Wang Peng 62
Courtesy Performing Arts Library
 Museum of Performance & Design
 25
Courtesy Hanna Ptaszkowska and
 Foksal Gallery Foundation 85
Courtesy SAMMLUNG VERBUND,
 Vienna 74
Scala, Florence 35
Scala, Florence/BPK, Bildagentur fuer
 Kunst, Kultur und Geschichte, Berlin.
 Photo: Joerg P. Anders 30 (right)
David von Schlegell Showing a painting
 by Harvey Quaytman image courtesy
 R H Quaytman 7
Fujiko Shiraga and the former members
 of the Gutai Art Association, Ashiya
 City Museum of Art & History 45
 (bottom)
Associazione Shozo Shimamoto,
 Napoli 2–3, 44 (top)
Harry Shunk and John Kender.
 Shunk-Kender © Roy Lichtenstein
 Foundation 40 (left)
Larisa Sitar 53
Photo by Jan Smaga, image courtesy
 Foksal Gallery Foundation 84
The State Museum of
 V.V.Mayakovsky 20
Tate Photography, 2012 44 (bottom), 50
 (top), 67, 33 (bottom)
Courtesy Warsaw Museum 79 (bottom)
Film stills: Roz Young 63 (left), 66 (left)

Index

Supporting Tate

Tate relies on a large number of supporters – individuals, foundations, companies and public sector sources – to enable it to deliver its programme of activities, both on and off its gallery sites. This support is essential in order for Tate to acquire works of art for the Collection, run education, outreach and exhibition programmes, care for the Collection in storage and enable art to be displayed, both digitally and physically, inside and outside Tate. Your donation will make a real difference and enable others to enjoy Tate and its Collection both now and in the future. There are a variety of ways in which you can help support Tate and also benefit as a UK or US taxpayer. Please contact us at:

Development Office
Tate
Millbank
London SWIP 4RG
Tel: 020 7887 4900
Fax: 020 7887 8098

American Patrons of Tate
520 West 27 Street Unit 404
New York, NY 10001
USA
Tel: 001 212 643 2818
Fax: 001 212 643 1001

Donations, of whatever size, are gratefully received, either to support particular areas of interest, or to contribute to general activity costs.

Gifts of Shares
We can accept gifts of quoted share and securities. All gifts of shares to Tate are exempt from capital gains tax, and higher rate taxpayers enjoy additional tax efficiencies. For further information please contact the Development Office.

Gift Aid
Through Gift Aid you can increase the value of your donation to Tate as we are able to reclaim the tax on your gift. Gift Aid applies to gifts of any size, whether regular or a one-off gift. Higher rate taxpayers are also able to claim additional personal tax relief. Contact us for further information and to make a Gift Aid Declaration.

Legacies
A legacy to Tate may take the form of a residual share of an estate, a specific cash sum or item of property such as a work of art. Legacies to Tate are free of inheritance tax, and help to secure a strong future for the Collection and galleries. For further information please contact the Development Office.

Offers in lieu of tax
Inheritance Tax can be satisfied by transferring to the Government a work of art of outstanding importance. In this case the amount of tax is reduced, and it can be made a condition of the offer that the work of art is allocated to Tate. Please contact us for details.

Tate Members
Tate Members enjoy unlimited free admission throughout the year to all exhibitions at Tate, as well as a number of other benefits such as exclusive use of our Members' Rooms and a free annual subscription to Tate Etc. Whilst enjoying the exclusive privileges of membership, you are also helping secure Tate's position at the very heart of British and modern art. Your support actively contributes to new purchases of important art, ensuring that the Tate's Collection continues to be relevant and comprehensive, as well as funding projects in London, Liverpool and St Ives that increase access and understanding for everyone.

Tate Patrons
Tate Patrons share a strong enthusiasm for art and are committed to giving significant financial support to Tate on an annual basis. The Patrons support the acquisition of works across Tate's broad collecting remit, as well as other areas of Tate activity such as conservation, education and research. The scheme provides a forum for Patrons to share their interest in art and to exchange knowledge and information in an enjoyable environment. United States taxpayers who wish to receive full tax exempt status from the IRS under Section 501 (c) (3) are able to support the Patrons through the American Patrons of Tate. For more information on the scheme please contact the Patrons office.

Corporate Membership
Corporate Membership at Tate Modern, Tate Britain and Tate Liverpool offers companies opportunities for corporate entertaining and the chance for a wide variety of employee benefits. These include special private views, special access to paying exhibitions, out-of-hours visits and tours, invitations to VIP events and talks at members' offices.

Corporate Investment
Tate has developed a range of imaginative partnerships with the corporate sector, ranging from international interpretation and exhibition programmes to local outreach and staff development programmes. We are particularly known for high-profile business to business marketing initiatives and employee benefit packages. Please contact the Corporate Fundraising team for further details.

Charity Details
The Tate Gallery is an exempt charity; the Museums & Galleries Act 1992 added the Tate Gallery to the list of exempt charities defined in the 1960 Charities Act. Tate Members is a registered charity (number 313021). Tate Foundation is a registered charity (number 1085314).

American Patrons of Tate American Patrons of Tate is an independent charity based in New York that supports the work of Tate in the United Kingdom. It receives full tax exempt status from the IRS under section 501(c)(3) allowing United States taxpayers to receive tax deductions on gifts towards annual membership programmes, exhibitions, scholarship and capital projects. For more information contact the American Patrons of Tate office.

Edward and Agnès Lee
Lex Service Plc
Lehman Brothers
Ruth and Stuart Lipton
Anders and Ulla Ljungh
The Frank Lloyd Family Trusts
London & Cambridge
 Properties Limited
London Electricity plc, EDF Group
Mr and Mrs George Loudon
Mayer, Brown, Rowe & Maw
Viviane and James Mayor
Ronald and Rita McAulay
The Mercers' Company
The Meyer Foundation
The Millennium Commission
Anthony and Deirdre Montagu
The Monument Trust
Mori Building, Ltd
Mr and Mrs M D Moross
Guy and Marion Naggar
Peter and Eileen Norton,
 The Peter Norton Family Foundation
Maja Oeri and Hans Bodenmann
Sir Peter and Lady Osborne
William A Palmer
Mr Frederik Paulsen
Pearson plc
The Pet Shop Boys
The Nyda and Oliver Prenn Foundation
Prudential plc
Railtrack plc
The Rayne Foundation
Reuters
Sir John and Lady Ritblat
Rolls-Royce plc
Barrie and Emmanuel Roman
Lord and Lady Rothschild
The Dr Mortimer and Theresa
 Sackler Foundation
J. Sainsbury plc
Ruth and Stephan Schmidheiny
Schroders
Mr and Mrs Charles Schwab
David and Sophie Shalit
Belle Shenkman Estate
William Sieghart
Peter Simon
Mr and Mrs Sven Skarendahl
London Borough of Southwark
The Foundation for Sports and the Arts
Mr and Mrs Nicholas Stanley
The Starr Foundation
The Jack Steinberg Charitable Trust
Charlotte Stevenson
Hugh and Catherine Stevenson
John Studzinski
David and Linda Supino
The Government of Switzerland
Carter and Mary Thacher
Insinger Townsley
UBS
UBS Warburg
David and Emma Verey
Dinah Verey
The Vintners' Company
Clodagh and Leslie Waddington
Robert and Felicity Waley-Cohen
Wasserstein, Perella & Co., Inc.
Gordon D Watson
The Weston Family
Mr and Mrs Stephen Wilberding
Michael S Wilson
Poju and Anita Zabludowicz
**and those donors who wish
to remain anonymous**

Donors to The Tate Modern Project
The Blavatnik Family Foundation
Lauren and Mark Booth
The Deborah Loeb Brice Foundation
The Lord Browne of Madingley,
 FRS, FREng
John and Christina Chandris
James Chanos
Paul Cooke
Ago Demirdjian and Tiqui
 Atencio Demirdjian
George Economou
Mala Gaonkar
Thomas Gibson in memory
 of Anthea Gibson
Lydia and Manfred Gorvy
Noam Gottesman
Maja Hoffmann/LUMA Foundation
Maxine Isaacs
Peter and Maria Kellner
Madeleine Kleinwort
Catherine Lagrange
Pierre Lagrange
Allison and Howard W. Lutnick
Donald B. Marron
Anthony and Deirdre Montagu
Elisabeth Murdoch
Alison and Paul Myners
Maureen Paley
Daniel and Elizabeth Peltz
Catherine and Franck Petitgas
Barrie and Emmanuel Roman
The Dr Mortimer and Theresa
 Sackler Foundation
John Studzinski, CBE
Tate Members
Nina and Graham Williams
**and those donors who wish
to remain anonymous**

**Tate Modern Benefactors
and Major Donors**
We would like to acknowledge
and thank the following benefactors
who have supported Tate Modern
prior to 30 May 2012
29th May 1961 Charitable Trust
Drew Aaron and Hana Soukupova
Carolyn Alexander
Basil Alkazzi
American Patrons of Tate
Annenberg Foundation
Klaus Anschel
The Fagus Anstruther Memorial Trust
Mehves and Dalinc Ariburnu
Arts Council England
The Art Fund
The Company of Arts Scholars, Dealers
 and Collectors' Charitable Fund
The Arts & Humanities
 Research Council
Charles Asprey
Marwan Assaf
Aurelius Charitable Trust
Miroslaw Balka
Victoria Barnsley, OBE
Mr John Bellany
Big Lottery Fund
The Charlotte Bonham-Carter
 Charitable Trust
Mr Pontus Bonnier
Louise Bourgeois
Frances Bowes
Ivor Braka
The Estate of Dr Marcella Louis Brenner
British Council
Mr and Mrs Ben Brown
Piers Butler
Armando Cabral
Pedro Cabrita Reis
Caldic Collectie, Wassenaar
Calouste Gulbenkian Foundation
Lucy Carter

John and Christina Chandris
James Chanos
Henry Christensen III
Patricia Phelps de Cisneros
The Clore Duffield Foundation
The Clothworkers' Foundation
Jenny Collins and Caroline Aperguis
Douglas S Cramer
Martin Creed
Bilge Ogut-Cumbusyan and
 Haro Cumbusyan
Daiwa Anglo-Japanese Foundation
Thomas Dane
Dimitris Daskalopoulos
Richard Deacon
Dedalus Foundation, Inc.
The Gladys Krieble Delmas Foundation
Ago Demirdjian and Tiqui
 Atencio Demirdjian
Department for Business, Innovation
 And Skills
The Department for Culture, Media
 and Sport
Anthony d'Offay
Peter Doig
Jytte Dresing, The Merla
 Art Foundation, Dresing Collection
The Duerckheim Collection
Maryam and Edward Eisler
Carla Emil and Rich Silverstein
Oscar Engelbert
Esmée Fairbairn Foundation
Fares and Tania Fares
The Estate of Maurice Farquharson
Wendy Fisher
Jeanne Donovan Fisher
Mrs Doris Fisher
Lady Lynn Forester de Rothschild
The Estate of Ann Forsdyke
Eric and Louise Franck
Amanda and Glenn Fuhrman
The Getty Foundation
Antonia Gibbs
Millie and Arne Glimcher
Goethe-Institut
Dr John Golding
Nicholas and Judith Goodison
Goodman Gallery, Johannesburg
 and Cape Town
David and Maggi Gordon
Lady Gosling
The Great Britain Sasakawa Foundation
The Estate of Alan Green
Chloë and Paul Gunn
The Haberdashers' Company
Andrew and Christine Hall
Paul Hamlyn Foundation
Viscount and Viscountess Hampden
 and Family
Dr Mark Hannam
Mr Toshio Hara
Hauser & Wirth
The Hayden Family Foundation
Stuart Heath Charitable Settlement
Janet Henderson
Heritage Lottery Fund
Mauro Herlitzka
Damien Hirst
The Henry C Hoare Charitable Trust
David Hockney
The Estate of Mrs Mimi Hodgkin
Marguerite Hoffman
Maja Hoffmann/LUMA Foundation
Jenny Holzer
Michael Hoppen
Billstone Foundation
Cristina Iglesias
Callum Innes
Institut Ramon Llull
The J Isaacs Charitable Trust
The Japan Foundation
Alain Jathiere
JISC

Panos Karpidas
J. Patrick Kennedy and
 Patricia A. Kennedy
Bharti Kher
Jack Kirkland
The Estate of RB Kitaj
Leon Kossoff
Jannis Kounellis
The Kreitman Foundation
Catherine Lagrange
Pierre Lagrange
Agnès and Edward Lee
Legacy Trust UK
The Leverhulme Trust
Gemma Levine
José Lima
The Estate of Barbara Lloyd
Doris J. Lockhart
Eugenio Lopez
Mark and Liza Loveday
The Henry Luce Foundation
John Lyon's Charity
Christopher Eykyn and
 Nicholas Maclean
Karim Makarius
The Estate of Sir Edwin Manton
The Michael Marks Charitable Trust
The JP Marland Charitable Trust
The Estate of Gordon Matta-Clark
Michael Werner , Inc
Boris and Vita Mikhailov
Sir Geoffroy Millais
Jean-Yves Mock
The Henry Moore Foundation
Peter Moores Foundation
Mr Minoru Mori, Hon KBE and
 Mrs Yoshiko Mori
NADFAS
National Heritage Memorial Fund
Mr Sean O'Connor
The Olivier Family
Dr John Osley
Outset Contemporary Art Fund
Irene Panagopoulos
Konstantinos Papageorgiou and
 Gregory Papadimitriou
Martin Parr
The Estate of Mr Brian and
 Mrs Nancy Pattenden
Stephen and Yana Peel
Catherine Petitgas
PHG Cadbury Charitable Trust
Stanley Picker Trust
The Pilgrim Trust
Heather and Tony Podesta Collection
Powell Charitable Trust
Gilberto Pozzi
Cindy and Howard Rachofsky
The Reed Foundation
Mrs Frances Reynolds
Manuel Rios
Miguel Rios
The Robert Mapplethorpe Foundation
Barrie and Emmanuel Roman
Rootstein Hopkins Foundation
Helen and Ken Rowe
Edward Ruscha
The Michael Harry Sacher
 Charitable Trust
The Estate of Simon Sainsbury
Ms Avis Saltsman
Sally and Anthony Salz
Gerd Sander
The Sandra Charitable Trust
Sherine Sawiris
The Finnis Scott Foundation
Candida and Rebecca Smith
Tishman Speyer
Cynthia and Abe Steinberger
Charlotte Stevenson
Mr Anthony Stoll
Mercedes and Ian Stoutzker
Mr Christen Sveaas

Julian Opie
Pilar Ordovás
Sir Richard Osborn
Joseph and Chloe O'Sullivan
Desmond Page
Maureen Paley
Dominic Palfreyman
Michael Palin
Mrs Adelaida Palm
Stephen and Clare Pardy
Mrs Véronique Parke
Mr Sanjay Parthasarathy
Miss Nathalie Philippe
Ms Michina Ponzone-Pope
Mr Oliver Prenn
Susan Prevezer QC
Mr Adam Prideaux
Mr and Mrs Ryan Prince
James Pyner
Mrs Phyllis Rapp
Mr and Mrs James Reed
Mr and Mrs Philip Renaud
The Reuben Foundation
Sir Tim Rice
Lady Ritblat
The Sylvie Fleming Collection
Ms Chao Roberts
David Rocklin
Frankie Rossi
Mr David V Rouch
Mr James Roundell
Naomi Russell
Mr Alex Sainsbury and Ms Elinor Jansz
Mr Richard Saltoun
Mrs Amanda Sater
Mrs Cecilia Scarpa
Cherrill and Ian Scheer
Sylvia Scheuer
Mrs Cara Schulze
Andrew and Belinda Scott
The Hon Richard Sharp
Mr Stuart Shave
Neville Shulman, CBE
The Schneer Foundation
Ms Julia Simmonds
Jennifer Smith
Mrs Cindy Sofer
Mrs Carol Sopher
Mr George Soros
Louise Spence
Mr and Mrs Nicholas Stanley
Mr Nicos Steratzias
Stacie Styles
Mrs Patricia Swannell
Mr James Swartz
The Lady Juliet Tadgell
Christopher and Sally Tennant
Lady Tennant
Mr Henry Tinsley
Karen Townshend
Melissa Ulfane
Mr Marc Vandecandelaere
Mrs Cecilia Versteegh
Mr Jorge Villon
Gisela von Sanden
Mr David von Simson
Audrey Wallrock
Stephen and Linda Waterhouse
Offer Waterman
Terry Watkins
Miss Cheyenne Westphal
Mr David Wood
Mr Douglas Woolf
**and those who wish to remain
anonymous**

Young Patrons
Stephanie Alemeiba
Ms Maria Allen
Miss Noor Al-Rahim
HRH Princess Alia Al-Senussi
Miss Sharifa Alsudairi
Sigurdur Arngrimsson
Miss Katharine Arnold
Miss Joy Asfar
Kirtland Ash
Miss Olivia Aubry
Flavie Audi
Josh Bell and Jsen Wintle
Ms Shruti Belliappa
Mr Edouard Benveniste-Schuler
Miss Margherita Berloni
Raimund Berthold
Ms Natalia Blaskovicova
Dr Brenda Blott
Mrs Sofia Bocca
Ms Lara Bohinc
Mr Andrew Bourne
Miss Camilla Bullus
Miss Verena Butt
Miss May Calil
Miss Sarah Calodney
Matt Carey-Williams and Donnie Roark
Dr Peter Chocian
Mrs Mona Collins
Thamara Corm
Miss Amanda C Cronin
Mrs Suzy Franczak Davis
Ms Lora de Felice
Mr Stanislas de Quenetain
Mr Alexander Dellal
Mira Dimitrova
Ms Michelle D'Souza
Miss Roxanna Farboud
Jane and Richard Found
Mr Andreas Gegner
Ms Alexandra Ghashghai
Mrs Benedetta Ghione-Webb
Mr Nick Hackworth
Alex Haidas
Ms Susan Harris
Sara Harrison
Kira Allegra Heller
Mrs Samantha Heyworth
Katherine Ireland
Miss Eloise Isaac
Ms Melek Huma Kabakci
Miss Meruyert Kaliyeva
Mr Efe Kapanci
Ms Tanya Kazeminy Mackay
Mr Benjamin Khalili
Ms Marijana Kolak
Miss Constanze Kubern
Miss Marina Kurikhina
Mr Jimmy Lahoud
Ms Anna Lapshina
Mrs Julie Lawson
Ms Joanne Leigh
Miss Mc Llamas
Mr Justin Lobo
Alex Logsdail
Mrs Siobhan Loughran
Charlotte Lucas
Alessandro Luongo
Mr John Madden
Ms Sonia Mak
Mr Jean-David Malat
Ms Clémence Mauchamp
Miss Charlotte Maxwell
Mr John McLaughlin
Miss Nina Moaddel
Mr Fernando Moncho Lobo
Erin Morris
Mrs Annette Nygren
Phyllis Papadavid

Alexander V. Petalas
Mrs Stephanie Petit
The Piper Gallery
Lauren Prakke (Chair, Young
 Patrons Ambassador Group)
Ivetta Rabinovich
Mr Eugenio Re Rebaudengo
Mr Bruce Ritchie and Mrs Shadi Ritchie
Kimberley and Michael Robson-Ortiz
Mr Daniel Ross
Mr Simon Sakhai
Miss Tatiana Sapegina
Mr Simon Scheuer
Franz Schwarz
Count Indoo Sella di Monteluce
Preeya Seth
Miss Kimberly Sgarlata
Henrietta Shields
Ms Heather Shimizu
Mr Paul Shin
Ms Marie-Anya Shriro
Mr Max Silver
Tammy Smulders
Mr Saadi Soudavar
Miss Malgosia Stepnik
Alexandra Sterling
Mr Dominic Stolerman
Mr Edward Tang
Miss Inge Theron
Soren S K Tholstrup
Hannah Tjaden
Mrs Padideh Trojanow
Mr Philippos Tsangrides
Dr George Tzircotis
Mr Rupert Van Millingen
Mr Neil Wenman
Ms Hailey Widrig Ritcheson
Ms Seda Yalcinkaya
Michelle Yue
Miss Burcu Yuksel
Miss Tiffany Zabludowicz
Mr Fabrizio Zappaterra
**and those who wish to remain
anonymous**

**North American Acquisitions
Committee**
Carol and David Appel
Beth Rudin De Woody
Carla Emil and Rich Silverstein
Elisabeth Farrell and Panos Karpidas
Glenn Fuhrman
Andrea and Marc Glimcher
Pamela Joyner
Monica Kalpakian
Massimo Marcucci
Lillian Mauer
Liza Mauer and Andrew Sheiner
Nancy McCain
Stuart and Della McLaughlin
Stavros Merjos
Gregory R. Miller
Shabin and Nadir Mohamed
Elisa Nuyten & David Dime
Amy and John Phelan
Liz Gerring Radke and Kirk Radke
Laura Rapp and Jay Smith
Robert Rennie (Chair) and Carey Fouks
Donald R Sobey
Robert Sobey
Ira Statfeld
Christen and Derek Wilson
**and those who wish to remain
anonymous**

**Latin American Acquisitions
Committee**
Monica and Robert Aguirre
Karen and Leon Amitai
Patricia Moraes and Pedro Barbosa
Luis Benshimol
Billy Bickford, Jr. and Oscar Cuellar
Estrellita and Daniel Brodsky
Carmen Buqueras
Rita Rovelli Caltagirone
Trudy and Paul Cejas
Patricia Phelps de Cisneros
David Cohen
Gerard Cohen
HSH the Prince Pierre d'Arenberg
Tiqui Atencio Demirdjian (Chair)
Lily Gabriella Elia
Angelica Fuentes de Vergara
William A. Haseltine
Mauro Herlitzka
Yaz Hernandez
Rocio and Boris Hirmas Said
Anne Marie and Geoffrey Isaac
Nicole Junkermann
Jack Kirkland
Fatima and Eskander Maleki
Fernanda Feitosa and Heitor Martins
Becky and Jimmy Mayer
Solita and Steven Mishaan
Catherine and Michel Pastor
Catherine Petitgas
Ferdinand Porák
Isabella Prata and Idel Arcuschin
Frances Reynolds
Erica Roberts
Judko Rosenstock and Oscar Hernandez
Guillermo Rozenblum
Alin Ryan von Buch
Lilly Scarpetta and Roberto Pumarejo
Catherine Shriro
Norma Smith
Susana and Ricardo Steinbruch
Juan Carlos Verme
Tania and Arnoldo Wald
Juan Yarur
**and those who wish to remain
anonymous**

Asia-Pacific Acquisitions Committee
Bonnie and R Derek Bandeen
Mr and Mrs John Carrafiell
Mrs Christina Chandris
Richard Chang
Pierre TM Chen, Yageo Foundation,
 Taiwan
Katie de Tilly
Mr. Hyung-Teh Do
Ms Mareva Grabowski
Elizabeth Griffith
Ms Kyoko Hattori
Cees Hendrikse
Mr Yongsoo Huh
Lady Tessa Keswick
Mr Chang-Il Kim
Ms Yung Hee Kim
The Red Mansion Foundation
Alan Lau
Woong-Yeul Lee
Mr William Lim
Ms Kai-Yin Lo
Anne Louis-Dreyfus
Mrs. Geraldine Elaine Marden
Mr Jackson See
Mr Paul Serfaty
Dr Gene Sherman AM
Mr Robert Shum
Sir David Tang (Chair)
Mr. Budi Tek, The Yuz Foundation
Rudy Tseng (Taiwan)
**and those who wish to remain
anonymous**